SECRET GARDENS
OF THE SOUTH EAST

SECRET GARDENS
OF THE SOUTH EAST

A PRIVATE TOUR

BARBARA SEGALL

PHOTOGRAPHS BY
CLIVE BOURSNELL

FOREWORD BY
FERGUS GARRETT

FRANCES
LINCOLN

Contents

HALF-TITLE Topiary birds and shapes delight at Balmoral Cottage, Kent.
TITLE Exuberant plantings edge the Flower Garden at Gravetye Manor, West Sussex.
LEFT Pencil-slim upright junipers sign the way to Toune Priory, a 'ruin' created from a thousand hornbeam whips to form the imagined Romanesque priory, at Town Place, East Sussex.

Foreword

GARDENS ARE COMPLEX PIECES OF ART in which we fine-tune nature to paint a picture. But they are influenced by many things. Sometimes they tell historical stories, rich with memories of the passage of time and the people involved in their making. These transport the visitor to past times within a growing, changing and living environment.

Gardens can also be about architecture, whether historic or modern. They may be designed for a purpose, to hide the picture and then reveal it, to move the eye and the heart, to surprise or to soothe, to excite and to inspire. Sometimes gardens evolve organically to have their own presence, unconventional, yet skilfully and sensitively formed and comfortable in their own skin. They are also about the land, the soil, the materials surrounding them, and the landscape in which they sit.

Surrey, Sussex, and Kent all have their own special conditions, whether the foundations are the chalk of the South Downs – a bleached landscape with knapped flint universal in the walls and buildings – or on the ragstone and rolling hills of Kent, or the clay of Sussex within the mosaic of small fields, hedges and woodlands of the Low Weald. Each place has its own feel. Our special individual microclimates enable us to grow a wide range of plants. The views and borrowed landscapes are different and as a result so are the gardens. This sense of place speaks to each of us – the unique qualities and atmosphere of an area, with each region and position having its own special quality.

Gardens are also about people, and even though the soil and climate play their part in the process of directing what we can grow and how we can grow it, it is people who give gardens their essential spirit. People are the driving force, riding the horse of nature, galloping and guiding it through an ever-changing painting – unique to the person creating it.

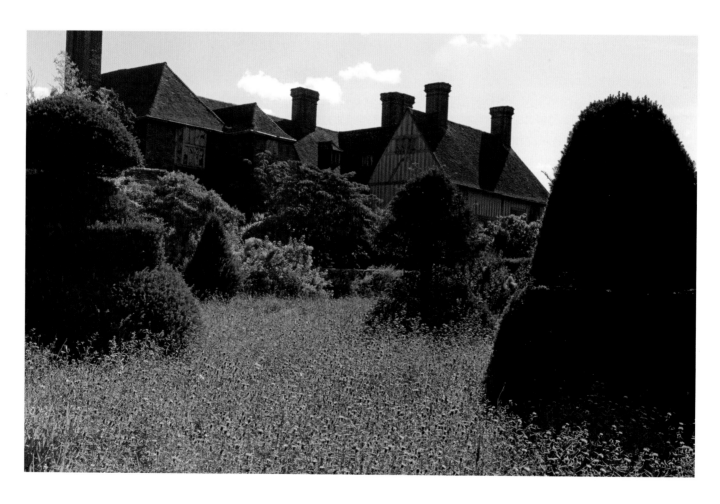

Sometimes, the result is wild and dynamic, other times static and architectural; sometimes the colours are cool, other times searingly hot and clashing. Sometimes the picture makes no sense to our inner aesthetic – but each time the experience gives us something to think about, evoking and provoking thoughts, stimulating, and intriguing.

Gardens are about relationships too. Great Dixter, where I have spent the last 30 years of my gardening life, is a result of the union between Edwin Lutyens, the great Arts and Crafts architect, and his strong-minded client Nathaniel Lloyd. Together they assembled the bones of the garden – that perfect footprint you see today. Nathaniel's wife Daisy gardened it with curiosity, at first with her husband by her side, and then with her youngest child, Christopher. Christopher Lloyd went on to become one of the greatest gardeners of all time, gardening with great freedom and experimentation, playing with joyous clashing colours, bucking the trends and breaking all the rules. He did this within the exceptional framework laid out by his father and Lutyens, and with the spirit of his mother in mind.

I joined Christopher in 1993 and we gardened in the same way – he was my mentor and I, his student. And through my union with him Great Dixter lives on. Not set in aspic, not conventional, but with its own special energy, and qualities, full of surprises, and always fresh. Barbara Segall has a remarkable ability and experience to express the crucial characteristics of every garden in this book, and alongside Clive Boursnell's evocative photographs the following pages capture every place they visit.

Fergus Garrett, Great Dixter 2021

OPPOSITE Formality and informality blend happily at Great Dixter, as shaped yews and wildflowers offer a counterpoint to the roofs and chimneys of the house.

BELOW Fergus Garrett has gardened at Great Dixter for several decades, adding to and extending the inimitable garden experimentation of his friend and mentor the late Christopher Lloyd.

Introduction

KENT, SURREY AND SUSSEX are the counties that sum up the phrase 'the garden of England', and each county on its own could have filled a book double, treble even quadruple the size of this one. In these three counties a wealth of history and horticulture has combined with the rolling landscapes, wooded valleys and meandering waterways to provide some of the most beguiling and interesting gardens in the United Kingdom.

The South East has traditionally been the place where Londoners holidayed… think of bathing huts and naughty postcards. It is also an area where many grand houses and castles were built with palatial gardens established around them.

The names of gardeners and 'influencers' such as Vita Sackville-West, Gertrude Jekyll, William Robinson, Christopher Lloyd and John Brookes appear in many chapters. Think of the conversations one might have had with them in these gardens! It was exciting enough, though, to be in the places they once had lived in and created. Among the unforgettable, heart-stopping horticultural moments were my visits to Vita's first garden, Long Barn in Kent, Gertrude Jekyll's Munstead Wood in Surrey and William Robinson's Gravetye Manor in West Sussex. But there were similar moments in every garden I visited for this book.

Great gardens such as Sissinghurst and Great Dixter were mentioned at every turn on my journeys to gather stories, and I am grateful to Fergus Garrett, Director of Great Dixter for his foreword to this book. Both these gardens were too well-known to be included as 'secret' gardens.

Secret Gardens of the South East covers a range of gardens in villages and towns, as well as in deep countryside, and all are privately owned. Some have been owned by one family for generations, while others have been transformed by new owners. Some open for the National Gardens Scheme (see page 140), while others open privately or occasionally for charity.

This book features 20 gardens. I visited all 20 and more, and loved meeting owners and gardeners and seeing how individual and charming each garden is.

All are expressions of their current and past owners' love of plants and place and showcase their creativity. In some of the larger gardens, even when the owners are fully involved in the work, there are other hands whose input is well respected. In each of the chapters we have included the garden teams and owners in the 'portraits'.

Not all are secret or unknown in every sense of the word, but until you visit them their special attributes are not revealed. Step through the garden gate and you will discover so much to delight you. I hope you will enjoy seeing them through the lens of photographer Clive Boursnell who will entice you further and further into the corners of every one of these sumptuous gardens of the South East.

Barbara Segall, Suffolk 2022

RIGHT At the height of summer, the Long Border that runs alongside the sandstone wall of the Flower Garden at Gravetye Manor in Sussex rushes upwards with stately perennials skying their flower spires.
OPPOSITE TOP A former tennis court is now the site of an informal and romantic Rose Garden at Long Barn in Sussex.
OPPOSITE BOTTOM The Main Flower Border, at Munstead Wood in Surrey, some 200 feet/61 metres long, blooms in waves of colour following Gertrude Jekyll's original iconic, complicated drawing.

1
87 Albert Street
Whitstable, Kent

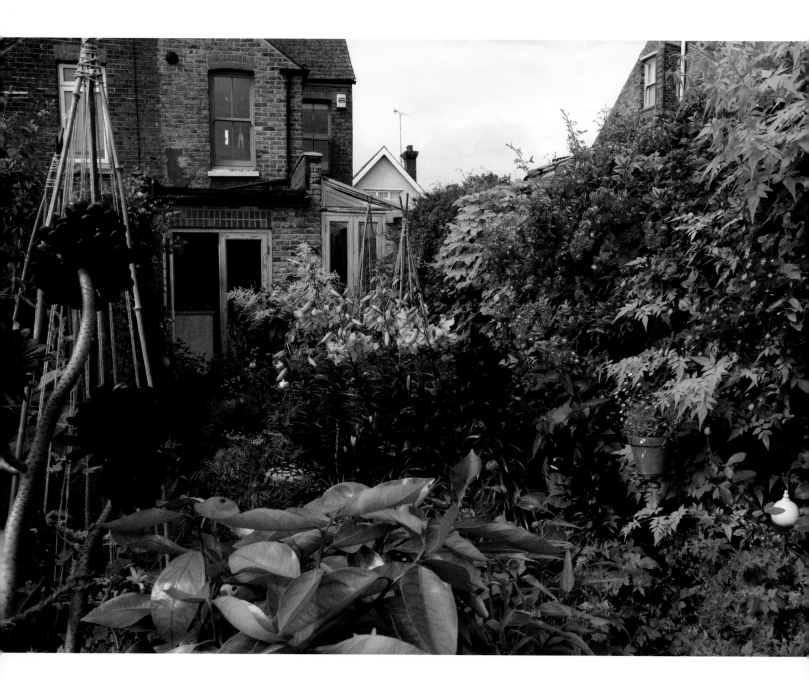

Bounded by wooden fences topped with trellis, the garden at number 87 is just 45 by 13 feet/14 by 4 metres, yet it holds a cornucopia of plants that provide seasonal colour throughout the year. Paul Carey and Phil Gomm have gardened here since 2010 and with their combined planting skills they know how to set the scene and get the best performance all year round from the plants that thrive here.

When they met in London, Paul, a civil servant, had a flat with a balcony garden, and Phil, who had gained an RHS Level 2 certificate in the Principles of Horticulture, was working as a gardener in Lincolnshire. Paul's flat was a plant paradise, full of indoor plants as well as a packed terrace, some reflecting his grandmother's colourful garden in the Caribbean.

Paul and Phil brought vanloads of plants with them to Whitstable, all needing instant liberation, but they had to bring the garden around before they could get plants into the ground. 'It was a classic gravel garden with a membrane that was breaking up and we knew that the soil was impoverished,' explains Phil.

The plants they inherited were singles or, as Phil describes them, 'orphan plants', just one of each. They kept an apple tree, a *Clematis montana*, a Boston ivy (*Parthenocissus henryana*) and the muehlenbeckia which has become a talking point in the garden. They dug out all the gravel and old membrane, waged war on an invasive bamboo and filled two skips with debris. 'That was more than a decade ago and then we basically re-booted the garden, with a mix of compost and topsoil. It was not an instant transformation . . . but once the curving brick sett path was laid from back door to garden gate and the additional trellis added to the wall and fence, we were ready for planting.'

OPPOSITE Looking from the garden gate towards the house, it is hard to believe that there is a garden path snaking through the colourful plantings.
BELOW The view from the house towards the gate and greenhouse is brightened by stands of echinacea, tithonia, *Ammi majus*, rudbeckia and lilies that vie for space with wigwams holding annuals such as morning glory.

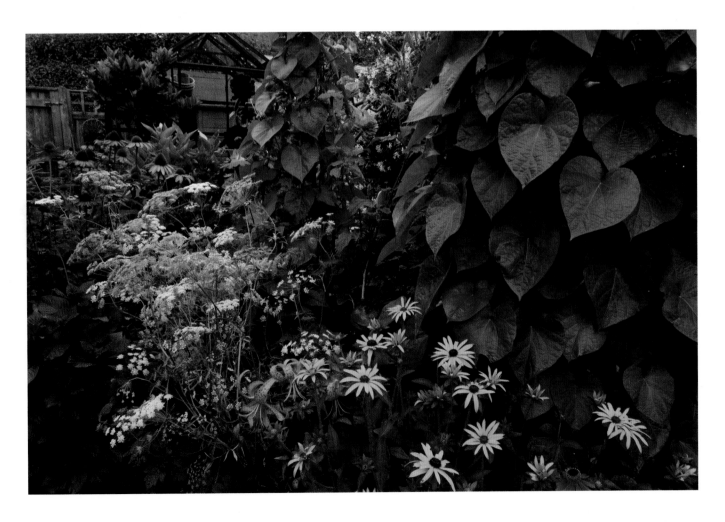

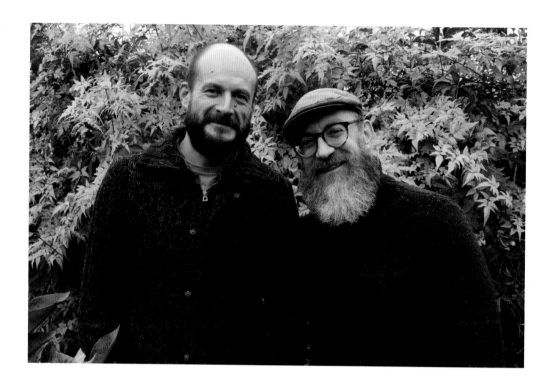

Supporting role

Fortunately, Paul and Phil enjoy the same plant palette: the main consideration is that one end of the garden is hot and sunny and the other is shaded and, more importantly, it is a narrow garden, with a limited ground level planting area. 'We had to make sense of the two ends of the garden, so we have used colour to link them and decided to literally go "up the walls" to gain plant space.' This garden could have been 'all fence', with a limited number of ground-cover plants, but Phil and Paul bought into the idea that they needed to stop apologizing for the garden's shortcomings, and instead embrace the fences. 'Sandwiched between two boundaries, it seemed obvious to use them for plants. We could have painted them or continued to dislike them but turning them into a positive felt better.'

Now both sides and even the rear wall of the house support numerous climbing plants. There are roughly 20 clematis including *Clematis cirrhosa* and *C. alpina* for early seasonal colour, jasmine and roses (for colour and fragrance) and a golden hop. The inherited muehlenbeckia is now a much-loved feature. It grows column-like as an upright shrub, to the height of the trellis on top of the fence. 'We use all the devices, flower colour and shape, foliage shape and texture. We are drawn to foliage, especially of ferns (including *Dryopteris wallichiana*, *Osmunda regalis* and hart's tongue fern) and shade-loving plants in the woodland area near the house.'

Spring sees the garden in a demure mood, first with a sweep of a thousand snowdrops, masses of hellebores and epimediums rushing through to light up the ground. The dark purple-black of Paul's hedge-like collection of aeoniums at the hot, sunny end of the garden is the highlight colour used to ripple through the borders at various heights in summer.

The pompom allium flowers lead the visual rhythm with the purple-blotched foliage of *Geranium phaeum* picking up the melody as one of the ground-covering staples of the borders.

'We do change things quite often and in early summer, lilies, including the dark maroon flowers of *Lilium* 'Night Flyer' and the huge yellow and bronze spotted flowers of *L. leichtlinii*, with dark astrantias, really start to rock the colours. Providing a cool citrine-yellow tone at ground level is *Alchemilla mollis*.'

Border control

Tall perennials, such as rudbeckias, dark-red crocosmia, floaty thalictrum and veronicastrum underplanted with nasturtiums, jostle a little with salvias such as 'Amistad', while wild carrots and *Ammi majus* bring a soft, frothy note with their white umbels, tying it all together and damping down the high-octane colours.

Phil, whose background in 3D design, photography and film combines so well with his garden credentials, particularly likes plants that offer softness as well as height, such as grasses

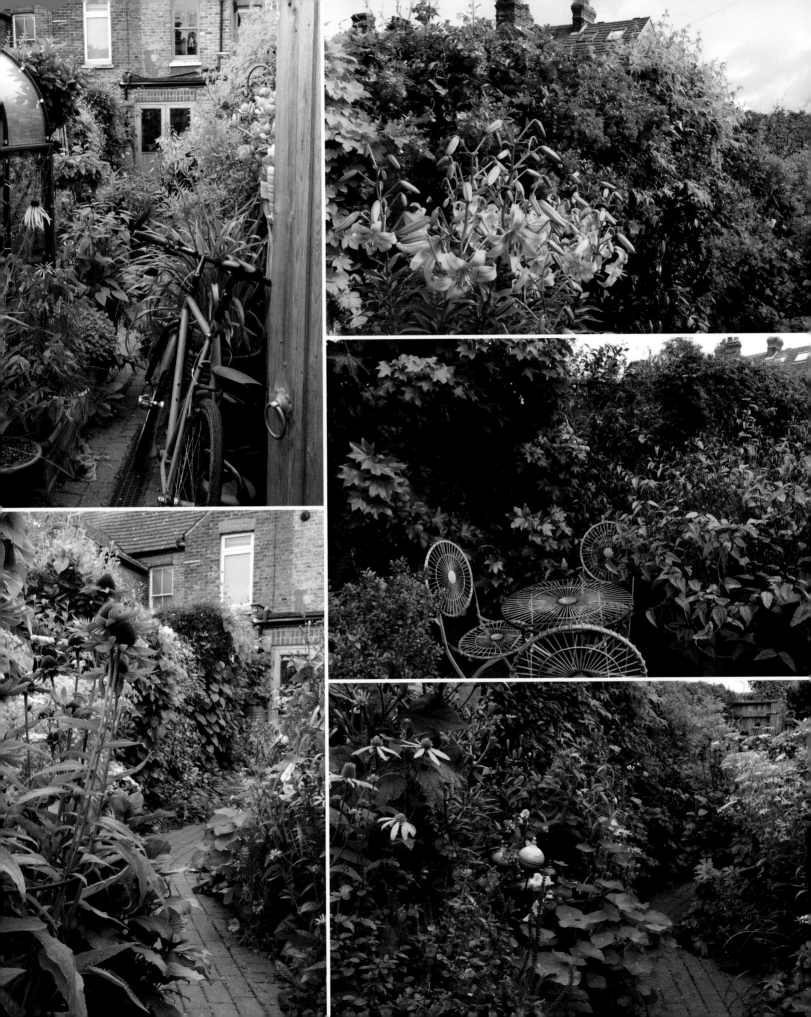

'We have a degree of obsession around plants… when we see a plant for the first time, even if we don't have space for it we will probably buy it.'

and echinaceas. 'I like their immersive, almost ephemeral qualities and the way they float in the air, capturing light and movement,' he says.

In summer, the fences are alive with colour from annual climbers such as *Mina lobata*, morning glory and clinging nasturtiums. They take colour right to the top of the wall and fence, and when the sun sets in the far corner they are backlit, offering a stained-glass effect. *Clematis* 'Rooguchi' with its bell-like purple-blue flowers and *C.* 'My Angel' provide high summer colour. The rose 'Madame Alfred Carrière' offers its fragrance on the back wall of the house, led across on wires.

The real backbone of upwardly swarming plants comes from evergreens such as *Hydrangea seemannii*, which has not yet provided its familiar blizzard of flowers. Climbers grown for their foliage include the variegated Kiwi vine (*Actinidia kolomikta*), the golden variegated star jasmine and *Clematis* 'Golden Celebration', all of which light up the side and tops of the boundaries.

Packed flower borders, highlight plants in pots that come and go in their season and a retired ladder, each tread lined with succulent treasures, are part of the mix that Paul and Phil have created in a small and limited space. Small it may be, but there is still room for a mini greenhouse to protect tender plants in winter and shelter seedlings and cuttings in summer.

The garden is not large enough for a statue but there are several purple and bronze ceramic spheres on metal stalks that double as plant supports and accents, bouncing the eye around the garden. They come from a potter in the French village of Aubeterre-sur-Dronne in the Charente.

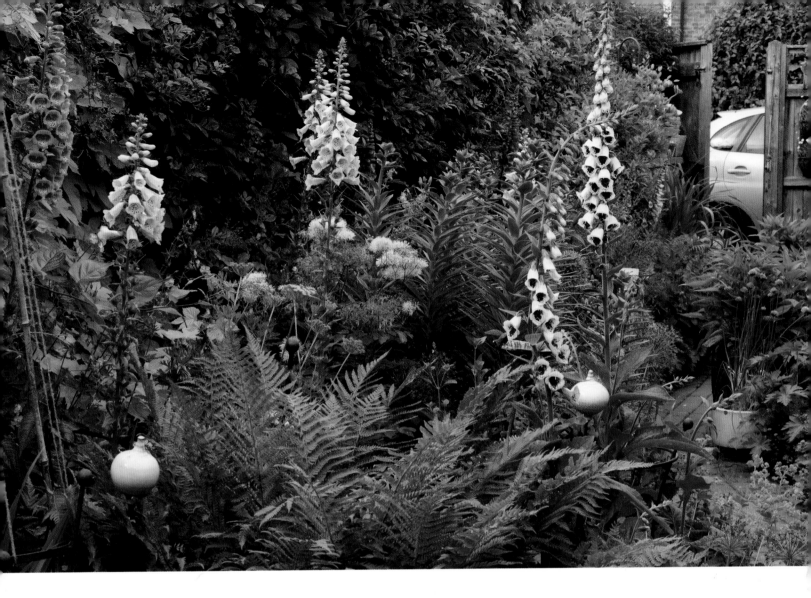

Maintenance is essential

The garden is enjoyed by so much wildlife, the annuals attracting pollinators, while glass drinking-stations on metal stands, ostensibly for birds, are used by bees and other insects for a quick drink on hot days.

Maintenance in a small garden is all about spotting any plants that are too vigorous and doing what Phil calls 'thug-wrangling' to control them. Phil and Paul are constantly deadheading, cutting back foliage and taking out any plants that do not earn their keep.

'We are noticing that some older perennials are losing their vitality, so we are starting to lift and divide plants such as astrantia and hakonechloa.'

There are many plants that Paul and Phil would love to grow in their garden and sometimes they feel as if they are shopping in their imaginations for a garden they do not have!

'We have a degree of obsession around plants. It is like a voyage of discovery… when we see a plant for the first time, even if we don't have space for it, we will probably buy it.'

They first opened their garden under the National Gardens Scheme in 2016 and they were unprepared for the number of visitors – around 500 – who visited that day. Paul was on duty at the gate while Phil was the maestro at the back door of the house.

'Before the garden opened we genuinely wondered what we were doing. Then we didn't speak to each other all day because we never stopped talking to our visitors!' At the close of the day they were shell-shocked.

'We realized that people were responding to our garden with pleasure. Suddenly we knew that we had a built a world that others liked… and maybe we were gardeners after all!'

OPPOSITE Succulents come out to sunbathe on ladders and shelves in summer, following their winter stay in the small but packed greenhouse at the far end of the garden.
ABOVE Each of the two borders that line the path is densely planted, inspiring visitors with similarly small garden spaces to believe that there is no limit on colour and style.

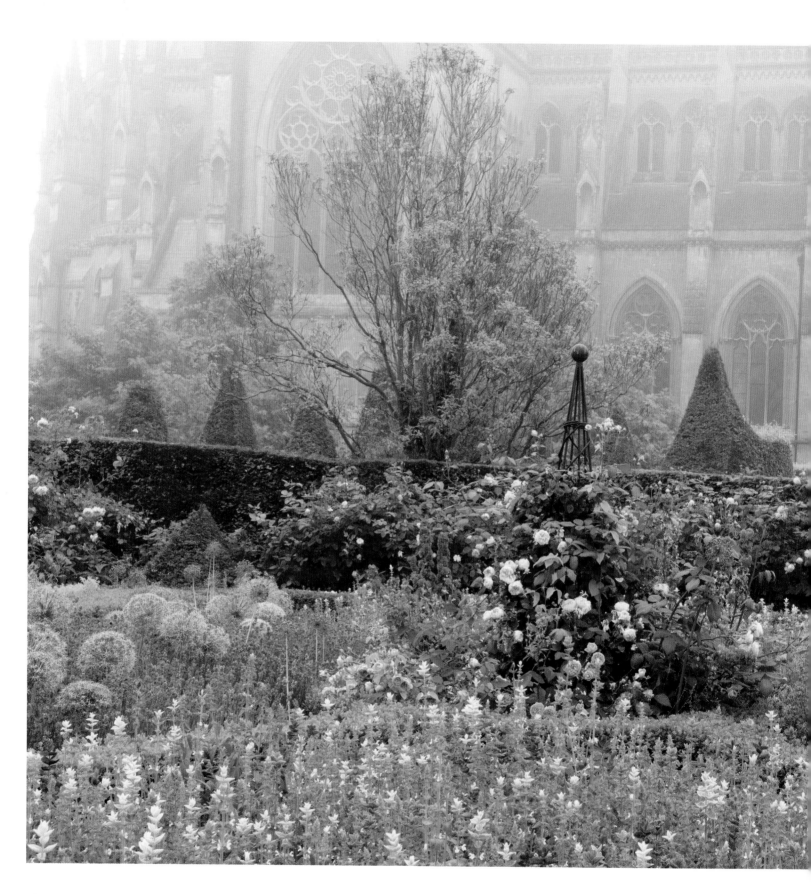

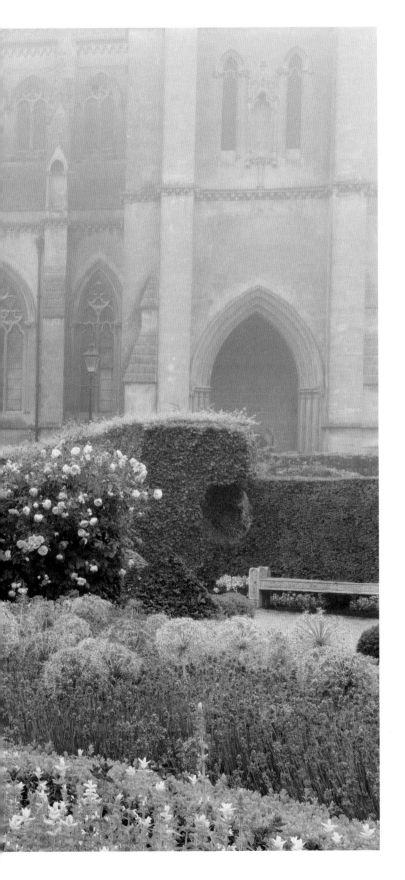

2
Arundel Castle
Arundel, West Sussex

YOU COULD BE FORGIVEN for thinking that the walled gardens at Arundel Castle, caught between its battlements and turrets and the vaulted arches of the Victorian cathedral, might be superfluous to requirements. In any case, how could they stand up to the grandeur of these two architectural giants? Thanks to the vision of the owners, the Duke and Duchess of Norfolk, and the fearlessness of head gardener and landscape designer Martin Duncan, the walled gardens compete well with the drama of the landscape, providing their own grandeur in the scale and depth of the planting.

Arundel Castle has been the seat of the Dukes of Norfolk since the twelfth century, and its 40 acres/16 hectares have been changed and improved by successive generations. In the past 20 years the eighteenth Duke, Edward, and the Duchess, Georgina, have been key to the creation of new gardens and exciting plantings. According to Martin they have been great exponents and supporters of the garden and landscape projects he has undertaken during his decade-plus at Arundel.

Courtyards, rills and fountains

In 2008, the year before Martin's arrival, the Collector Earl's Garden, conceived by the Duke and Duchess and designed by Isabel and Julian Bannerman with architect Russell Taylor, was formally opened by HRH Prince Charles. Built on the site of a former car park, it consists of three courtyards, two terraces, a rill, temples and fountains. This is the first garden visitors see, designed to pay homage to Thomas Howard, the fourteenth Earl (1585–1646), and to re-imagine the Italianate garden of his London home (Arundel House). It consists of three courts on an upper terrace, with the rill, dyed blue to represent the River Arun, being central. Oak was used to create over-sized urns, obelisks, benches and two pergolas. Huge terracotta containers cluster together lining the rill and fountains, displaying seasonal plantings, starting with the annual tulip festival.

Caught in early morning mist, the windows and buttresses of Arundel Cathedral provide a dramatic borrowed backdrop to the annual Allium Extravaganza at Arundel Castle.

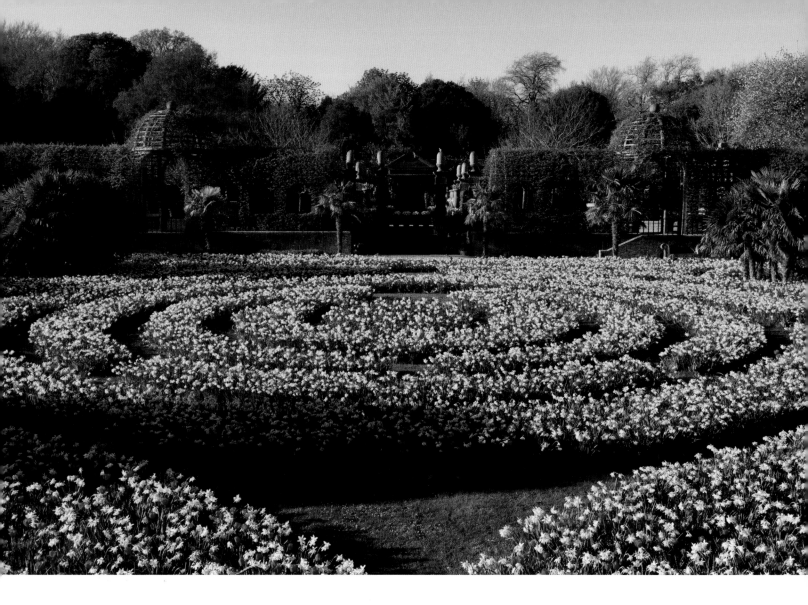

The organic Kitchen Garden was the first element that the Duchess turned her attention to in 1997, redesigning the beds and commissioning the restoration of the Victorian vine and peach glasshouse. Today it is a bountiful collection of fruit, vegetables and herbs, with paw paws, bananas and guava ripening in the new tropical glasshouse.

Martin came to Arundel with a high-flying curriculum vitae: starting with horticulture and agriculture in southern Africa, going on to service in the British Army, then landscape and horticulture education in the UK, with practical experience as a gardener and landscaper all over the world. In Bermuda, as Superintendent of Horticulture, he managed everything from the island's botanic gardens to the governor's residence and public parks. That he is unafraid of scale is clearly an asset at Arundel, considering that plant and bulb orders run into the thousands. Additionally, he uses his considerable landscape and horticultural skills to create and manage stunning seasonal and all-year plantings that, though dramatic and grand, offer a sense of intimacy.

Garden theatricals

Martin and his team of seven gardeners and five volunteers tend meticulously to the setting – propagating, dividing, planting, watering and deadheading the plants, even raking the gravel daily. From the rill and the two other courts, the view is over the lower terrace, towards Oberon's Palace. Here, in a shell-encrusted fountain room above a grotto, a set-piece of garden theatre takes place regularly and resplendently. A

ABOVE Tulips in their thousands, including 'Apeldoorn' and 'Kingsblood', with massed plantings of *Narcissus* 'Thalia', have transformed the grass labyrinth into a spring eye-catcher.
OPPOSITE TOP AND CENTRE Tulips in huge terracotta containers line the dramatic rill and waterfall, with larger-than-life wooden columns and loggia designed by Isabel and Julian Bannerman forming part of the Collector Earl's Garden.
OPPOSITE BOTTOM The spectacle of the golden crown held high above the fountain by a jet of water is a theatrical treat that never fails to enchant.

'There has to be a "wow" factor or the plants would be lost in the drama of the architecture and history of the site.'

MARTIN DUNCAN, HEAD GARDENER

golden crown, lofted on a jet of water, is held high above the fountain, a piece of hydraulic magic that never fails to enchant.

But the drama continues. In 2010–11 the Bannermans designed a grass labyrinth in the pristine lawn between the upper and lower terraces. Four years later, Martin suggested that it be re-purposed as the world's first tulip labyrinth, and so 15,000 red tulips, *Tulipa* 'Apeldoorn', were planted and in 2016 the labyrinth burst on to the spring scene. In 2021, another 14,000 red tulips, 'Apeldoorn' and 'Kingsblood', were added. The colour of their massed ranks may have been diluted by the addition of 18,000 *Narcissus* 'Thalia' but the effect is not diminished. In summer, once the bulbs have died back and the labyrinth mown, the turf becomes the seating area for the annual Shakespeare production.

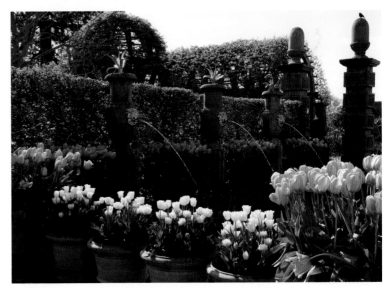

Throughout the grounds and the walled gardens blue spires of camassia and pompoms of purple, white and amethyst alliums are the next autumn plantings to bring rivers of colour: 'Purple Rain', 'Purple Sensation', *schubertii*, 'Mohican' and 'Summer Drummer'. The annual Allium Extravaganza boasts 36,000 flowers, making the total number of bulbs planted at Arundel more than 1.2 million.

The English Herbaceous Borders were the first to feel Martin's uncompromising, yet ultimately softening, touch. He stripped out lines of low box hedging, allowing billowing perennials – such as alchemilla, catmint and hardy geraniums – to drift on to gravel paths. Similarly, he shaped and curved stately linear yew hedges that backed each separate compartment, as well as the breaks between. Now these yew buttresses draw your eye in and through, insisting that you follow on foot to admire the waves of colour from roses and perennials in each bay.

The Stumpery

In 2012 Martin redesigned the Cut Flower Garden, introducing a box hedge designed in a 'dickie-bow' shape to hold seasonal flowers. In spring it dazzles with tulips, alliums and other bulbs and in late summer with dahlia displays, including the dinner plate blooms of Babylon dahlias.

Next up is the Stumpery, created in 2013, using yew, sweet chestnut and oak, mostly casualties of the 1987 storms. The

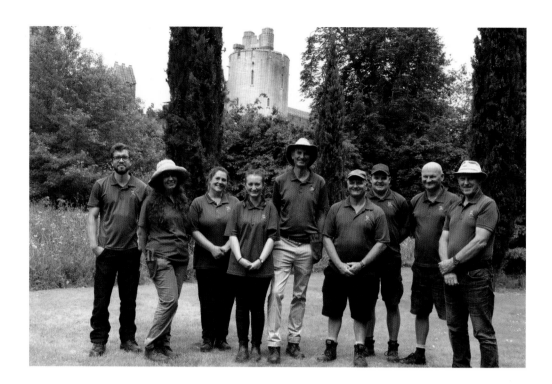

RIGHT The garden team at Arundel Castle (left to right): Joe Bedding, Izzy McKinley, Daniella Porter Wendt, Rose Philpot, Martin Duncan (Head Gardener and Landscape Designer), Stuart Whitson, Nathan Treadwell (slightly at the back), Stuart Scutt (without hat), Stuart Hilton. OPPOSITE Yew hedges, espaliered apples and oak stumps take shape as garden structures, adding to the drama of the historic architecture of the castle and the cathedral at Arundel. In addition, massed spring bulbs carpet the ground and sweep up towards the battlements.

team removed established yew cones and repositioned them beyond the walled garden in an area known as the American Ground. Several stumps are grouped to make a focal stump mound, giving the area height. To soften and cover the bases Martin used large mounding perennials such as citrine-yellow lupins, euphorbias, hellebores, ferns, large-leaved hostas, toad lily, angel's fishing rods and silver, lanceolate-leaved pulmonarias. He also planted miniature tulips, low-growing alliums, wild strawberries and saxifrages.

Martin and his team have also worked on the Tropical Borders that run along either side of the lower labyrinth terrace, part of the original Earl Collector's Garden, removing the iron edging and curving the turf edges. In 2018, four deep violin-shaped borders were cut on the left and right sides; here ornamental bananas are joined by the hardy jelly palm (*Butia capitata*) and multi-stemmed Chusan palm (*Trachycarpus fortunei*), their size and foliage completing the gargantuan, other-worldly impression.

Martin gardens the wider landscape of the grounds as naturally as possible, so that the link with the gardened area is retained. Massed plantings of narcissus, tulips, alliums and camassia, wild flower banks and a reduced mowing regime have helped increase the wildlife population. The key, according to Martin, is to do things in scale. He says there has to be a 'wow' factor or the plants would be lost in the drama of the architecture and history of the site.

'Working with the Duke and Duchess is paramount, gaining their trust offers me the freedom to suggest and then take on big challenges. I like looking at the whole range of the garden elements here. For me it is natural to walk from the inner gardens out into the wilder, less formal landscape.' Indeed, beyond the inner garden walls there is much to enjoy in every season.

Stately obelisks

In the Rose Garden, developed by the Duchess, twenty varieties bloom against the backdrop of the castle. Entry is through a Gothic-style archway clothed with the rambler 'Adélaïde d'Orléans' and the Gothic theme continues into the seats and stately obelisks with gold tops for the roses to clamber over.

Farthest away from the walled gardens is the latest conservation project, the Water Gardens, begun in 2018. Three historic 'stew' ponds, at one time used to keep fish for the table, were restored alongside a thatched roundhouse, wooden walkway and bridges. To complete the natural picture 1,500 water plants were set into the water or margins, and camassia in the grassed areas.

Some historic sites may seem mired in a time-warp; not so Arundel where the Norfolks, ably assisted by Martin Duncan and his team, have demonstrated that although Arundel is part of history it continues to make history for the future.

3
Balmoral Cottage
Benenden, Kent

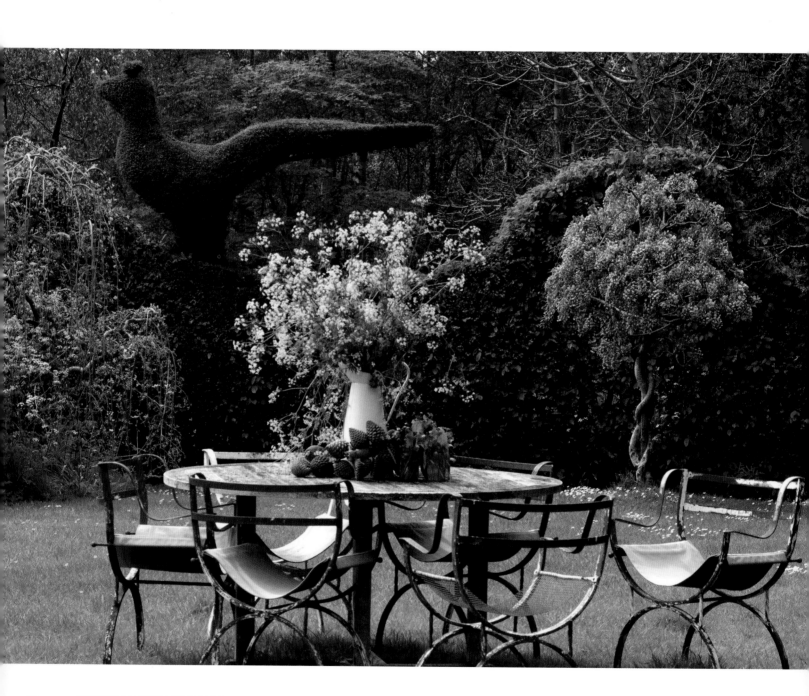

THAT MOMENT when you meet your future down a little lane, see a gate and opening it find the rest of time ahead of you…? Well, that is literally what happened when Charlotte and Donald Molesworth found and bought Balmoral Cottage in Benenden in 1983.

Donald, a professional gardener, had been working next door at The Grange, the former home of Collingwood 'Cherry' Ingram (1880–1981), the plant hunter credited with returning endangered cherries to Japan to ensure the authenticity of the annual 'sakura' blossom festival.

For eight years Charlotte had been living in and teaching art at Benenden School, and on walks around the village often stepped along the rough track leading to this tiny house, which had the best sunsets imaginable. Probably named Balmoral to celebrate a visit of Queen Victoria to Benenden, it was the gardener's cottage for The Grange.

The Molesworths brought with them to Balmoral Cottage the first of many animals to share their garden lives, including bees, rescue dogs, donkeys (there have been nine) and companion sheep, hens and a cockerel.

They knew that they would need plenty of plants to make their garden and, being thrifty and resourceful they brought many plants from their parents' gardens. From Donald's family came woodland trilliums, dog's-tooth violets and *Narcissus pseudonarcissus* which have self-seeded and spread down each side of that original track. Charlotte's mother's garden was packed with old-fashioned roses, cottage-garden plants and topiary, so her contributions included double white primroses and several thousand box cuttings.

LEFT Shown off in a vintage jug, Charlotte's grand display of hedgerow and garden finds is closely scrutinized by a shapely topiary peahen, one of many that fly above the hedges. The shape of the frothy mass of table-top cow parsley is a perfect match for the mop-head of tightly held flowers on a twisted-stem, standard wisteria.

BELOW The path to the garden gate is lined with the now-mature box hedging planted by Charlotte and Donald Molesworth when they first moved here.

'Through necessity and choice – because we love chasing down and recycling objects and getting most of our plants for free as cuttings or from seed – we have created the garden and its features on a shoestring. We both have hawk-eyes and are always looking for second-hand or dumped stuff with potential. Reclamation yards were cheap when we started out, and generally we avoid buying anything new… it's our policy for helping Mother Earth.'

Addicted to topiary

The plants that now define the 1.5-acre/0.6-hectare garden and established Charlotte as a topiarist, were a mass of tiny evergreen cuttings and seedlings of box and yew given by Charlotte's mother, her Aunt Joyce and their friends in response to their wedding-gift request for unwanted yew seedlings.

Influenced by her mother's topiary, Charlotte's enthusiasm flourished, so much so that she and Donald were founding members of the European Boxwood and Topiary Society established in 1996 by *Buxus* specialist Elizabeth Braimbridge.

Charlotte bought some species and clone-rooted cuttings at reasonable prices from Elizabeth's nursery, Langley Boxwood.

'Many gardens I knew as a child had topiary in them, so it was no surprise that I would have topiary in mine, but now, several decades on, perhaps I have taken it to an extreme!'

They grew the yew and box cuttings on in a nursery bed. Later, once they had reached heights of 12–18 in/30–45 cm, the bushy young plants were moved into place.

Mostly the rescued and gifted seedlings and cuttings were set out in long lines to become the mixed tapestry, waved hedges of box, yew, holly and hornbeam which would eventually divide the garden into intimate sections. The box was also used for the double hedges that form the long walk leading to the pond, and they separate the garden rooms from the lawned areas.

'I became addicted. Topiary is relatively labour-saving as yew only needs one cut per year in autumn or winter, and I cut box in alternate years. It looks good all year (bar a period in summer when it looks a little woolly) and is a way to establish the "good bones" of height and structure in a garden.'

'We avoid buying anything new… it's our policy for helping Mother Earth.'

Sharp shears are key

Starting the topiary and hedge plants off so young also meant that Charlotte could see how each plant was developing and alter or train its branch structure. Yew, destined to become the hedge-top topiary shapes, was also planted in. Charlotte assessed the plants as they grew, never cutting the apical tips of the yews until they were ready for topiarizing. Weaving and meshing branches together are key techniques for melding the hedge plants.

'The plants were often moved around into different parts of the garden while we fine-tuned the layout, until they became too heavy to move. When the height of the hedges was established, I cut them so that they were waved and curved. It added an element of flowing informality.' Now mature, the topiary shapes add character while topiary birds fill the skyline and float above the curved and tapered hedges.

To clip the hedges and to create the birds, twists and spirals that appear to grow out of them, Charlotte advises using canes and string, safe ladders and good, sharp shears and loppers. She has a family trio of tripod ladders of varying heights and the best shears possible.

'My Japanese shears need to be kept sharp, but are so well-balanced they are like an extension of my arm. I never tire of clipping: I am always eyeing plants here and in other people's gardens.'

With so much green material from clipping and mowing it is no surprise that the various compost piles are essential to the garden.

'These are the pumping heart of the garden, often smelly and although we love them, not always attractive, but we have space to accommodate them. We compost everything except prunings of box, rose and any material that could potentially

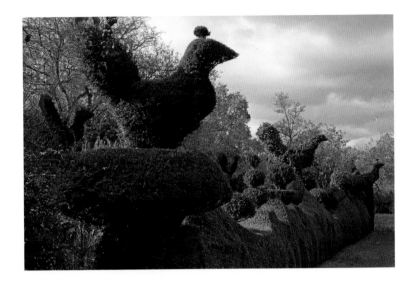

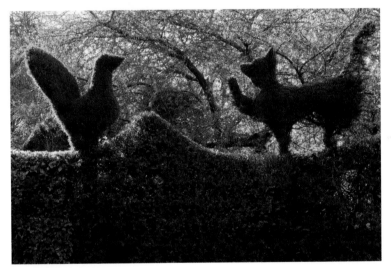

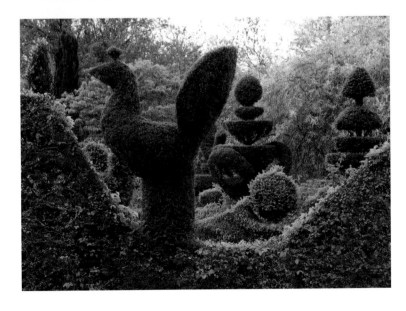

LEFT Ornamental trees on the boundary contribute a soft framework for the formality of the topiary and hedges within the garden.

RIGHT TOP One side of the double *allée* of box hedging with topiary birds that lines the long walk leading to the pond.

RIGHT CENTRE Bird meets cat atop a hedge: Charlotte always 'eyes' the various shapes in the branches as the plant grows, then cuts and encourages them over time into finished topiary.

RIGHT BOTTOM Geometric shapes and tiered topiary, as well as birds and animals, combine to offer visitors a magical, almost surreal, garden experience.

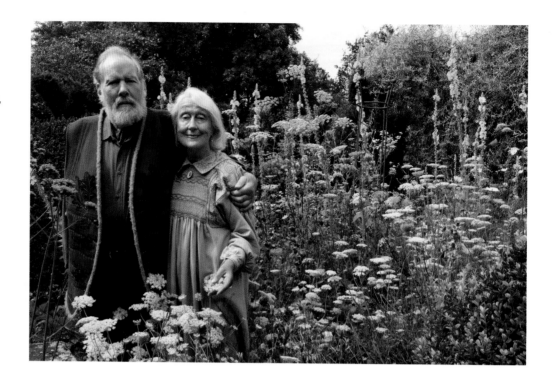

harbour disease or is too woody to compost. Instead, this is added to long-term heaps which become wildlife habitats. Our compost from these piles is like peat in texture. We use this "black gold" for all our potting up, growing on and mulching.'

Right at the start, an art school friend, Adrian Grey, helped the Molesworths dig out a pond at the far end of the garden which has become one of wildlife havens here.

Informal contrasts

Between the hedges and topiary, more relaxed and informal combinations of bulbs, shrubs and herbaceous perennials furnish and clothe the spaces. Softly coloured moss roses mingle with acanthus, white foxgloves, geraniums, alliums, many umbels, sedums, ornamental grasses, artemisia and Canary spurge (*Euphorbia mellifera*). It is essentially a green and grey foliage garden, with no actual colour theme in the herbaceous plantings. 'So long as the colours don't argue,' says Charlotte.

The Molesworth's thrift meant that gifts of plant tokens were converted into trees that are now well-established. The Hupeh crab apple, *Malus hupehensis* (Charlotte is sure it was one collected by Collingwood Ingram), elders including *Sambucus nigra* 'Pulverulenta' with its white variegated foliage, the filigree-leaved *S. nigra* 'Tenuifolia' and the upright, columnar *S. nigra* 'Fastigiata', as well as hawthorns *Crataegus schraderiana* and *C. tanacetifolia*, are among those that give them pleasure as much for ornament as for wildlife.

Annuals are found only in the cutting garden and the garden of The Potting Shed, which was Collingwood Ingram's own potting shed, and where visitors may book in to stay. Here *Ammi majus*, nicotiana, white cosmos and white foxgloves are a few of Charlotte's choices.

Backing on to The Potting Shed is the tiny Kent-barn studio where Charlotte draws and paints but 'the garden pulls so hard on my time that I have little time for my own work.'

Formidable energy

If she is not in her studio, Charlotte is somewhere in the garden, the polytunnel or the vegetable garden. 'We grow half to three-quarters of all our vegetables and fruit. We dehydrate and freeze for winter and live on salad almost all year from the polytunnel.'

Charlotte's energy is formidable but she admits that the garden they created has 'no reverse gear… we never thought about how to make the garden manageable at this point in our lives.'

When there is time, there is much pleasure in sitting together, or with friends and family, at the slate table rescued from a greenhouse demolition. Always in use for outdoor eating, it is set decoratively with flowers, foliage and fruit from the garden in bowls or a heavy vase. Their collections of succulents and pelargoniums are arranged against the wall of the Kent barn.

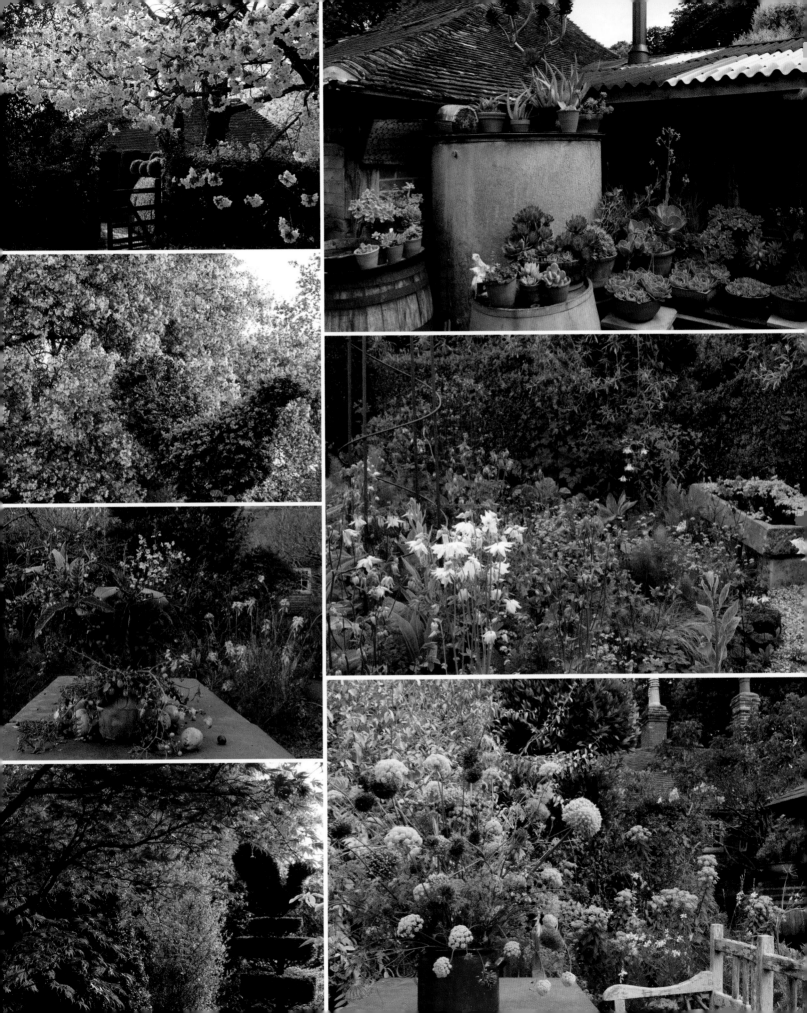

4
Boyton Court
Maidstone, Kent

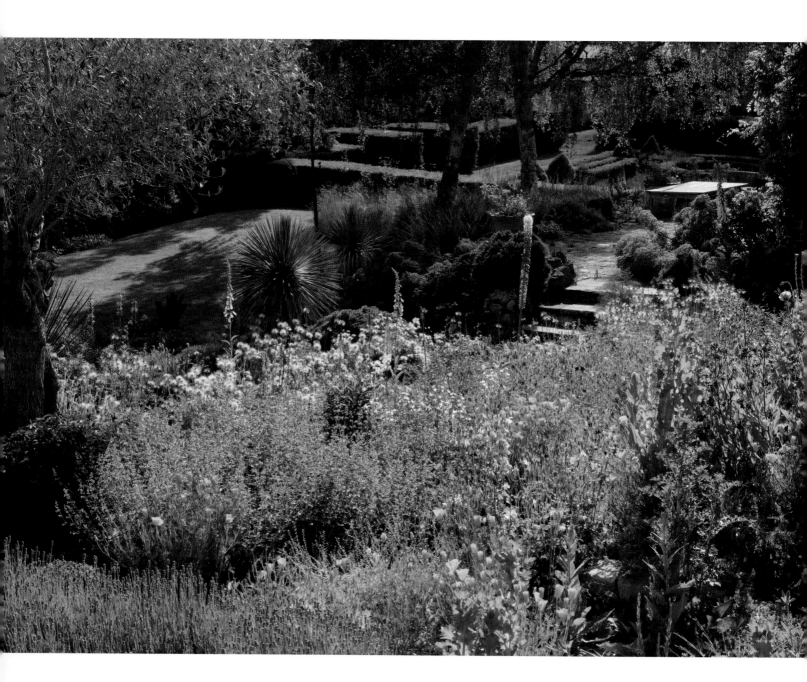

MANY GARDENERS move to a new home with a small selection of their favourite plants. Adrian Cooper moved house in 2011 with multiple collections numbering thousands of plants which have fascinated him since he was eight years old. He and his wife Samantha (Sam) Cooper were fortunate that the move from Blackheath to Kent could be achieved over several months.

The terraced garden of just over 3 acres/1.2 hectares, complete with olive terraces, a lavender bank, an arboretum and a tranquil pond, slopes southwards from the house, providing views of the Low Weald towards the South Coast, about 35 miles/56 km. At its highest point the garden is 190 feet/58 metres above sea level and so while any coastal warmth is absent, frost simply rolls down the hill and disperses swiftly. The soil at Boyton Court is a rocky loam lying on ragstone with a pH of 7.5, sustaining most plant groups.

Essentially Boyton Court is a dry garden but there are natural springs that flow down through a formal raised canal-like pool – the *acequia* (so-called as it resembles water systems in Spain) – at the top of the garden, via a formal lily pond and meandering stream to the lake above the arboretum at the far end of the property. The garden's previous owners opened it for the National Garden Scheme and had created formal areas with box parterres, an ornamental pool and ample borders, all of which Adrian and Sam embraced. But the large untouched areas gave Adrian a blank canvas to develop special plant habitats and to experiment with hardiness, woodland and meadow establishment and to develop as much biodiversity as possible.

Hooked on alpines

Adrian's plant enthusiasms began early: the first plants he grew were antirrhinums. By the time he was 12 years old he

LEFT In summer, Californian poppy, foxgloves and nepeta jostle for a place in the sun in the scree garden below the alpine house where Adrian grows some of his oldest plants.

BELOW On one of the upper terraces the previous owners created a formal parterre garden, which Adrian and Samantha have been happy to leave in place.

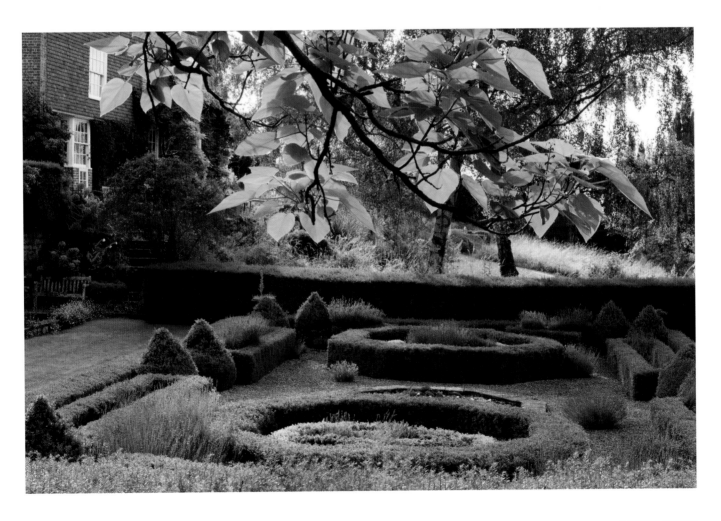

'Nature does not dig over everything so a no-dig policy was the only sensible way to grow plants.'

was hooked on alpines. 'We visited Will Ingwersen's famous nursery one Saturday in early spring, an unforgettable day for me, and it was the year I joined the Alpine Garden Society.' Now at Boyton Court he numbers the species of special plants of all groups that he majors on at 3,000 and rising.

'I was always aware of nature since I spent much time in my grandfather's small garden in Surrey, but we moved to Botswana for a few years for my dad's work where my love of the natural world blossomed and my interest in geology was ignited. Later my PhD in geochemistry was life-changing and a scientific approach became key to my experimental plantings.' He thought about making plants his career but realized he preferred to keep work and his plant passions separate.

Most of the plants Adrian grows are wild species and while many are under glass, he has created a garden that showcases them in cultivation, in combination with hybrids and garden cultivars, to create a magical whole.

'I realized early that nature does not dig over everything so a no-dig policy was the only sensible way to grow plants – although at that stage I did not know about mycorrhizal fungi and how digging would damage their benefits!'

Glasshouse landscaping

Adrian built three separate glasshouses to keep alpines, bulbs and xeric plants. Within them, using his knowledge of rocks and soils, he has recreated the landscapes and conditions for these plants to thrive.

'I believe most plants grow better with a free root run and I want them to look as natural as possible. Plus, maintenance is easier!'

The alpine house holds some of Adrian's oldest plants and is perched above the olive terraces. Step through it and

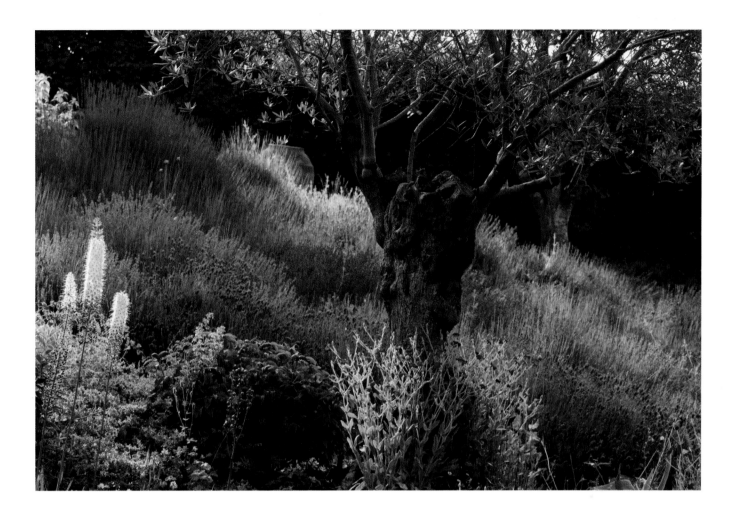

you are on the scree of the olive terraces that transport you to a rocky Mediterranean mountainside. Just below them is Adrian's favourite bench where he can absorb all the colour of the seasonal flowerings, as well as the insect life that the terraces attract.

'It is a very dynamic space, with waves of colour and shape from low-growing spring crocus, iris, pulsatilla, gladiolus species, alpine columbines to tall eryngiums and verbascums in summer, with alpines tucked into the walls.'

The ancient olives contribute greatly to the Mediterranean hillside. Once a grass slope, a farmer cut the terraces with a bulldozer and Adrian constructed the stone walls and prepared the terraces. He stripped off the topsoil, and pea shingle was spread on to the bedrock which now supports a seasonal show of plants that have naturalized the site.

A lavender bank further enhances and emphasizes the Mediterranean aspect of the site. Planted by the previous owners, various species of lavender, tightly packed in rows, appear to roll down the slope. The lavenders are sheared annually to keep a relaxed shape. Above the lavender bank is one of several areas in the garden where Sam has planted vegetables, her particular passion.

Naturalizing the terraces

Beyond the confines of the glasshouses a different story emerges. Adrian is taking the naturalization on the terraces further and in several areas is going wilder and wilder, experimenting with hardiness and habitats. He has planted some 3,000 bulbs into an area that was previously just a mown grass slope. These include

OPPOSITE The visual trajectory of the garden's slope away from the house takes in a series of different areas, such as the lavender bank and meadow garden, before reaching the lake and the summerhouse at the furthest boundary, all the while borrowing the sweeping views of the surrounding countryside.
ABOVE Lavenders, in varying shades of blue, bask in the hot sun on the lavender bank and, together with the olive trees, add to the Mediterranean atmosphere of this part of the garden.

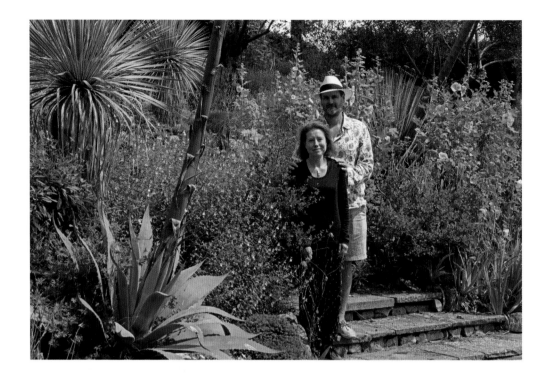

scillas, crocuses and Sprenger tulips (*Tulipa sprengeri*) which he is hoping will naturalize in the grass, along with many other spring- and summer-flowering wild flowers and orchids.

A similar bank, this time sloping away from the xeric glasshouse, is being transformed into a dry, wild bank. 'I put in place large stones in groups and spread 30 tonnes of ballast across the slope.' Next he planted masses of special bulbs and plants into the ground and sowed seed direct… waiting to see how it developed. The bulbs are the first to burst through in spring and include species from the central steppes of Asia: species tulips, irises and alliums. Then the annuals, perennials and grasses take the stage alongside some mature, ten-year-old agaves that survive well on this sun-trap bank, although a few have been lost in wet winters.

In high summer it is the kniphofia and dianthus that steal the show, alongside wild carrot, cosmos and verbena. 'The German pink (*Dianthus carthusianorum*) would not grow where I wanted them but have established spectacularly where it suits them.'

The make-up of the bank changes subtly from year to year, with cosmos dominating one year and verbena another. 'I want a balance that looks good so will only remove plants that crowd others too much. Currently I love the way the dianthus look.'

In autumn, Adrian strims off the annuals and perennials and protects some of the cycads and tree ferns, but otherwise he gardens naturally, intervening as little as possible.

Arboretum and lake

Below the bulb house, the land slopes gently alongside the stream where, in shade cast by birch and willow, Adrian has lined the edges with logs and boulders and planted tree ferns, candelabra primroses and ferns. He uses baskets in bright colours to protect precious plants from squirrels and badgers.

'The stream is a very special environment I built to grow cypripediums, blechnums and other rare plants. It is a wonderful microclimate!' Furthest from the house Adrian has established an arboretum of about 1.25 acres/0.5 hectares on what was rich farmland. Trees in the collection are rare and special, selected for interesting colour or bark, and many will also cope with climate change. They include the Mount Omei hornbeam (*Carpinus omeiensis*), Amur maple (*Acer tataricum*), the Franklin tree (*Franklinia alatamaha*) which was discovered in the 1750s and is extinct in the wild, and *Meliosma veitchiorum*.

The arboretum and lake are at the outer limits of the garden. 'It is a long way back to go for a drink or a book, so it seemed natural to site a gazebo there!' Adrian has help to deal with the boundary hedges, lawn and parterres. 'I do *most* of the weeding. I want this to be my garden and the knowledge to grow, plant and look after it is highly specialized. My main interest is in growing and looking after plants.'

This plantsman's country garden at Boyton Court is the result of Adrian's expertise and highly experimental approach, bursting with exciting and unusual plants.

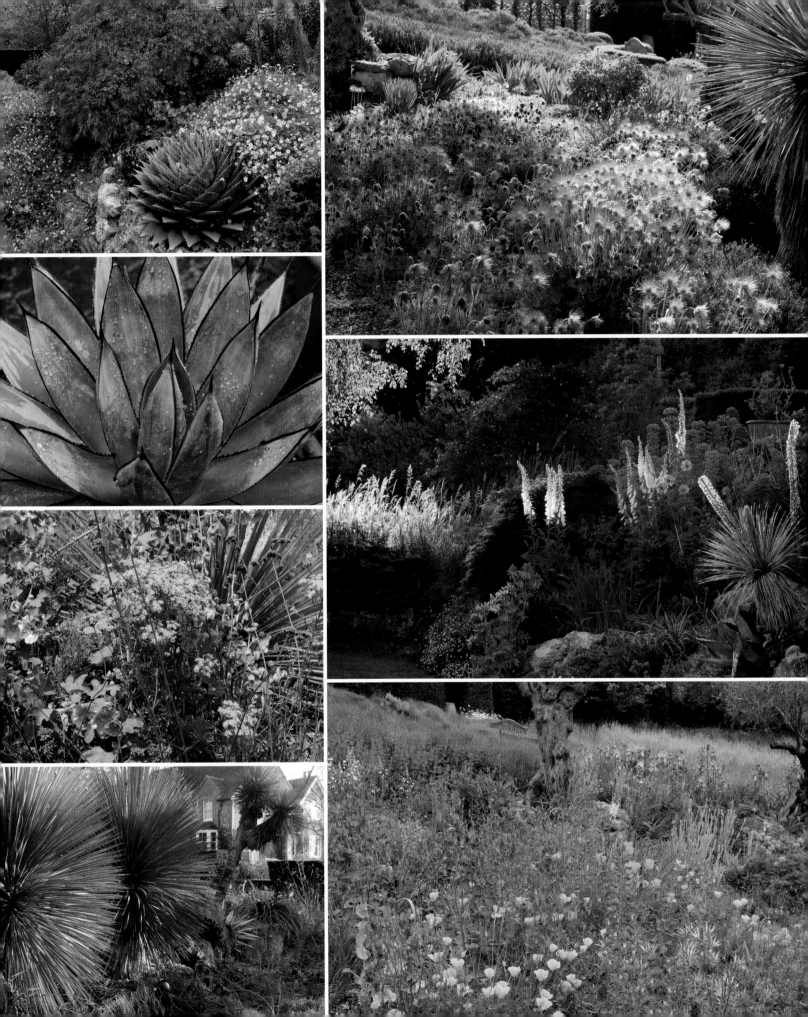

5
Clinton Lodge Gardens
Fletching, East Sussex

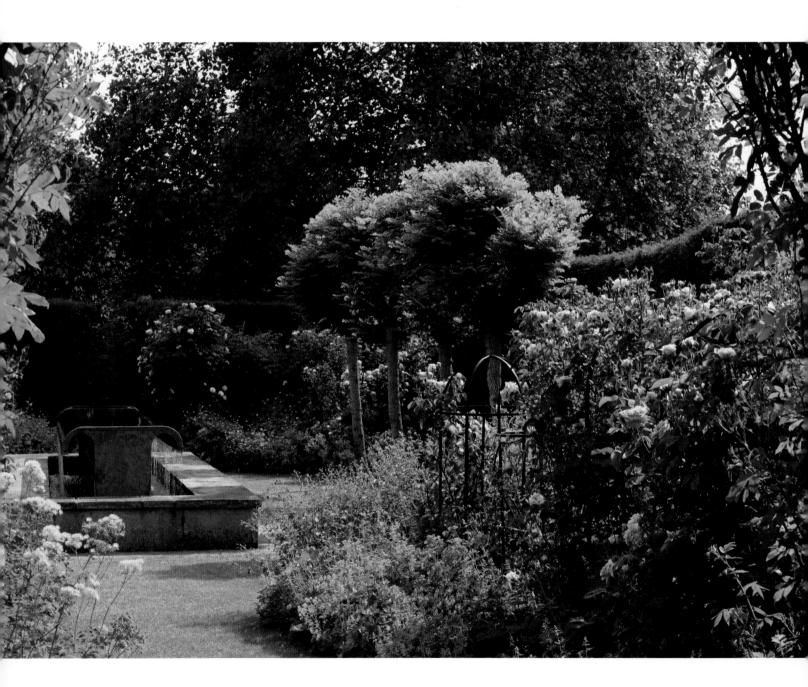

Lady Noel Collum has gardened the 6 acres/2.4 hectares of Clinton Lodge for over 50 years, arriving here in 1972 with her husband, the late Sir Hugh Collum, and their two children.

'I loved the idea of a garden. I had no childhood experience of gardening but I knew that if I ever did have garden space I wanted to make it enjoyable and peaceful. Looking back, what I loved most at Clinton Lodge was the view, and I wanted to enhance its relationship with the Georgian part of the house.'

Over the years Noel Collum has been fortunate to receive advice from her friend, garden designer Julian Treyer-Evans,

LEFT In 2010 Noel Collum asked sculptor William Pye to install a water feature in the existing Rose Garden which she renamed The Pye Garden. To accommodate the water feature he replaced the rose borders on either side of with lines of mop-head acacias.

BELOW Made from patinated bronze, the table-like water feature is called *Tavoleau* and it produces a shimmering curtain-like effect. The nineteenth-century roses, including 'Charles de Mills' and 'Chapeau de Napoleon', offer their fragrant blooms at nose level.

who implemented many garden projects. 'Julian and I would talk, I would have a vague idea and he would make it work!'

She has also, in recent decades, appreciated the professionalism of head gardener Gavin Whitton and several others who have been with her for more than 16 years.

'Everything happened gradually here and of course there have been many changes over the five decades. The 1987 hurricane helpfully cleared the way for the realization of many of my ideas.'

Simplicity is key

In the early years she made few changes, but she had an instinct for what she wanted and with her background in history she researched early garden designers.

'I read Russell Page's *The Education of a Gardener* at least five times and through my work at Christie's I was influenced and inspired by portraits which often included a pastiche or exaggerated depiction of a garden. I felt that my garden should reflect the various ages of the house.'

'I felt that my garden should reflect the various ages of the house.'

Simplicity is paramount: to suit the late Georgian architecture of Clinton Lodge she wanted to set it off with a lawn lined with trees, linking the house to the distant view. A double row of hornbeams running at right angles from the house, parallel with each other, provided the framework. These were clipped into formal box shapes and eventually backed by a yew hedge. At their base massed snowdrops were naturalized.

The hornbeams lead you visually out to the ha-ha and beyond, vaulting into the parkland where in summer cattle graze and in winter deer gather. Treyer-Evans suggested curving the line of trees in the immediate vicinity in the parkland. He also suggested raising a mound, half a mile away, to place a folly, an eye-catcher or a column (which is what they decided upon). English oaks, now clipped, were planted at some distance in front of the column's base so that it appears to be floating on a pillow of greenery. Noel's late husband commissioned the carving of two quotations on its base: 'All the rest is down to nature' on one side and on the other 'O rare Collum' makes a playful pun on their surname.

What satisfies Noel now is the tranquility of the lawn, the hornbeams, the two white urns and the parkland rolling out below the ha-ha, suggesting that everything is under control, without being regimented.

Hidden from view

The formal gardens that Noel has created, including the Herb Garden, a Wild Garden, the 'Banqueting House' Garden, the Rose Garden and the Cutting Garden, are mainly to one side of the house, each enclosed and hidden from view by clipped yew or beech hedges. On the other side is there is a tiny orchard underplanted with pink crinums.

The gardens are accessed by characterful passages, some hedged and some with plant-clad metal arches or pergolas, so that you can walk from one garden room to another without being distracted. There are also five long vistas to discover.

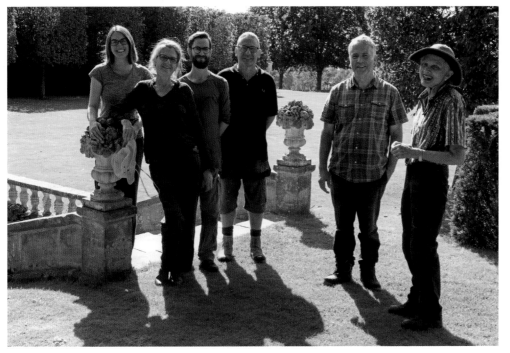

OPPOSITE The view from the eye-catcher column back to the late-Georgian architecture of Clinton Lodge.

ABOVE The tranquility of the lawn and the lines of shaped hornbeams set the house off, allowing its striking architecture to shine without competition from colourful border plantings.

LEFT The garden team at Clinton Lodge Gardens (left to right): Rebecca McDougall, Margaret Oelofse, Henry Rattray, Justin Walters, Gavin Whitton (Head Gardener) and Lady Collum.

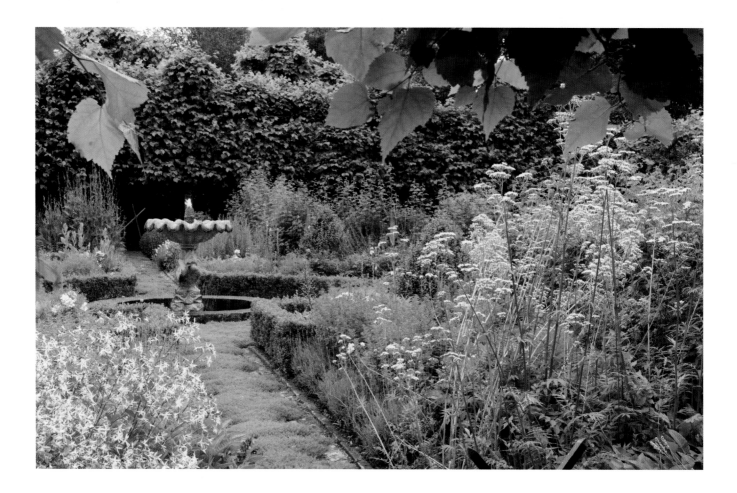

Given her interest in history it is no surprise that the seventeenth-century Herb Garden, one of the hedged gardens, is laid out as a traditional knot garden with covered lime walks, box-lined quadrants and knots filling corner spaces. All the plants in this garden would have been grown at that time for the kitchen or for medicinal use, including hedges of the sweet briar (*Rosa rubiginosa*) grown for their rose hips.

Noel is particularly proud of the chamomile paths and the turf seats. A matter of principle is that all seats and benches here should be for two companions to sit side by side and that they are placed at strategic viewpoints.

Tranquil effects

One of the early changes she made to the existing garden was to balance the single border with a second border.

'In Victorian times there would have double borders and I felt it would be aesthetically pleasing to create a second border against the newly planted yew hedge.'

She filled both borders with plants that bloom from spring through to mid-autumn, offering flowers in blue and white, for the tranquil effect she aims to create. They include white and blue phlox, agapanthus, sea kale (*Crambe cordifolia*), astrantia and *Clematis heracleifolia*, *Veronica veronicastrum*, philadelphus, salvias and white Japanese anemones.

From the herbaceous borders you step into the peaceful arcaded Cloister Walk, draped with white wisteria in summer and lined by two borders holding white-flowered clematis on metal supports, and borders filled with white astrantia, white lilies and hellebores and hostas. From this walk you can glimpse the Wild Garden, which in spring is full of pheasant's eye (*Narcissus poeticus*) and in summer daisies and buttercups.

The other change was in the Rose Garden where hybrid tea roses dominated. They were replaced with old historic roses which flower at a better height and whose scent in high summer is powerful. The metal arbour at the entrance is clothed with the fragrant rambler *Rosa* 'The Garland', with ample flower clusters and good autumn foliage.

In 2010 the Rose Garden was renamed The Pye Garden, for the sculptor William Pye, whose work Noel admired in a Wiltshire garden. She asked Pye to design a water feature for her rose garden. Called *Tavoleau* and made from patinated bronze, the table-like structure has a large flat surface of water

ABOVE The Herb Garden with its chamomile paths and turf seats was laid out as a traditional knot garden.
OPPOSITE The formal gardens, including the relatively new 'Banqueting House' Garden, the Pye Garden and Cistern Garden are all enclosed and hidden from view. Plant-lined, hedged corridors lead from one to the other.

that reflects sky, clouds and roses in the garden. As the water drops over the side of the 'table' it divides into thin filaments and falls like a shimmering curtain. Pye redesigned the layout here so that *Tavoleau* would be integrated in its new setting. Two lines of mop-head acacias have replaced the rose borders on either side of it.

Health benefits

Noel has allowed a modern feel in the garden created around the swimming pool, which was in place when she arrived at Clinton Lodge. 'I had to make a positive out of a negative. To me a twentieth-century swimming pool doesn't sit well near a seventeenth- and eighteenth-century house. Fortunately it was enclosed by a good, high wall, but there was a lot of concrete around it.'

The health benefits of a daily swim were a strong positive. However, the concrete was removed and the blue base of the pool changed to a stone colour. The rose 'Thalia' swarms around and above the changing rooms, and apple trees soften the impact of the pool. Shrubs, including *Hydrangea paniculata* and clump-forming agapanthus enliven the borders from mid- to late summer. The apple trees are supported by metal posts and trained on curved metal hoops, all joined as an 'apple garland' or 'arcade'.

One of the gardens popular with visitors was the Potager (now the Cutting Garden) inspired by Rosemary Verey's ornamental kitchen garden at Barnsley House. 'I couldn't keep pace with all the veg and so have changed it into a cutting garden, which I use for large flower arrangements to soften and humanize the rooms in the house.'

Clinton Lodge Gardens with its garden rooms, romantic walkways and parklands has been opening for the National Garden Scheme for the past 40 years. Even though countless people have visited over those decades, for Noel it remains a peaceful and tranquil setting, a very personal space, full of plants that offer fragrance and simplicity.

LEFT TOP In spring in the Orchard, white foxgloves soar under the apple trees, which are densely underplanted with crinums.
LEFT CENTRE The Pear Walk is one of the many plant-lined passages, or corridors, that link the various garden areas. Underplanted with spring bulbs, in summer lilies and Japanese anemones rise high in the border.
LEFT BOTTOM One of many towering trees in the garden, the tulip tree (*Liriodendron tulipifera*) offers its showy blooms in summer.
OPPOSITE TOP The view through the Cloister Walk arcades, clad with white wisteria and *Clematis alba* 'Luxurians', to the Wild Garden, with its spring tide of *Narcissus poeticus* 'Pheasant's Eye' and tulips.
OPPOSITE BOTTOM Apples trained on a metal support form an arcade that softens the impact of the twentieth-century swimming pool.

6
Denmans Garden
Fontwell, West Sussex

GARDENS ARE OFTEN THE RESULT OF collaboration of several people over succeeding generations. At Denmans Garden the baton was passed from the hand of the creator of the original exuberant and innovative planting to another creative hand over several years. Then from 2017 onwards, a renovation and restoration team, led by the current owner Gwendolyn van Paasschen (Wendy), determined to grasp the baton to celebrate the garden and its two talented creators, Joyce Robinson (1903–96) and John Brookes MBE (1933–2018).

LEFT The Circle Pond in front of Joyce Robinson's cottage was built in 1982. In 2018 John Brookes removed mountains of overgrown shrubs, trees, weeds and piles of rubbish from the site and revised it so that the lawn surrounded the pond entirely. Now the team at Denmans is restoring the original gravel, the curve of the lawn and plans to add plants identified from photographs and lists as being there in 1983.
BELOW John used texture, shape and form of plants including ornamental grasses to achieve strong structure in borders. Here *Pennisetum alopecuroides* and *Miscanthus sinensis* backed by a *Metasequoia glyptostroboides* planted by Joyce, catch the sunbeams.

These were 'two fiery and stubborn geniuses', who for the next 16 years overlapped in the garden.

Denmans became the home of Mr and Mrs Hugh Robinson in 1947. The grounds were in a state of neglect, and for a time Joyce Robinson or Mrs J.R. as she was also known, continued with her grower husband to produce fruit and veg ready to transport on the night train to London's Covent Garden.

Joyce Robinson was a remarkable plantswoman, collecting and propagating unusual plants, as well as growing many from seed. Not for her the well-trodden route of purchasing plants from a nursery with the possibility of some design or planting suggestions. She has not always been credited for the innovative horticulture which she established at Denmans, but it was just that which attracted John Brookes to the place.

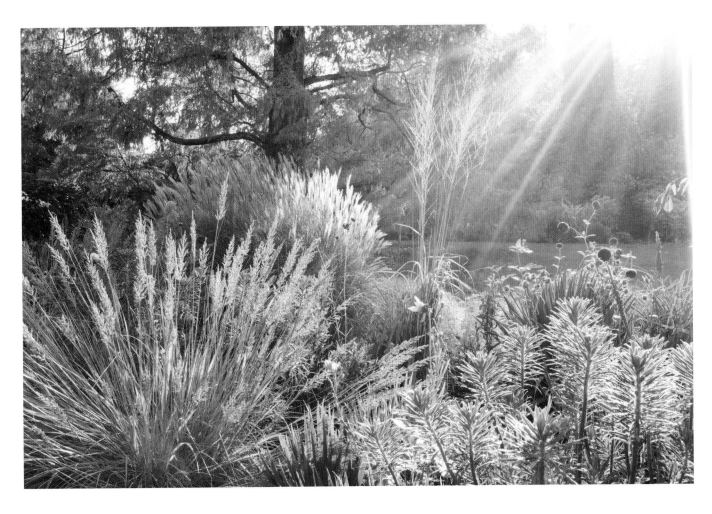

Inspiration from Delos

A visit to Greece in 1969 resulted in her creating an exceptional garden. On the island of Delos she saw a rich abundance of plants growing in the natural gravel and stony setting.

On her return she began experimenting with her first gravel garden in the walled garden, where for so many years she had grown vegetables. She avoided a traditional garden as it would be high maintenance, and she also wanted to be able to walk around the garden 'dry shod', so working with gravel was the perfect solution. She was particular about the gravel and chose a rounded marine gravel dredged from the harbour at nearby Littlehampton rather than chipped quarried gravel.

She chose plants to look natural and fill the space in soft, billowing clumps. They were mainly self-seeders, allowing her to edit out those that were too enthusiastic. She also planted climbers and roses close to the walls to clothe and soften the brick.

Then, in 1972, Joyce turned her attention to the Nut Walk on the west side of the garden. Here she took shrubs and herbaceous plants out and replaced them with gravel, so that visitors could walk right in and among the remaining plants.

First impressions

In 1973, John Brookes, already an established and dynamic international garden designer, brought students to visit Denmans. According to Gwendolyn, he fell in love with the garden's originality, Mrs Robinson's style of planting and her use of gravel, a material that he had included in some of his designs for posh town gardens – his garden rooms, where the hard landscaping came first for him.

In particular, he liked the way the garden was 'itself, and not pretending to be anything other'. He loved its tranquility, something that today's visitors also comment on. Plants were usually last in his mind when he designed a space so it was notable that the way Mrs Robinson used plants was an aspect that attracted him most.

He broached the subject of basing his school of design at the garden, and when that was turned down, he went to Iran to open the Inchbald School of Interior Design in Tehran. The fall of the Shah and the installation of an Islamist regime followed soon after, so he left for India to research his book *Gardens of Paradise*.

Rivers of gravel

Then in 1977, when she was 73, inspired by the winterbourne rivers of the region (seasonal rivers that run dry in summer and full in winter), Mrs Robinson got going on a tractor and began carving out two shapely dry riverbeds, which she filled with rounded stones and pebbles of different sizes, culminating in a dry waterhole. The gently sloping 1-acre/0.4-hectare area was punctuated with large rocks, shrubby willows and grasses to clothe areas of the rivers in a naturalistic way. When he returned to visit in 1979 John Brookes was again full of admiration for her creativity. Today Gwendolyn suggests that what Joyce was doing was more land art than horticulture.

At this point, recognizing that she needed help to maintain the garden, Joyce agreed to John living in the Clock House and setting up the Clock House School of Garden Design. They drew up a four-year agreement during which time he would gradually take over management of the garden. Gwendolyn describes them as 'two fiery and stubborn geniuses', who over the next 16 years that they overlapped in the garden, 'enjoyed or endured' a push-me-pull-you working relationship.

In that time John Brookes created his own garden around the Clock House, filled with Mediterranean plants and linear, Mondrian-inspired hard landscaping. In the main gardens he re-shaped many of the beds, while respecting Mrs Robinson's plantings and understanding how they softened the harder, more defined lines and structures that he created.

In 1984, John persuaded Mrs Robinson to let him create, with the collaboration of water garden designer Anthony Archer-Wills, the lower pool into which the gravel riverbeds could 'flow'. A statue, *The Dreamer* by Marian Smith, near the pool, was one of the many focal points that John introduced into the garden.

OPPOSITE Sinuous gravel paths, brick circles, an urn and a fastigiate yew are among the hallmarks of John's work in the Walled Garden, originally created by Joyce. Box balls and cubes also reinforce the curving lines that were inspired by Brazilian landscape designer Roberto Burle-Marx. ABOVE The statue, *The Dreamer*, by Marian Smith, was one of the focal points introduced by John Brookes when he added the pond at the end of the 'gravel' stream created by Joyce Robinson.

RIGHT Karen Quinn, Graham Best, Mike Palmer and Gwendolyn van Paasschen, with John's beloved pug dog, the late Puggy (a.k.a. Mabel).

OPPOSITE Throughout the garden John employed seasonal colour from bulbs such as alliums in unmown grass and narcissi in borders, herbaceous plants, roses, as well as foliage, fruit and fragrance to hold and extend attention. In the area near the iconic Clock House where he lived he created his own more linear garden filled with Mediterranean plants.

Enter Gwendolyn

At this point Gwendolyn enters the story, albeit from her home in the United States. In 1993 and 1994 she attended a series of John's masterclasses at the New York Botanical Gardens and was asked by a friend and client for design help. 'The ink was hardly dry on my qualifications so I persuaded my friend to invite John Brookes to New York to see if he would take up the project. John arrived in a winter snowstorm in 1998 and over that first weekend the plans for the project and our friendship were set fair.'

On Mrs Robinson's death in 1996 John and his business partner bought Denmans from her estate. He spent the next 22 years fusing an overlay of his design with her naturalistic planting style and transforming what he called her 'glorious disarray' into a more 'controlled disarray'. He saw it as a simplification of the garden, extending the gravel and emphasizing the curves, inspired by those he had seen in Brazil created by Roberto Burle-Marx, to create more sinuous patterning.

In 1999 Gwendolyn visited Denmans for the first time and saw *in situ* what was meant by the new term 'architectural planting', many examples of which John had introduced into the garden. His signature architectural plants included cynara, cordyline, verbascum and columnar yews which he used to reinforce the lines and curves of the garden's design. All of this contrasted and complemented Mrs Robinson's naturalistic plantings.

Unfortunately for the garden's fabric, a lengthy dispute with his business partner led to a period of enforced neglect. Gwendolyn became involved in supporting John in his legal battles and by 2017 he had regained control of Denmans.

Refreshing and restoring

Gwendolyn, Denmans's new owner and chair of the newly established John Brookes-Denmans Foundation, then began the restoration work on the buildings. John and head gardener Graham Best worked ferociously to take out overgrown and neglected plants.

John died in 2018 but by this time the recovery was progressing well and, in 2020, the garden's future was assured when it was added to the National Heritage List for England as a Grade II post-war garden, became an RHS Partner Garden and reopened to visitors on a regular basis.

While there is not a defined 'road map' from John, Gwendolyn and her team, including General Manager Mike Palmer and head gardener Graham Best, are renovating and refreshing, restoring and re-invigorating the garden with the guiding principle of doing nothing that is irreversible.

Above all, they are celebrating the fact that there have been 50 years of gravel gardening on this site, that the garden's future is protected and that plans for an educational programme are in place to stimulate future generations.

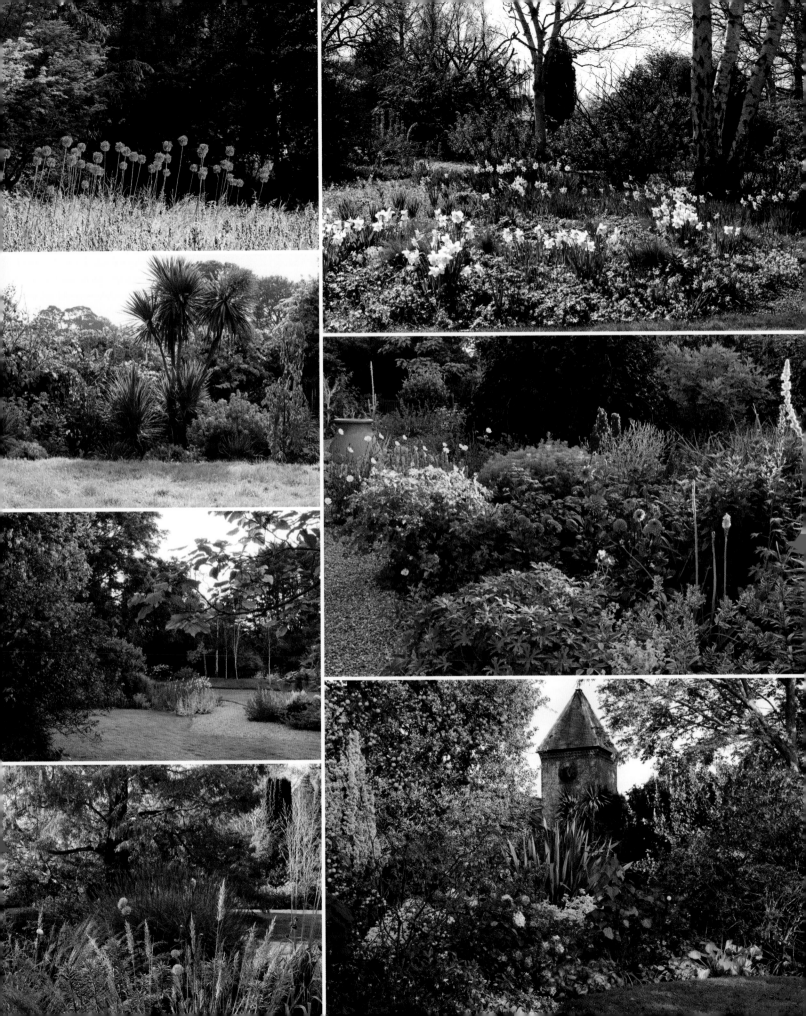

7
Doddington Place Gardens
Sittingbourne, Kent

AT DODDINGTON PLACE GARDENS there are many familiar garden features such as a woodland, a rock garden and a formal sunk garden, topiary and pools – but here each has its own twist and excitement.

Doddington Place was built in 1870 for Sir John Croft, of the port and sherry family – the Croft Original. In 1873–74 the garden designer Markham Nesfield (son of William Nesfield, landscape architect 1793–1881) was asked to design a terrace on the south side of the house, and although the low walls and balustrading survive, his planting plan was not put in place.

Soon after their introduction in 1853 into Europe and the UK, *Sequoiadendron giganteum* became status symbols

in gardens. At Doddington Place Gardens there is a stately – grander than grand – towering Wellingtonia Walk now underplanted with thousands of snowdrops.

From the moment you drive past the lodge with its pretty borders, there is a sense of a rural idyll, as if you are relaxing into a comfortable, well-furnished room. The busy world has been left behind and for the length of your visit you will find pin-sharp horticulture that allows blowsy annuals, soaring trees and rolling yew topiary to shine.

At 10 acres/4 hectares it is not too large to take in on a day visit and yet there is so much that will repay closer and slower scrutiny. And then there are the views. The house came into the Jeffreys and Oldfield families as a co-purchase in 1906, based solely, according to the wife of one of its owners, Maude Jeffreys (née Oldfield), on the beauty of the views.

The Italianate Sunk Garden to the south-east of the hall and the Rock Garden were established when around 1909 Maude Jeffreys commissioned a London designer, John Dyke Coleridge, to extend the gardens.

LEFT Sentinel oaks head the double avenue of gleaming silver birch 'Grayswood Ghost' that line the Pond Walk. Every spring their trunks are brushed, then sponge-washed with a dash of washing-up liquid.
BELOW The Folly Walk leads to the building Richard Oldfield designed to commemorate his first wife and son. Pond Walk is just the other side of the towering yew hedge.

Woodland Garden

In the 1960s Maude's nephew John Oldfield, the next owner of the house, discovered that in the predominantly chalk downland on the property there were several acres of acid loam. He set about creating a woodland garden, underplanting the existing woodland with acid-loving camellias, azaleas, rhododendron and acers. More recently the handkerchief tree (*Davidia involucrata*), dogwood (*Cornus* 'Eddie's White Wonder') and Japanese snowbell (*Styrax japonicus*) have been added.

The storms of 1987 took out at least 60 trees, which allowed light into the woodland and boosted the acid-loving plants. In spring the bird song is astonishingly lovely, as are the leaves, buds, flowers and stems that seem to swirl at ground to shoulder height as they ripple colourfully on either side of the roughly diagonal paths. Other woodlanders planted here include *Magnolia wilsonii*, mountain laurel (*Kalmia latifolia*) and serviceberry (*Amelanchier canadensis*).

Doddington Place, today a Grade II-listed Victorian mansion set in a parkland of 80 acres/32 hectares, is home to Richard Oldfield and his wife the author Amicia de Moubray. They continue the family routine of maintaining and renovating, as well as initiating new projects to keep the garden fresh and lively.

'It feels as if we have changed and refreshed quite a lot in a relatively short time. Apart from the main garden, we unified the house, which was divided in two in 2007 when Richard's aunt died, and we created a new, private garden,' Amicia explains.

Spring Garden

During the 2020 lockdown, the gardeners decided to make a seat with some paving stones that had been lying around unused. The resulting bench has an organic feel to it, laid like a drystone wall. Now it is a place to sit, enjoy the views and think. Spring bulbs and herbaceous flowering plants including leucojum and pulmonaria are bedded in around it.

One of Richard's early projects was the Folly he designed to commemorate his first wife Alexandra, who died in 1995 and, latterly, his son who died in 2017. Leading to and from the Folly is the peaceful curving Folly Walk.

Running parallel are the dazzling Spring Garden, planted with narcissi, magnolias and fritillaries, the Pond Walk

ABOVE The low walls and balustrading of the South Terrace above the Sunk Garden were designed by John Duke Coleridge (1879–1934).
OPPOSITE Spring fills Doddington with colour from bulbs such as the snowdrops nestling at the base of the avenue of giant wellingtonias, massed narcissi in borders and woodland, mixed bulbs in long grass, and overflowing containers, as well as from flowering ornamental and orchard trees and densely packed hellebore plantings.

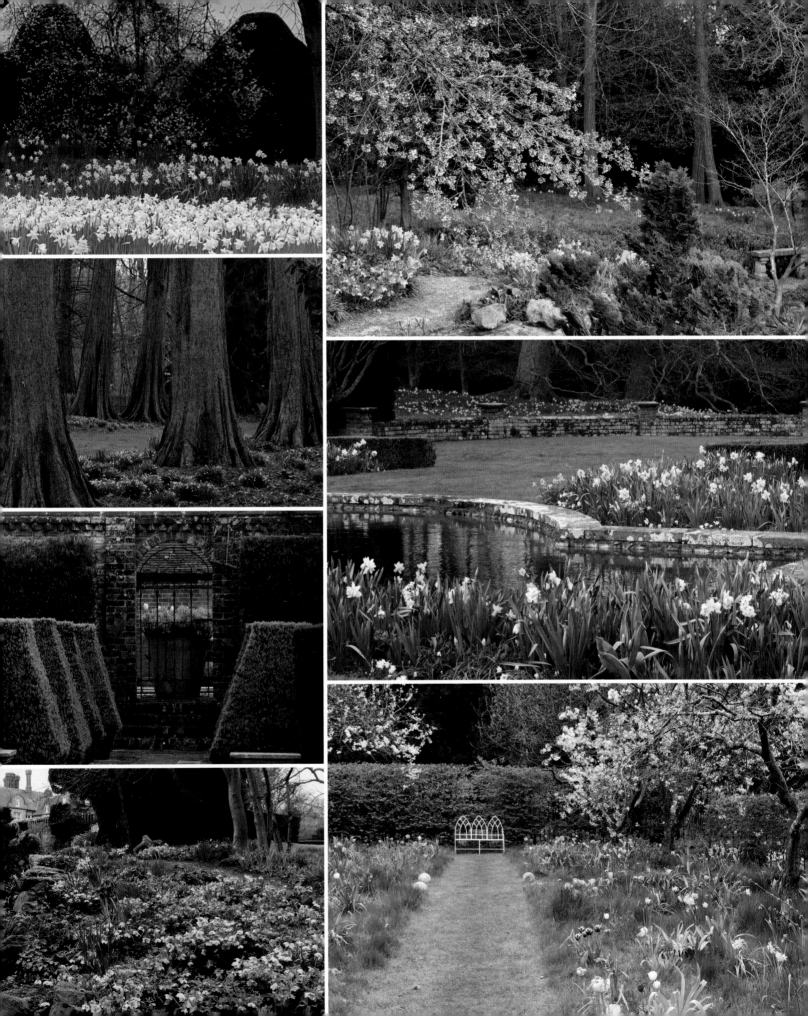

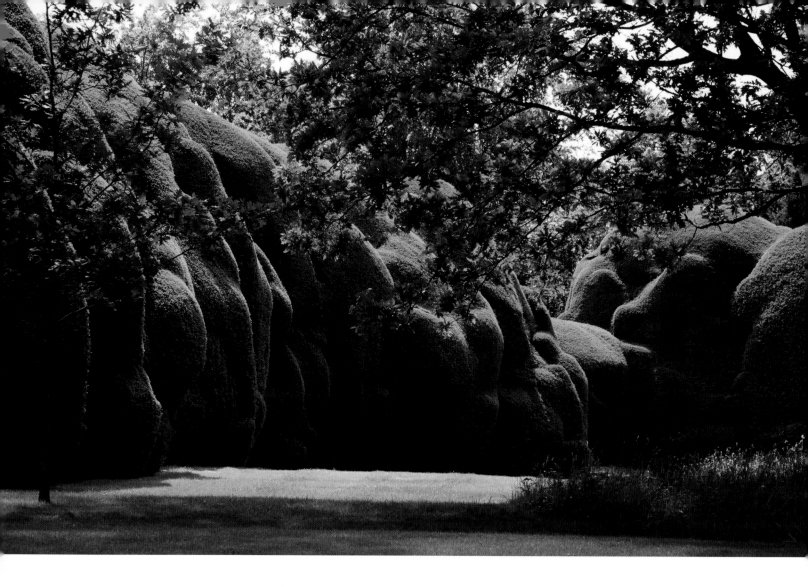

ABOVE One of the memorable mature yew hedges at Doddington was probably planted just before the First World War.
RIGHT (Left to right) David Breakell, Louise Meyern, Robert Breakall, Lucy Adams (Head Gardener), Amicia and Richard Oldfield.
OPPOSITE TOP The Edwardian Rock Garden was completely renovated in 2007–8.
OPPOSITE CENTRE The park beyond the ha-ha is in a Countryside Stewardship Scheme. The sheep keep the grass under control.
OPPOSITE BOTTOM A corner of the garden close to the Pond Walk and the Folly Walk in late summer with a pleasing mixture of textures.

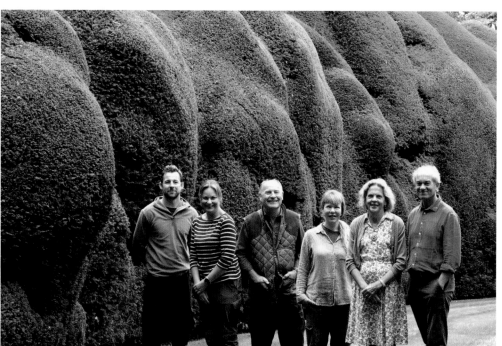

'We had to either abandon the rockery or do something dramatic to take it forward.'

with its avenue of birches (*Betula utilis* subsp. *jacquemontii* 'Grayswood Ghost'), all with whiter-than-white, washed trunks and the closely clipped circle of box that encloses the glassy sundial – the Millennium Column Sundial. Throughout the garden various ponds and pools offer stark and breathtaking reflections of sky, clouds and plant shapes, but the Millennium Column Sundial made by David Harber in 2000, eclipses them all with its angular mirror faces.

'Richard is keen on the trees and on the bigger picture of how things should look, as well as the vistas,' says Amicia. 'I tend to focus more closely at ground level on colour, shape and texture of the herbaceous plants, but I do love the woodland.'

In 2007–8, the Edwardian rockery was completely renovated. It had become weedy and overgrown, many of the stone paths were uneven and dangerous. 'We had to either abandon the rockery or do something dramatic to take it forward,' says Amicia.

Matt Jackson, then head gardener, was a rock climber and had restored the quarry garden at Scotney Castle, so was the ideal person to oversee the purchase of stone and to recreate the site. New stones were introduced to the original paths, the waterfall, the series of pools and the framework and then the soil was completely refreshed.

Rethinking and refreshing

Amicia came to Doddington from London where she had no garden, but was undaunted by the prospect of 10 acres/ 4 hectares! 'My parents took us to woodland gardens such as Leonardslee when I was a child, so I wasn't put off rhododendrons and azaleas in the least.'

She asked Janet Bryant, a local horticulturist, to run a gardening course for her, and later she took a garden design course at the English Garden School in London.

In 2010–11 Amicia commissioned designer Kirsty Knight Bruce to refresh and rethink the 100-year-old Sunk Garden. Kirsty added eight new beds and the existing beds were widened and deepened. Amicia knew that she could rely on Kirsty's skill with colour and plant combinations – and the resulting seasonal displays provided vibrant waves of blooms at varying heights.

In 2011, Lucy Adams, an art graduate turned gardener, joined the team, later becoming head gardener. Lucy's art training complemented Kirsty's original design. In subsequent

years, Lucy has changed the planting, matching Amicia's bold approach to using colour in the borders. Each year Amicia and Lucy note successes and failures, and the winter seed list sessions set the pace for the next year's plantings. Spring bulbs steal the show throughout the garden. In the Sunk Garden white narcissus and muscari are the main choice, topped up annually to replace any that are blind or are dug up to make way for summer plantings of dahlias.

Memorable framework

For the summer displays Lucy sows from a long list of annuals, including *Ammi majus*, *A. visnaga* and *Daucus carota*. She also sets in plants such as *Dahlia* 'Honka Fragile' and the false aster *Boltonia asteroides*. Later perennials such as echinacea and heleniums, and other tall-growing summer herbaceous plants rise up. 'The beds get fuller and fuller and whenever we see a gap, we fill it,' says Amicia.

But the most memorable framework is provided by the towering and rolling yew hedges linking the different areas visually and physically moving you onwards. They obscure,

enclose and reveal parts of the garden, and offer a green breathing space to gather your thoughts. Planted by Maude Jeffreys (née Oldfield) before the First World War, they were clipped formally until, during the Second World War they were more or less abandoned to grow into the weird, cloud-like shapes that they are now.

Above the Sunk Garden and nearer to the house are the Ghost Borders, a popular feature of Edwardian gardens, offering a quieter colour palette with the grey foliage of *Elaeagnus* 'Quicksilver' and willow leaf pear (*Pyrus salicifolia*).

Dahlias are high summer favourites throughout the garden, but in a small almost cloistered courtyard near the Ghost Borders, they are given free rein, showing off and raising the temperature considerably.

For the past 60 years Doddington Place Gardens has opened to the public through the National Garden Scheme. Amicia says that this is the main driver for keeping it on form: 'You have to keep to certain standards and then of course you visit gardens and see new things and want to try them out, so it is constantly evolving.'

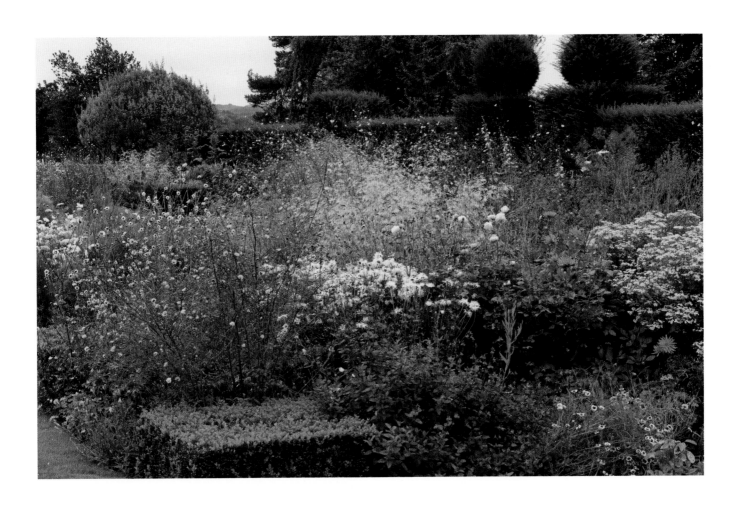

OPPOSITE Amicia invited designer Kirsty Knight Bruce to rethink the century-old Sunk Garden. The result was the addition of eight new beds, and the extending of the existing borders.

ABOVE Lucy Adams (Head Gardener) and Amicia plan for the Sunk Garden displays to be as colourful and packed as possible. Annuals, perennials and dahlias combine to provide its explosive displays.

LEFT Offering a fairy tale look a yew hedge appears to tumble over the wall at the end of the South Terrace. Plaques in the wall below it commemorate several generations of Oldfield family dogs.

8

Gravetye Manor
East Grinstead, West Sussex

THE LANE TO GRAVETYE MANOR winds alongside tree-clad slopes that sparkle with bluebells in spring, signalling the horticultural legacy that its nineteenth-century owner William Robinson (1838–1935) left at the property. Records show that Gravetye and its estate have been worked and inhabited since 1570, but its modern garden association began in 1885, when Robinson bought the property. He had started as a garden 'boy' in Ireland, worked his way to Regents Park in London and by 1867 was *The Times* horticultural correspondent.

LEFT From the porch at the entrance to the Flower Garden *Canna indica* 'Purpurea', *Cosmos bipinnatus* 'Purity', *Thalictrum delavayi* 'Elin', stands of fennel, roses, heleniums and dahlias offer a summer welcome and entice visitors outside.

BELOW The view from the sundial, at the centre of the lawned quadrants of the Flower Garden, widens towards the meadow and lake, and borders full of plants such as *Stipa gigantea*, *Salvia confertiflora*, *Dahlia* 'Magenta Star', *Rosa glauca* and Kiss-me-over-the-garden-gate (*Persicaria orientalis*) demand attention.

At Gravetye, Robinson was able to put into practice the strongly held views he voiced in his garden magazines and books. Here he would be able to grow a flower garden, make a wild garden, naturalize bulbs in grass and plant trees and shrubs. Here he created natural, more informal gardens, diverting gardeners from the rigidity of Victorian bedding he so disliked.

Robinson's legacy

In 1958, some 23 years after Robinson's death, Gravetye became a prestigious small hotel. There have been periods of disrepair but fortunately in 2010 Jeremy and Elizabeth Hosking took it over: 'We were concerned that someone else would not restore the garden to its full glory, respecting William Robinson's legacy for the future so that it wasn't lost,' explains Elizabeth.

The Hoskings hired Tom Coward, former deputy head gardener at Great Dixter, ensuring that the garden and the kitchen garden would play a lead role in the hotel's success. Under Tom's guidance the garden's star has risen and risen.

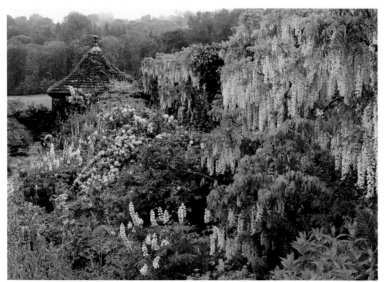

'You have to plant in a progressive way, so that the garden moves forward.'

Tom Coward is clear about the garden's aim: 'It was a garden for Robinson's purpose when it began and it continues to be a garden for a purpose. It is important that it is managed as an historic garden, but it is dangerous to obsess about history. There are layers of history, it is a living landscape and is constantly changing. We have to respect the legacy and each layer of history.' Today Tom is balancing the Robinsonian legacy while steering the garden towards a sustainable future.

Rising to the challenge

When Tom arrived at Gravetye, the infrastructure of the garden had declined and there were perennial weed problems. In the Kitchen Garden there were brambles and thistles and no clear system for cropping. Tom and his team set about updating the irrigation system and installing deer fences. 'We dug and dug, then grassed it over and put chickens out on it for a year, before we could think about sowing and planting productively for the restaurant.'

They also dug out the entire Flower Garden, similarly infested with weeds. The challenge then was to either replant it exactly as Robinson had it or, like Robinson, be more progressive. Tom found that the most useful archival references were the many paintings of the garden, some commissioned by Robinson for his various publications.

That they retained the lawn in the Flower Garden, which in Robinson's time consisted of numerous small rose beds, is an example of the regard shown to the layers of the garden's

LEFT TOP The Azalea Bank on the west side of Gravetye Manor is an example of Robinson's plantings where he used tough herbaceous perennials planted intensively under shrubs such as *Azalea* 'Irene Kostar' and *A. luteum*. The dense plantings formed carpets and outcompeted any weeds.
LEFT CENTRE The Pergola leading to the Summerhouse in the Flower Garden is clothed with the fragrant *Wisteria floribunda* 'Alba'.
LEFT BOTTOM Slightly elevated above the main entrance to Gravetye Manor, the Wild Garden offers visitors a tranquil space filled with well-established plantings of rhododendron, azaleas, birch and acers, including *Acer japonicum*.
OPPOSITE The Long Border runs below the sandstone wall of the Flower Garden and is a tour-de force of rhythmic and layered planting of shrubs, roses, ornamental grasses, annuals and perennials, including *Miscanthus giganteus*, *Crocosmia* 'Zeal Giant', *Hydrangea paniculata* 'Big Ben', *Cynara cardunculus* and *Erigeron annuus*.

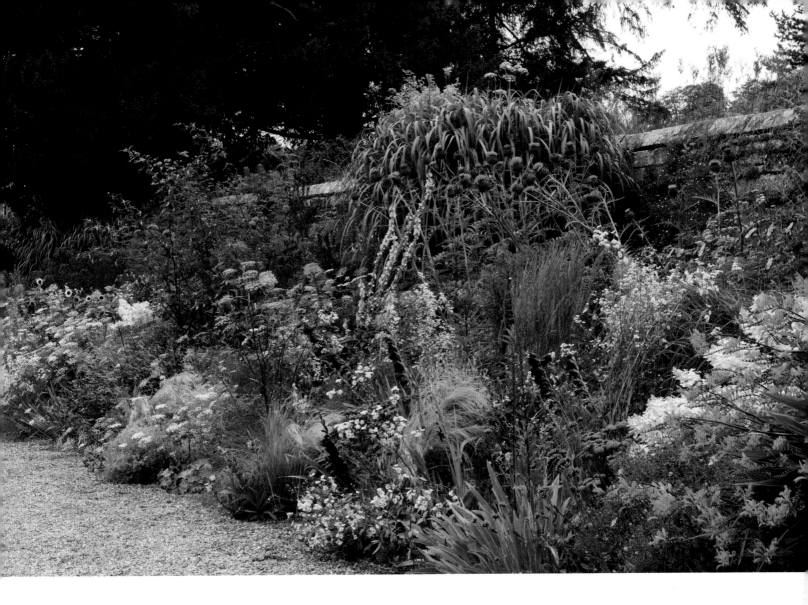

history. As Tom notes: 'We respected that a previous owner, Peter Herbert, had put the lawn down.'

The team tackled the weeds in the Flower Garden by thorough digging and making successional plantings of annuals alongside the perennials, grasses and dahlias, to outcompete the weeds.

The Long Border, which nestles close to a sandstone wall running alongside the Flower Garden, was dug out completely and left fallow for two years. But the resulting billowing abundance of roses, shrubs and perennials, such as glory flower (*Clerodendrum bungei*), willow-leaved pear (*Pyrus salicifolia*), *Crocosmia* 'Zeal Giant' and ironweed (*Vernonia arkansana* 'Mammuth'), made the effort worthwhile.

The planting in the Long Border – some 230-feet/70-metres long – is a perfect example of Tom's appreciation of Robinson's tenets. Shrubs, roses, perennials, ground-hugging plants and climbers are woven together, sometimes repeated, more meadow-like than a conventional border and with no edge, the colours rise and fall, crashing like waves on the shore.

'When you work in an historic garden you have to refine the plants, remove what can you and look at it dispassionately. In some ways it is like looking at 150 years of clutter!' The lockdowns of 2020 and 2021 offered Tom the opportunity to do just this. 'There was time and space to assess how the plants were working in combination. You have to plant in a progressive way, so that the garden moves forward,' he says.

Gravetye Manor's garden is about 30 acres/12 hectares set within 1,000 acres/404 hectares of the greater estate, with many of the elements dating to Robinson's time. The view to the lake from the Long Border and the Flower Garden takes in the Meadow, where Robinson first experimented with crocus and narcissus. His book *The Wild Garden* (1870) sets out his methodology and here are the living results. For Tom it is important to see this through, making careful additions year by year to create a self-sustaining population, all the while noting the naturalized bulbs' vigour. He adds petticoat daffodil (*Narcissus bulbocodium*) near the lake, and *Crocus* 'Pickwick' and 'Victor Hugo' to lead the charge from the Long Border towards the lake.

Always on show

An area that has given Tom as much pleasure as anxiety is the bank that rises between the hotel restaurant and the games lawn. He has planted it with successional mixed shrubs and perennials, because it is constantly in view , so it has to perform every day.

'You have to be patient with shrubs – they take time and need space. The solution is to grow some herbaceous plants in pots to fill the space and give the shrubs time,' he explains.

To the south of the Flower Garden is a simple wooden pergola, clad with a white wisteria, whose racemes rain down. The Summerhouse, where Robinson sometimes worked and where hotel guests now take tea or simply sit to absorb the atmosphere, is reached along the pergola walk or directly from the Flower Garden.

In 1898, Robinson decided to move the Kitchen Garden to a south-facing slope above the hotel, where it is now. It took three labourers three years to dig it out and build the walls of the unique oval shape that Robinson felt would best suit crops.

Dished to the sun, the Kitchen Garden sits well on the slope, catches the light and, as Tom says, the curve of the walls aids air drainage, so that cold air is funnelled into a tighter space and drains away swiftly. 'The main priority here is heritage; since there are so few surviving working walled kitchen gardens, we have a good opportunity to highlight modern horticultural skills within this setting,' he explains.

Productivity is an important factor and they can boast 90 per cent self-sufficiency in providing Gravetye's chef with key crops which are showcased on the menu at their peak. And the Kitchen Garden is one of the areas that guests enjoy walking in – spotting the baby veg, watercress, gooseberries, blueberries, raspberries, pears, apricots and around 40 varieties of apple, as well as the cutflowers for every room.

The Orchard, holding some of Robinson's original trees, is the actualization of his wild garden principles. Seasonal colour, starting with narcissi, bluebells, camassia and even pockets of peonies, asters, geraniums and lilies, rolls out in the long grass. The further you walk from the house the less formal and more naturalistic the scene becomes, with the blossom and meadow drawing you along.

Trees and shrubs were important to Robinson and it is due to his US travels and the contacts he made that the garden has such interesting collections of conifers, rhododendrons, azaleas and magnolias from China. Notable are an *Acer palmatum* 'Aurea' boasting the best girth for an English specimen and possibly the best handkerchief tree (*Davidia involucrata* var. *vilmoriniana*), thought to be an original introduction by plant hunter Augustine Henry.

While guests and visitors to Gravetye can enjoy the moment, Tom looks to the future to keep the beauty going, with successional plantings in woodland, meadow and flower gardens. One future plan is to have an avenue of Henry's handkerchief trees. As the reputation of the modern garden at Gravetye Manor flourishes, one of Tom's hopes is that interest in Robinson, undoubtedly an 'influencer' who in his lifetime was a well-known, household name, also will be revived.

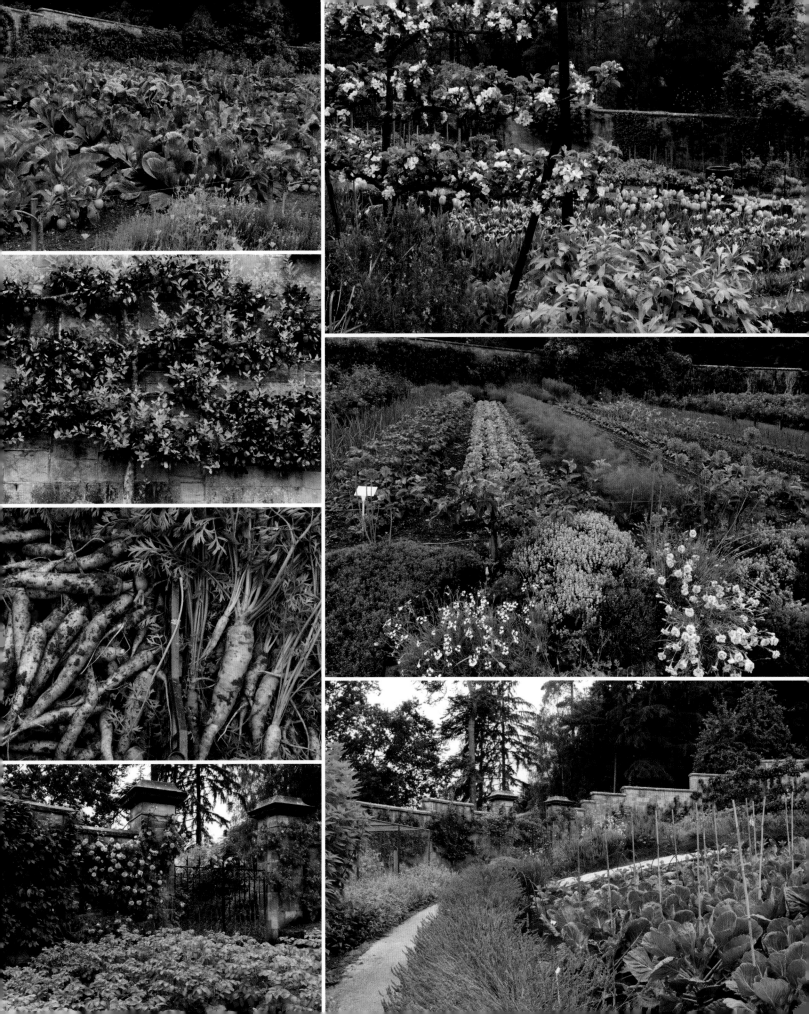

9

Long Barn
Sevenoaks, Kent

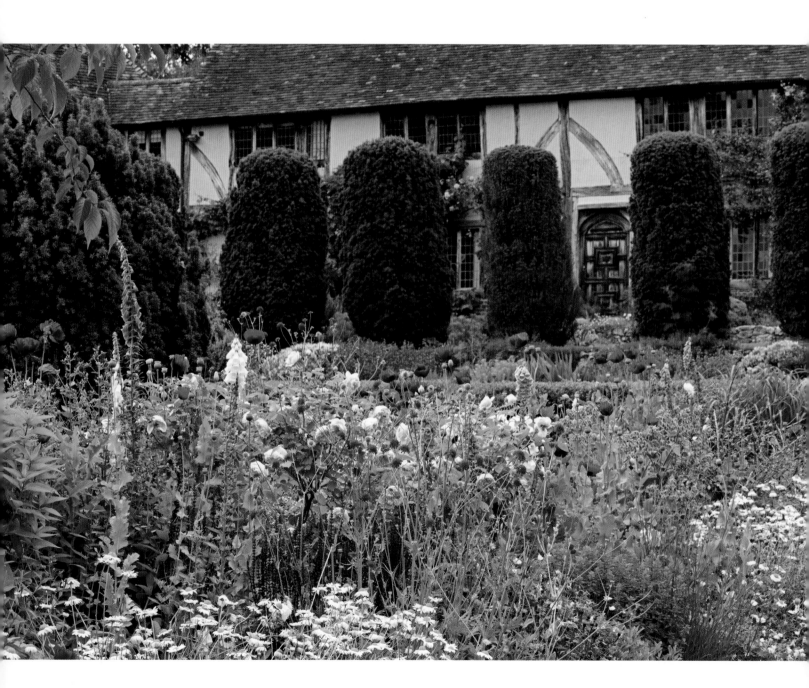

TAKING ON ANY GARDEN is daunting enough but when the house and garden has impeccable historic form, as in the case of Long Barn, the first garden of Vita Sackville-West and Harold Nicolson, the stress level might well ratchet up. But not so for Rebecca and Lars Lemonius.

Rebecca relates to the fact that Vita and Harold were experimenting in this garden. 'At that moment they had no idea what they were doing. Just as it was for me when I arrived here!'

'It was empowering when I realized that when Vita began here she was learning, experimenting and making mistakes. So it was with me, and here I am now, not doing any worse than she.'

Iconic backstory

Rebecca and Lars moved to Long Barn in 2007. It was not on the market but they had heard it might be up for sale, and on impulse Rebecca put a note through the door asking the owners to let her know if they decided to sell.

Not only did Sir Brandon and Lady Sarah Gough contact her, but they were patient, giving her and Lars the chance to be sure that this wayward Grade II* listed house with a Grade II garden, was right for them. The Goughs, who had owned it for 20 years, moved next door, which was fortunate since Rebecca rushed there many times asking for plant identifications.

'We knew its iconic backstory as Vita and Harold's first garden, then discovered that Charles Lindbergh (the US aviator)

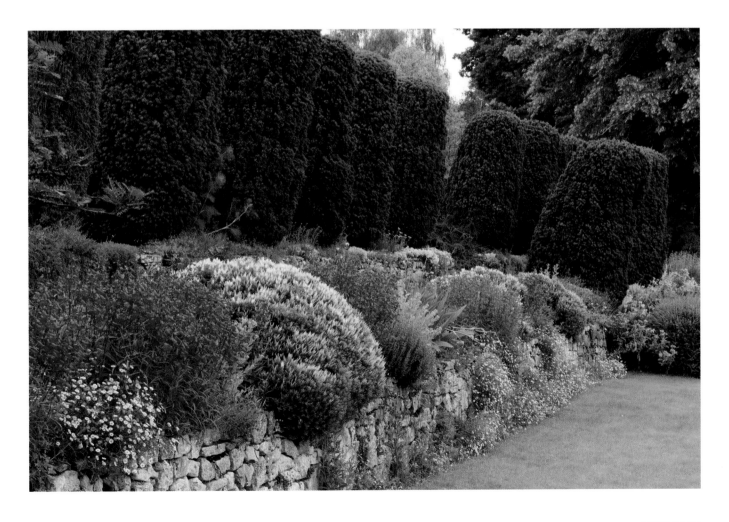

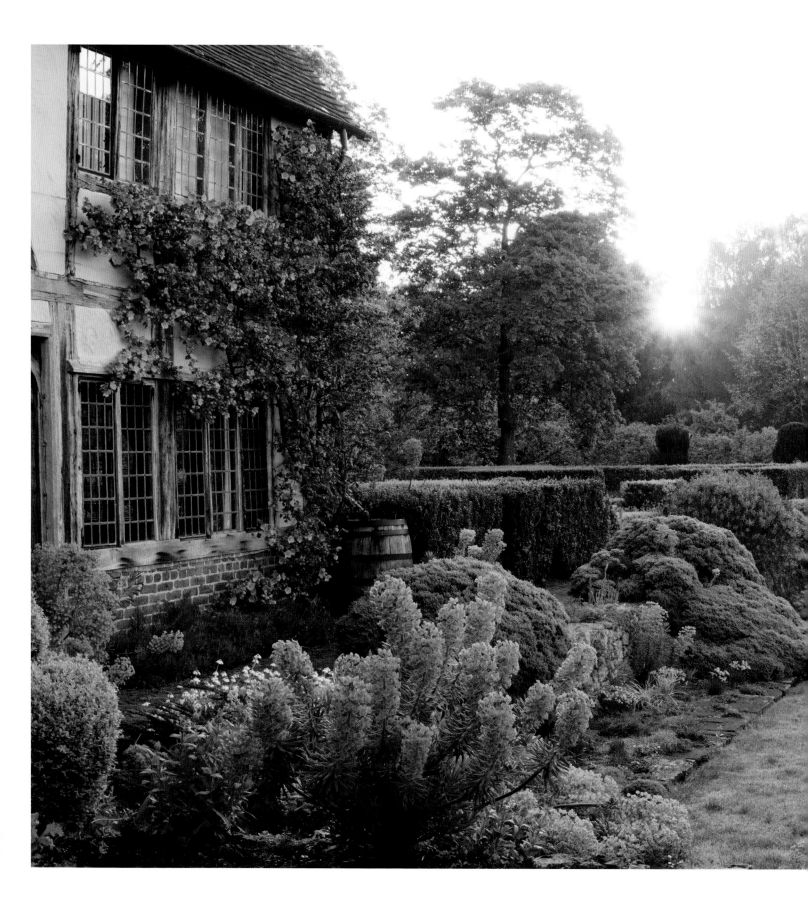

and his wife, author Anne Morrow, had lived here and later that many celebrities had called it home. One of the reasons that Vita was attracted to it was the local legend that printing pioneer William Caxton was born in the house,' recalls Rebecca.

The Nicolsons had returned from Constantinople in March 1915, looking for their first family home. Vita's mother (Lady Sackville-West, a.k.a. Bonne Mama) lent them the money for the purchase. There were many garden luminaries on hand to turn to for help: Edwin Lutyens was one such. He was close to Bonne Mama and so was corralled in as an unofficial mentor. Lutyens worked with Harold on the design of the Dutch Garden where they created six L-shaped raised, brick-enclosed borders, now referred to as the Lutyens Borders or the Dutch Beds. This lower part of the garden is often waterlogged in winter, which was why Lutyens advised that the borders should be raised. Crab apples were planted into the four right-hand L-shapes, ornamental cherries in the four left-hand ones, but the apples were too poorly to survive.

'To me this is an example of one of Vita's early horticultural mistakes, albeit a beautiful one, as trees in raised beds, with soggy bottoms just don't thrive,' says Rebecca.

Floral abundance

Lutyens had a poor view of Long Barn and suggested the Nicolsons should sell and move! In fact, by 1932 they had moved to Sissinghurst and sold Long Barn much later in 1945.

The basic structure that Harold devised, with the north-south and east-west axes of yews and terraces, still holds the garden together, even though it lacks the refined accuracy of similar features he later designed at Sissinghurst. Here there are not many straight alignments, rather approximations that fit with the character of the house and the lie of the land.

Today, as then, the texture, colour and rhythm of the stately yews that march across the east-west axis offer a peaceful balance to the crammed floral abundance sweeping across the house walls or bursting out of raised beds. The yews also offer seasonal ornament, especially in winter, when they catch the frost or a rim of snow. Each day their shadow work on the lawns as the sun sinks adds a different dimension. And when their dark shapes rise out of an autumnal mist, another layer of drama is offered.

The terraces formed from a series of brick or stone walls at varying heights appear to step graciously down from the

The barn wall provides a strong backdrop as well as a hotspot for Californian glory (*Fremontodendron californicum*). Together with the lime-green torches of *Euphorbia characias* subsp. *wulfenni*, they offer a counterpoint to the closely clipped hedging and lawns on the Main Lawn.

*'Every year some of our visitors weep —
they are literally moved to tears.'*

courtyard terrace near the house, to the Main Lawn and lower to another large lawn, the Pleasaunce, to reach the lower level of the garden that holds the Lutyens Borders and the Kitchen Garden.

The Goughs carried out a major renovation of the garden, adding a few beds and reinstating borders that previous owners had grassed over. They also created a box parterre in between two made by Vita. The parterres are situated just to the east of the brick terrace in front of the house. The Goughs wove their initials, B and S, into the patterning of the new parterre. They also converted the tennis court into a rose lawn.

Lining the east-west wall of the Main Lawn are the gravel-covered Cretan Borders. These hold jewel-like scree and alpine plants, and you can sense that they were created for plants seen on the Nicolsons' travels.

Early history

Rebecca and Lars have not changed anything structurally apart from the vegetable garden, where they have laid brick paths and added a useful propagation building.

'Basically we are maintaining what is here in terms of structure and ringing the changes with the planting. The history of its early owners is integral to why we maintain it as we do.'

OPPOSITE TOP The L-shaped beds in the lower garden, known as the Dutch Beds were created by Lutyens working with Harold Nicolson. Now called the Lutyens Borders, their exuberant colour spills over the raised edges.
OPPOSITE BOTTOM The parterre on the top terrace was the work of Sir Brandon and Lady Sarah Gough.
ABOVE The former tennis court became a rose garden.

RIGHT (Left to right) Anna Ribo, Peter Scheiner, Rebecca Lemonius, Andrew Ferris and Russell Webb.

OPPOSITE Some of the garden rooms at Long Barn such as the Secret Garden and the Pool Garden seem to hint at the enclosed gardens that Vita and Harold created later at Sissinghurst.

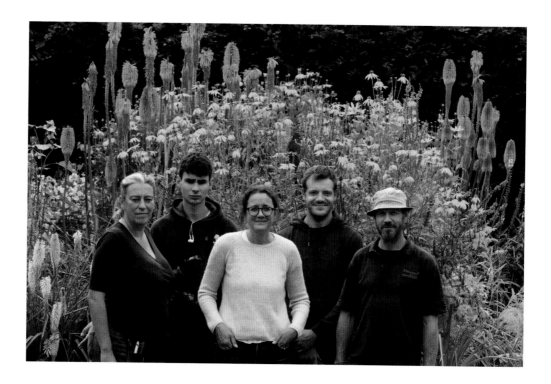

Long Barn is on solid clay, making for a tough environment for plants. Recent changes in the weather mean some plants are short-lived, and the planting is amended to accommodate. No original planting plans survive but there is a wealth of old photos and references from letters. The story they tell is of rusticity and of an exuberant cottage garden, with formal, structural plantings to enclose and 'tame' the abundance of Vita's planting.

Rebecca keeps Vita's style of full and exuberant borders going, letting plants self-sow, editing this lightly and introducing the plants that she favours. She is particularly focused on the textural contrasts of leaves, as well as of the form and structure of plants. Different sections of the garden are subtly distinct and colour is embraced.

Although there is a feeling of enclosure and intimacy, Long Barn is not fully a series of discrete, enclosed garden rooms but has manageable, informal sections that make it relatable to visitors and offers small vignettes that you could easily transfer to other spaces.

'Every year some of our visitors weep – they are literally moved to tears. There is something in the atmosphere of the garden or maybe they are "Vita fans" and being here is like a pilgrimage. In certain lights, not necessarily at dusk, but when the light drops and the air is still, it feels other-worldly, and this makes people emotional. It is lovely to see it through other people's eyes… and we too are wowed on a daily basis.'

The visitors book is full of praise for the garden's atmosphere, with people describing the experience as walking back in time, through a portal into another world.

Full expression

Rebecca is a lawyer who has always loved gardening and is fascinated by the process of growing something from seed and cuttings. When she lived in a flat in London's Little Venice, she attended a talk by Sir Tim Smit about the Lost Gardens of Heligan. 'That triggered something in me and I knew I wanted a garden. In the meantime the balcony of my flat became overloaded with plants from nearby Clifton Nursery.

'Now when I visit Sissinghurst I see the final, full expression of the experimentation that began at Long Barn. And here at Long Barn I can see where those thoughts started. You can see from the lie of the land and the way the garden grew organically, that it wasn't laid out formally. The way the land fell away meant terracing was a given. Then they put in hedges and walls that reined in Vita's exuberant plantings and her way of cramming more and more in.'

On leaving Long Barn for Sissinghurst Vita took all the statuary as well as the blue entrance gates. Today most of the statuary at Long Barn was put here by the Goughs. Rebecca is comfortable with the statuary as it feels so familiar. She would, however, like the blue gates back!

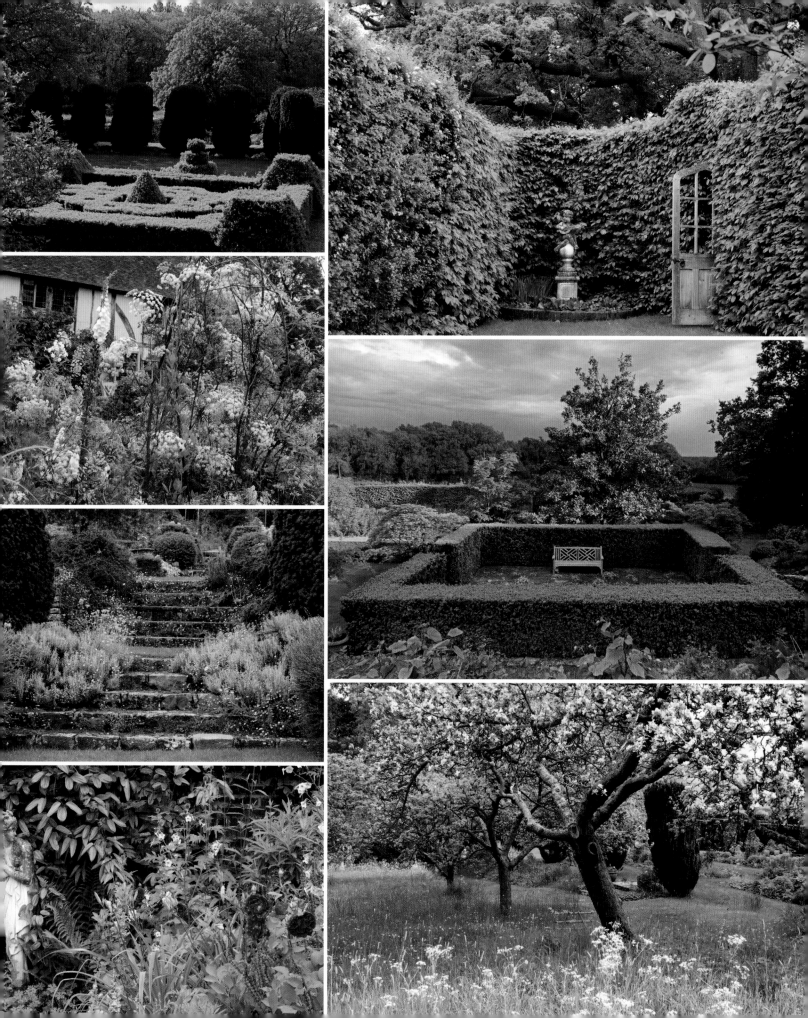

10
Malthouse Farm Garden
Hassocks, East Sussex

RICHARD AND HELEN KEYS came to Malthouse Farm at the start of this millennium transforming the 5.5 acres/2.25 hectares of field and stable yard where opera singer Dame Josephine Barstow once kept Arabian horses. It's now the setting for a series of intimate, distinctive garden rooms and large-scale field installations.

In this time, Helen has experimented with colour and form and created several enclosed areas, before turning her attention to the wider landscape. Here, below the main, intensively planted, colourful garden rooms, she has deftly transformed a former field into two installations of land art, using simple shapes and repeating plants. Helen brought the knowledge and experience of her previous garden to Malthouse Farm consolidated with a course given by garden designer Mariana Hollis. 'Although I wanted this garden to feel less contained than my former garden, I had to have adequate hedges to protect the plants from the fierce South Westerlies that blow through.'

Some gardens have an exciting borrowed landscape, which is always a bonus, and at Malthouse Farm the South Downs are the pre-eminent, borrowed view. While Helen's aim was to have protective hedges, this had to be tempered by the fact that the view itself was the fourth boundary and the majestic, ever-changing light of the calm and rolling landscape had to be visible from the house and the garden.

While they both love all aspects of the garden, Richard enjoys its proximity to the Downs and the variety, density, complexity and colours the garden offers through the year. For Helen, the enjoyment comes from the seasonal canvas it provides which she can continue to mould and embellish.

The first thing that Helen did on arrival was to cut and shape the massive hornbeam hedge running north–south from the

OPPOSITE Beyond the enclosed flower gardens Helen has created several blocks of wildflowers.
BELOW In the Lower Field where the view rolls towards the South Downs, Richard designed a series of hornbeam hedges that appear to hop in sinus rhythm across the straight line of the central grass path, that they have named the Hornbeam Sine.

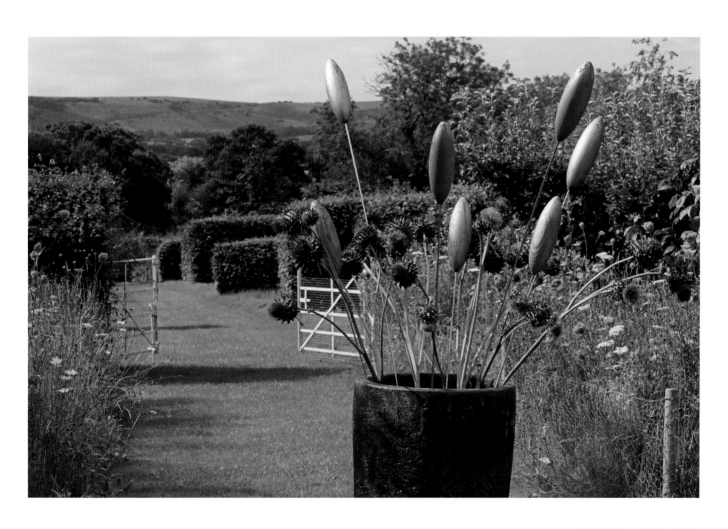

ABOVE A Lutyens bench in the Late Summer Garden keeps company with *Dahlia* 'Autumn Lustre', *Salvia* 'Amistad', *Verbena bonariensis* and *Penstemon* 'Garnett'.

RIGHT (Left to right) Richard and Helen Keyes, Leyla Tunnicliffe, Alex Bell (Head Gardener) and Nathan Carey.

OPPOSITE Four large raised beds in the Kitchen Garden provide much to harvest including salads, beans and asparagus, as well as sweet peas.

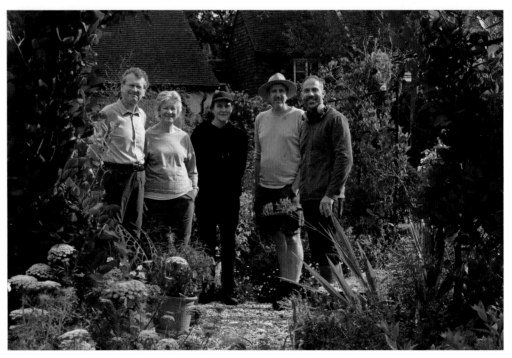

house. At this point she and Richard had not yet expanded the house by converting the stable block into a warm south-facing kitchen. The hedge, which had kept the stable yard hidden from view, lost its identity and needed to be incorporated into the whole garden. Helen reduced its height, closely shaped it and cut an arch in it so that there was a clear east–west axial view through the garden. She also gradually expanded the garden outwards from the terrace that runs east–west in front of the house. These intensively gardened areas, including a cottage garden, a late-summer flowering garden and the kitchen garden, each enclosed by protective, wind-breaking hedges or brick walls, are like coloured jewels, worn closely by the house.

The kitchen garden, a spacious but enclosed area, holds four large raised beds. Stepping from the kitchen onto a generous terrace, one is drawn straight into the productive area where Helen grows, among other things, salads, tomatoes, beans, asparagus and flowers, such as sweet peas, for cutting.

On the east–west axis backing on to the boundary brick wall is an arbour-bench painted blue-grey which lines up with the Lutyens bench at the opposite side of the axial path. Just under the arch in the hornbeam hedge is a formal pool featuring a glass bowl, one of many pieces created by Helen's brother, David Jackson, whose studio Red Hot Glass is in South Africa.

Seasonal colour

Equalling the vegetable garden in terms of shape and size is the cottage garden with borders arranged at the edges framing the lawn. Here there is colour in every season, reaching its height in summer when grasses, asters, dahlias and penstemons offer mounds of colour.

Helen uses box spirals and rounds, as well as ceramics and ironwork, to provide changes of height, to punctuate and support some of the blowsy planting and climbers. Among the artworks that draw your eye are several pieces by British ceramicist Carolyn Genders.

In the late summer garden, backed by a pleached hornbeam hedge and characterized by sweeping, relaxed, emphatically curved borders, the colour dial is turned up and Helen's palette of rich and vibrant flowers is matched by a vivid red metal bench that invites a sit-down.

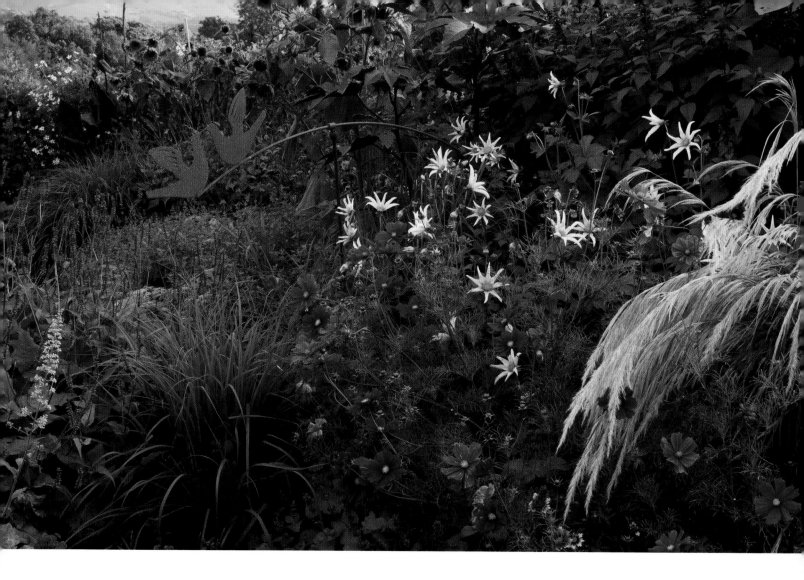

Dense planting and a summer-house (formerly a jacuzzi) separate and mask the tennis court, built on the sand school used by Dame Josephine for her horses. Below the tennis court and the late-summer garden the style and atmosphere changes as, once beyond the field gates, wild flowers in rectangular blocks contrast with the shapes of orchard trees.

Beyond the wild flowers and orchard Helen has created several large-scale plant installations using Richard's mathematical prowess and the assistance of long-term gardener Alex Bell. These installations deploy a narrow plant palette alongside varying the heights of the grass-mowing regimes.

ABOVE Helen continues her experiments with colour and form in different parts of the garden. She has created a number of beds, such as this one with massed sunflowers, *Dahlia* 'Honka Fragile', *Cosmos bipinnatus* 'Rubenza', the grass *Stipa pseudoichu* and a stately castor oil plant, under the wings of a rusted bird ornament that moves in the wind.
OPPOSITE TOP The Birch Maze in the lower part of the field.
OPPOSITE BOTTOM Helen used the rotten boards to create what she and Richard call Streat Henge.

A straight line of annually cut willows divides the two geometrical installations. The willow hedge holds three varieties with different stem colours. 'We cut it to the ground in late winter then use the stems to make edging in the garden and for sculptures. It reaches 8.2 feet/2.5 metres tall in a year and makes a fiery dividing line in autumn.'

Helen and Richard began planning and planting the Hornbeam Sine in 2003. Curved sections of closely planted and regularly clipped hornbeam follow a mathematical pattern giving the impression of leaping across a tightly mown path.

In the 'arms' of the hornbeam and opposite, Helen has planted clipped yew cones and specimen plantings of *Sorbus aria* 'Majestic'. In contrast to the mown path, the grass on either side of the hornbeams is allowed to grow long. In spring, massed small-flowered daffodils provide a seasonal colour break. 'The Sine draws its inspiration from a mathematical "sine" wave. We made it to draw us to the lower part of the garden towards the Downs,' says Helen. At the end of the Sine, a rusted metal arbour, smothered by the rose 'Rambling Rector' and underplanted with day lilies and grasses, entices you to look back to the house.

A grass grid

On the west side of the willow hedge line Helen has established a mostly monochrome geometrical grid. Using altered heights of cut, the grid of twelve roughly rectangular grass shapes stand out from the paths between and alongside them. In one of the grass shapes Helen has planted a birch maze; another section, where most of the woody garden rubbish is burned, has become an unofficial fire pit area.

Other themed areas include a raised maze on a mound, made of old car tyres, turf and top soil; Streat Henge, a towering installation of rotten wooden boards, once used to make the raised beds in the vegetable garden; and a living woven willow walkway much loved by children.

Thousands of daffodils, which multiply and die back as the grass lengthens, are planted into many of the long grass rectangles, in particular the Birch Maze and the Streat Henge.

'We let the grass flower then cut it, but we keep it longer in the grid sections than the interlinking mown paths. We love the way the taller grass sways and contrasts with the mown paths in between. In winter there is the additional ornament of a frosted grid. My visit to Le Jardin Plume, near Rouen in France, was the inspiration for these long grass sections, which they referred to as parterres.'

Similar frosted ornament is offered by the box spirals and hedging throughout the garden, especially in the front garden which was an early collaboration with Alex Bell. These tightly packed parterres of box, pittosporum and other clipped and shaped plants become table-like surfaces and are accompanied by blue, cream, pink and white flowers on obelisks or lining the brick or gravel paths, with stately terracotta urns and examples of Helen's brother's blown glass work, as focal features.

Without compromising the drama of the borrowed South Downs landscape, Helen has protectively enclosed the varied intricate, intimate and effervescent plant collections that surround and sweep away from the farmhouse, as if cantering, like the horses the land once supported, to the field edges.

ABOVE In the formal front garden topiary balls, cubes and hedges are softened by roses such as 'Penelope'. The striking blue blown glass was made by Helen's brother, David Jackson.

OPPOSITE Helen uses organic stone-like oval sculptures by Caroline Genders, David Jackson's shimmering glass works, metal birds and *The Double Pancake Bench*, and groupings of plants in pots, to add further ornament to the garden.

11
Marchants Garden and Nursery
Lewes, East Sussex

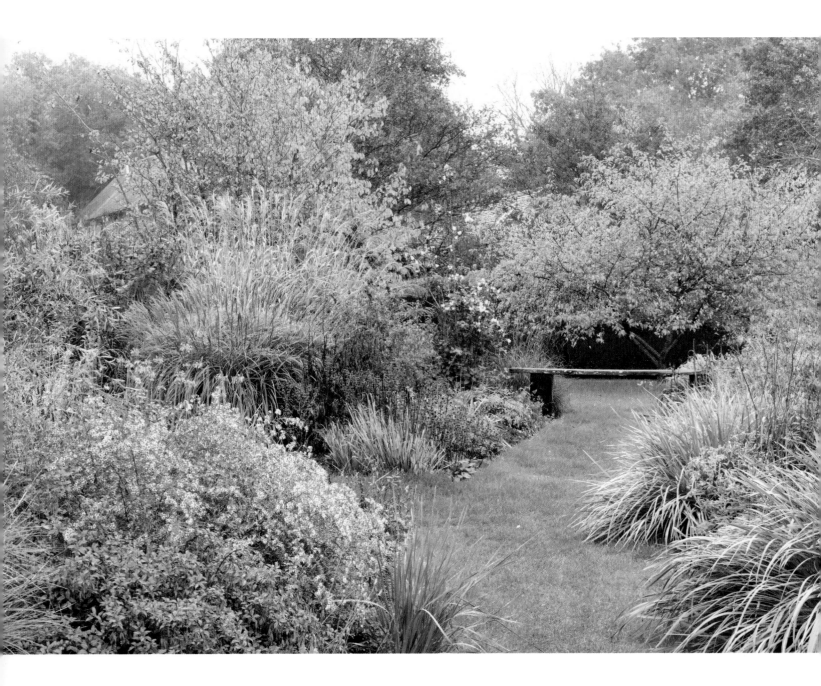

MANY PEOPLE turn to horticulture at critical points in their lives and nurseryman Graham Gough's decision to switch from a blossoming singing career was one such for him. He still sings as he works, but more importantly, the rhythm and cadences of his musicality are visually apparent in the garden he has made with his equally creative wife, textile artist Lucy Goffin.

Graham knew that he wanted to work outdoors when he left the Guildhall School of Music in London. He returned to his parents' home in Sussex where, like a Royal Botanic Gardens Kew Diploma student, he tended a vegetable patch, gaining confidence that he could 'make things grow'. 'Horticulture grounded me and set me on the path I have followed ever since,' he explains.

His mother sat him down one day and said he should learn the names of at least eight plants. So he did. He learned the names of flowers such as zinnia, salvia and galtonia from her Suttons seed catalogue, then answered an advertisement requesting help in a local garden and managed to dazzle with his newly acquired, albeit limited, plant knowledge.

'Someone I worked for suggested I visit Sissinghurst garden in Kent, which at that time was gardened by two legendary women, Pamela Schwerdt and Sibylle Kreutzberger. I went frequently and learned so much there. Through them I met another renowned plantswoman, Elizabeth Strangman of Washfield Nursery, where I literally had my horticultural education: I was there for 16 years, first as a volunteer, later as an employee, and then as a business partner.'

Graham acknowledges his good fortune to have had these opportunities, realizing that working at such places and with such gurus gave him the space he needed, as well as exceptional on-the-job expertise.

OPPOSITE Trees such as *Parrotia persica* and *Malus transitoria* add height and seasonal colour to the fireworks of the borders.
BELOW Grasses, including *Deschampsia cespitosa* (left) and *Stipa gigantea*, combine well with perennials such as *Lythrum virgatum* and *Fuchsia magellanica thomsonii*.

A wild field

In 1998 he decided to set up his own nursery, and with the help of Lucy, started Marchants Hardy Plants on the blank canvas of an exposed 2 acres/0.8 hectares of clay soil sloping gently on the Sussex Downs.

'There was nothing here – just a wild field – and friends joined us for a big bonfire soon after we bought the property. I think they thought we were mad for taking this on, and many said later that they had doubts that we would make it work.'

Graham's masterplan was drawn in his head and comprised three main pathways. These formed the backbone and would anchor the nursery and the garden into position in the landscape.

'They were like my own personal ley-lines. I have walked these paths many times and feel comfortable that the layout has worked well. I always saw the garden and the nursery as an extension each of the other, never as two entities.'

Priorities meant that he started getting the ground ready for a vegetable garden while Lucy went off to India on her annual textile working-safari.

Today, the borders and hedges in the nursery blend and merge with those lower down in the garden. Soft shapes all appear to flow seamlessly from the nursery, matching the organic shapes of the borders in the garden itself. Graham achieved his aim of showing gardeners just what the plants he was selling in pots would look like in a garden situation.

The garden sweeps down from the below the nursery in a rough curve, that echoes the rolling landscape of the nearby Sussex Downs – curves and circles are at the heart of the garden. Hedges are cut into soft rounded shapes enclosing and hugging the plants. Linking and contrasting grassy wild meadows also create a gentle, verdant look.

Swaying grass

Early on, Graham dug out a pond. He remembers Christopher Lloyd of Great Dixter (see page 7) warning him that it would bring all sorts of problems associated with ponds… and it has. Graham acknowledges the havoc caused by a vigorous giant rush which he has been trying to remove with a digger.

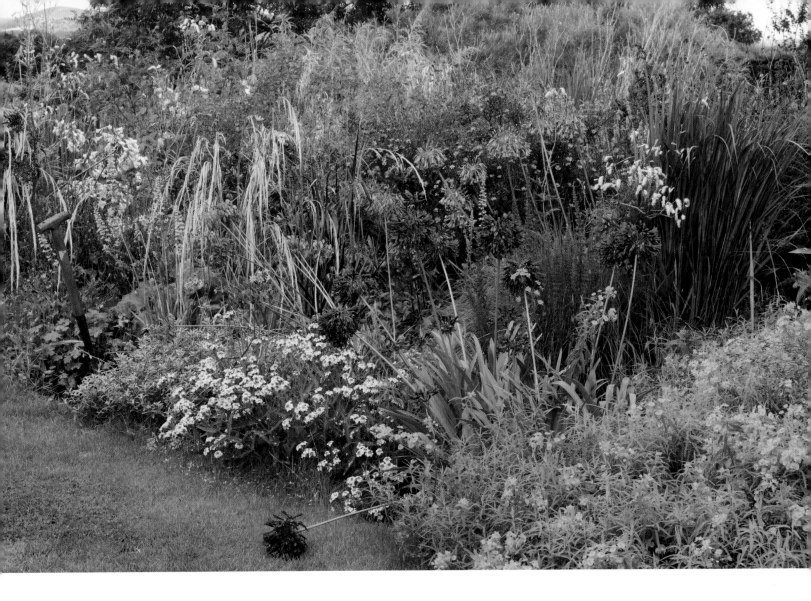

Graham set out the beds using his mower to transfer the shapes he had in his mind onto the ground. Excavated soil from the pond was mounded to create two juxtaposed borders which hold a collection of grasses and bold herbaceous plants. It is almost as if the mounded beds and the swaying stands of grasses are constantly in motion, like waves breaking on the shore.

At first, to lessen the effect of the wind and for plant shelter, Graham put up fences made from wooden battens of varying lengths – an idea borrowed from Hebridean farmers but adapted with a tapering curved top edge to echo shapes in

OPPOSITE Grasses, growing in combination with perennials, are the backbone of many of the borders offering vital seasonal shape and texture.
ABOVE Graham has planted agapanthus, including *Agapanthus* 'Blue Fox', *A.* 'Marchant's Melancholy Mauve' and *A.* 'Windsor Grey', throughout the garden. In summer their tall stems of white or blue flowers rise above lower-growing plants such as *Verbena rigida* 'Polaris' and *Euphorbia* 'Betton'. The drooping grass *Stipa pseudoichu* offers a quirky counterpoint.

'Friends thought we were mad for taking this on, they had doubts we could make it work.'

the landscape. Now that the hedges and clipped beech pillars have grown and matured, some of the batten fences have been taken down.

Lucy's textile and textural skills have been harnessed to make the woven willow hedge (propagated from *Salix purpurea* 'Nancy Saunders') which edges the back of the pond.

'Reliability is key when you have a nursery so I only propagate what I know is thoroughly garden-worthy and a good "doer". People appreciate honesty in this situation. I won't let someone try a plant if I don't think it will survive in their conditions.'

There are about 1,500 to 1,800 plants in the garden – far too many to attempt to propagate and sell – so when he is setting out his annual catalogue, Graham aims to provide a balanced plant

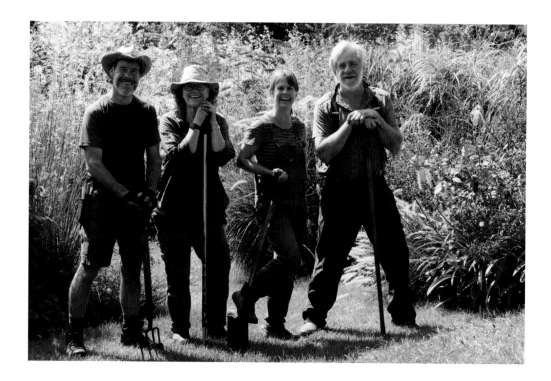

list. 'Maintaining plants in good health is an art and I am always trying to focus on that in the garden as well as in the nursery.'

Marchants' plant catalogue is a wonder of words (with no images) opening up Graham's personal plant world, painting descriptions of the plants he knows and grows so skilfully.

When Graham started the nursery, grasses were in hot demand but it was rare to see them grown well and in combination with perennials in the garden. At Marchants they are among the backbone, statement plants in each of the closely planted, self-supporting borders. Over the years, Graham has selected the perfect perennials to partner them, and the best ways to use them.

Snowdrop collection

In early spring, the nursery opens only for an annual two-day snowdrop sale when enthusiasts can see Marchants' snowdrop collection of up to fifty varieties. At that time, the spring garden offers displays of hellebores, wood anemones, ferns and snowflakes, as well as snowdrops. In late spring the garden show starts in earnest, with fruit and ornamental trees blooming and the borders beginning to swell with the rise of herbaceous plants and grasses. Bulbs such as camassia, which are grown in the meadows also offer a seasonal display.

Late summer into autumn is when the garden catches fire with glowing late-blooming flowers, coloured stems, and stunning foliage colour from trees such as the Caucasian ash (*Fraxinus oxycarpa*) and pin oak (*Quercus palustris*). Graham has planted agapanthus throughout the garden and their tall stems of white or blue flowers stand firm at this time in the tide of flowing grasses. So many of the border plants offer an extra dimension in this late season when their flowers, foliage and stems are back-lit by the light of the westerly setting sun.

Shape and texture are key to Graham's plant choices, with flower colour adding an extra element. Plants such as ornamental ginger (*Hedychium*), eupatorium and grasses including golden oats (*Stipa gigantea*), are among the foundation plants in the curvaceous borders that roll comfortably down towards the pond. Softer colours come from persicarias (including Graham's own selection, *Persicaria amplexicaulis* 'Marchant's Red Devil'), loosestrife (*Lythrum virgatum*) and floating flowers of white gaura (*Oenothera lindheimeri*).

Throughout the pandemic Graham and Lucy were able to build a strong team including nurserywoman and propagator Hannah Fox. They are now looking forward to spending more time gathering the threads of their exceptional plant tapestry in the garden, laying it down like one of the embroidered robes that Lucy creates in textiles.

From learning a handful of plants by rote, Graham is now one of those renowned horticulturists who he admired and learned so much from. Whether you are a garden visitor, a customer or a budding horticulturist, his hands-on knowledge and plant stories will stimulate and enliven your visit.

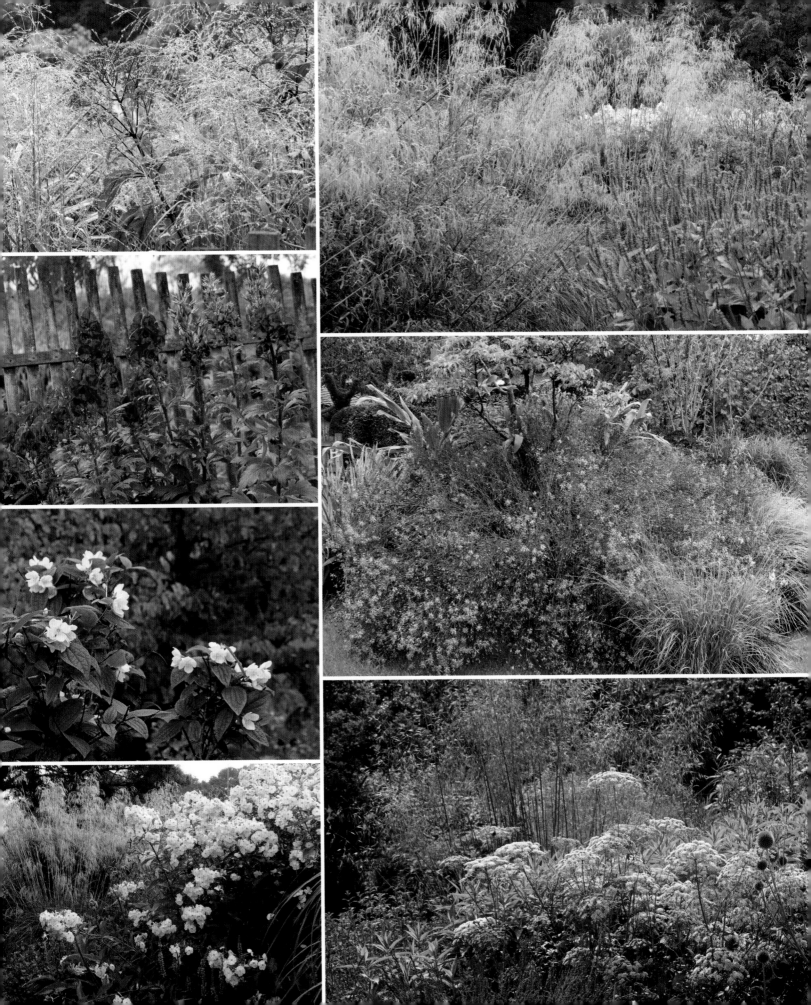

12
Moleshill House
Cobham, Surrey

THE GARDEN AT MOLESHILL HOUSE intrigues and beguiles you as soon as you step through the gates, following the gravel driveway that leads to the garden's heart. Its owner, Penny Snell VM CBE, knows just what a garden needs to grab and hold your attention, since for more than 42 years she has been the London organizer for the National Garden Scheme's (NGS) Garden Visitor's Handbook, affectionately known as the Yellow book. When she took London under her wing there were just 32 gardens listed and by 2021 that number had grown to 300. Penny's involvement with the NGS runs deep: from 2008–14 she was Chair of the charity and is now one of its Vice Presidents.

Penny always explains to potential NGS openers that their gardens should have 'a design, good horticultural features and be well-maintained'. And her own garden proves her ability to make enticing plant and landscaping features that will lead your eyes and feet along its many paths and tree-lined walks.

Penny moved to Moleshill House in the year of the great storm, 1987. It was then a very green garden, with 'an unappealing lawn and masses of large trees'. That seven were felled in the hurricane a few months later was a relief to Penny, their absence bringing light to the garden. A land exchange with a neighbour, soon after she began the garden, resulted in a strip of land and a new boundary, plus the building of a high brick wall giving Penny privacy from neighbours and the busy road.

To one side of the new land Penny planted 40 whitebeams (*Sorbus aria* 'Lutescens') to make a double walkway. While she still loves their bark and foliage she now knows how difficult they are to train and maintain as a pleached feature, as the whitebeams' natural impetus is upward, not along, and they need frequent shaping. The whitebeam walk is underplanted with spring bulbs such as snowdrops, wild daffodils (*Narcissus pseudonarcissus*), an orange tulip (*Tulipa whittallii*) and camassia, with cranesbill (*Geranium nodosum*) winding its tenacious way through in summer.

Constance Spry Flower School

Penny's connection with flowers and plants goes back to her childhood. The family lived in Sevenoaks, Kent, in a house so close to Knole Park (birthplace of Vita Sackville-West, 1892–1962) that it had a gate into the parkland, through which Penny regularly disappeared. She had early successes with sweet peas, much to her father's chagrin, as he had no luck in growing them.

When she left school she enrolled at the Constance Spry Flower School in London's Marylebone High Street. 'We learned everything to do with setting up a flower business, growing flowers, arranging them and running a business,' she says.

She followed this with a secretarial course, leading to a post with the Hennessy family (producers of the famous cognac). During that time she freelanced as a florist providing flowers for weddings, museums and art galleries. She worked for the

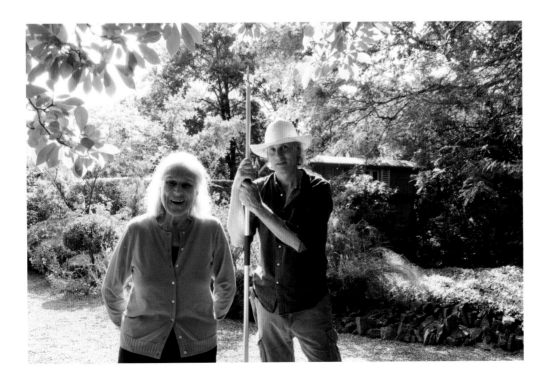

OPPOSITE A pleached hornbeam circle encloses the gravel garden at the centre of the main lawn. The base of the hornbeams is softened by a rim of gently flowing foliage of the ornamental grass *Hakonechloa macra*.
LEFT Penny Snell and Marc O'Neill.

'NGS gardens should have a design, good horticultural features and be well-maintained.'

Victoria and Albert Museum for twenty years dressing the main entrance with huge flower displays every week.

In her 0.5-acre/0.2 hectare Surrey garden there are several set pieces that showcase Penny's painterly skill. Penny uses rows of box plants in terracotta pots at the base of house walls to soften the meeting of brick and gravel, bringing the garden closer to the house and offering a counterpoint to the exuberant plantings in the lawn's borders. Elsewhere, great wreaths of ivy, resembling Grinling Gibbons' carved wooden flower-swags, swoop across the face of faux-lead boxes and urns and at every turn there are spirals and cones of box in pots.

Although Penny likes the formality of box topiary, pleached trees and clipped hedges she also likes plants to 'be themselves' and fill the borders in a flowing and expansive way. Box hedges may enclose some borders but the relaxed habits of the plants within, such as *Persicaria microcephala* 'Red Dragon', give her much pleasure. 'I don't like plants to be stiff and standing to attention,' she explains. Deep borders rim the base of the high walls, all with different plant characteristics. The many mature trees (still too many trees in Penny's opinion) support rambler and climbing roses of great size.

Self-seeders

From the gates a wide gravel drive takes you past several features that either invite you to step in, such as the Ivy Circle – a rockery transformed into a homage to land artist Richard Long – or to mark your card to return and investigate. Among them are a recently created stumpery, with ferns and shade-loving plants nestling in the crevices of large tree stumps; a vegetable and cutting garden; the chicken house; and a courtyard with a newly created green wall.

As you go deeper into the garden you find a series of carefully designed vignettes. One is the gravel garden around a colourful gypsy caravan, filled with self-seeders including evening primrose, calendula, white valerian, foxgloves and *Verbena bonariensis*. The caravan has heating and light and, says Penny 'we have all slept in it at different times, children and adults!'

The house, built in the 1880s for the Asprey family, is at the end of the gravel drive facing the lawn. Penny's first plan was to dig out curved, deep borders at the far edges of the lawn. Here she followed the advice of a friend and London NGS garden-owner, garden designer Anthony Noel, to plant box that would eventually be topiarized into domes to emphasize the circularity of the borders. This she did, planting very young box which are now huge. They have outgrown their positions and some hard decisions may have to be made about keeping them.

Pleached hornbeam

In 2014, with the help of her gardener Andrew Gaynor, Penny was able to put one of her many design schemes into action and change the garden completely. 'This is a flat, linear garden with no alteration in level and the main lawn was a large, curved mass of green. So to give it some movement and interest I thought a circle of pleached hornbeam would raise the eye level and give it some central horticultural interest,' she explains.

Andrew plotted this all on a computer and then planted a perfect circle of hornbeams (*Carpinus betulus*) that are now pleached and underplanted with a softly mounding circle of *Hakonechloa macra*. The lawn area within the hornbeam circle was a continuing disappointment, often dry, brown and lifeless in summer – and out it went. It was replaced with gravel, and now ornamental grasses, *Verbena bonariensis* and other drought-loving perennials self-seed and thrive there. Circles and curves are a recurring theme and include a dome-shaped gazebo supporting *Rosa* 'City of York'.

Close by, in a hidden corner beyond the south-facing conservatory, are many of the features you expect to find in an NGS garden, including an L-shape of espaliered crab apple trees and a magnificent archway of *Muehlenbeckia,* a plant more often seen trailing. Throughout the garden, objects and statuary, including a metal bedstead, rusted metal arum lilies, a deer and a heron, as well as a willow-work Green Man hung on a wall, draw you in to look more closely.

Penny spends all her time in the garden and although there are many seats, loungers and benches tucked away, she doesn't sit down often, or if she does, it is not for long… something always needs to be done. One of the saving graces of her sandy and free-draining soil is that in 2008 she invested in sinking a borehole. 'The joy is that however much water I use, it runs straight through my sand back to the water table.'

In 2021 Penny was delighted to welcome gardener and planting designer Marc O'Neill to take the garden forward with her. Despite claiming to be all 'projected out' Penny is sure to have new ideas, maybe her daughter's suggestion that she clear some concrete in front of the elegant garden room and with stylish but comfortable garden furniture transform it into a place where she might just sit in the evening sunshine…!

OPPOSITE Penny has created a series of garden vignettes, including a stumpery and a caravan garden.

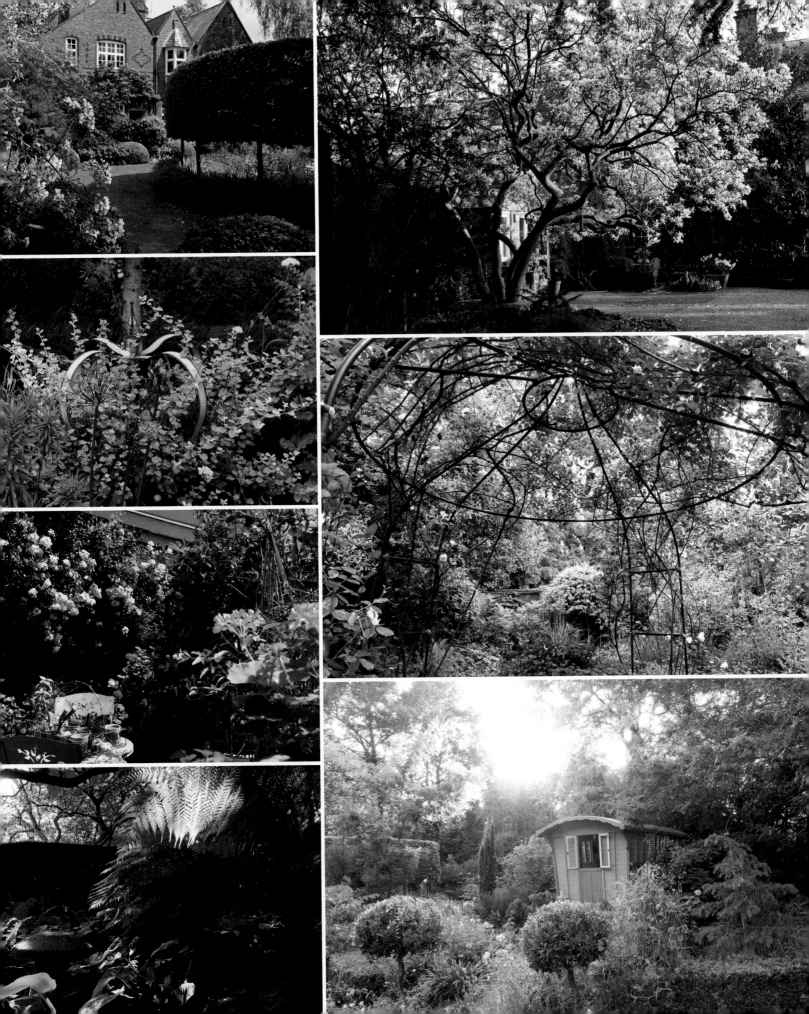

Munstead Wood and the Quadrangle
Godalming, Surrey

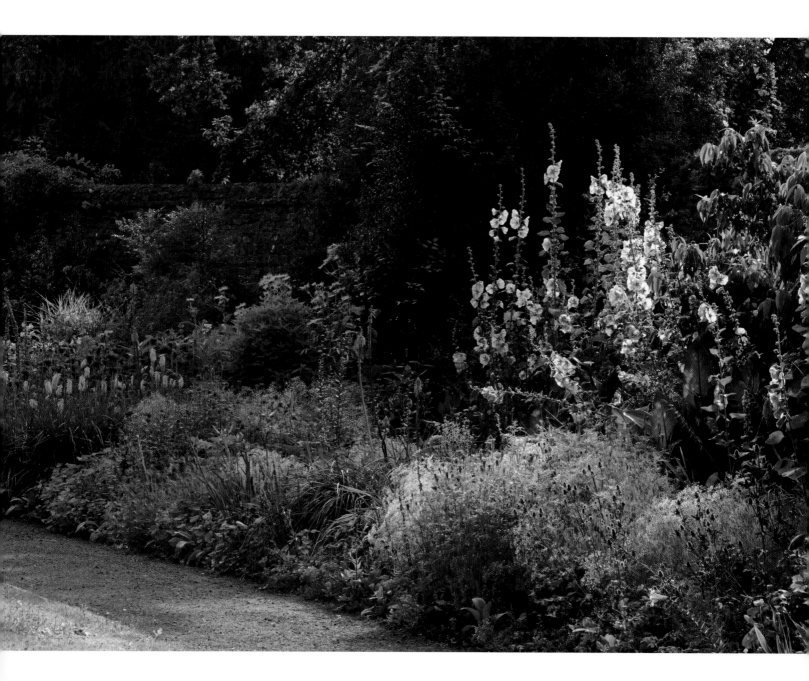

GARDENS ARE FRAGILE at the best of times, especially when ownership changes. When the garden of one of the most iconic gardeners of the twentieth century is passed down to relatives, the fragility can be even more acute.

So it was with Munstead Wood in Surrey, home and garden of Gertrude Jekyll (1843–1932). In 1949 her nephew Francis divided it into five parcels and sold off four. He lived out his life on the proceeds in one of the buildings on the property, The Hut. It is fortunate that the adjacent parcels of Munstead Wood and the Quadrangle separated by that sale are once again 'connected' albeit loosely.

The purchasers of Munstead Wood (the parcel consisting of Miss Jekyll's house and 10 acres/4 hectares of the garden) weren't interested in what they considered an old-fashioned, high maintenance site. To achieve the amenities of the family garden they wished for they tarmacked the paths, grassed over the borders, felled many of the trees and made a paddock for a pony and built a swimming pool.

Research and restoration

Munstead Wood was reprieved in 1968 when the late Sir Robert Clark and Lady Clark bought the property. A second reprieve followed the storm of 1987 when 200 trees came down: the Clarks' then head gardener, Stephen King, suggested it would be a good time to pay proper attention to its past and restore the garden. With Sir Robert's support, Stephen spent the next seven years clearing, researching and replanting the garden.

Research was informed by the 1,000 articles and several books which featured Jekyll's own plans and photographs. Stephen uncovered the outlines and edges of the borders and reconstructed their original positions, creating planting which is now mature.

LEFT Annabel maintains the 200-foot-/61-metre-long Main Flower Border using Miss Jekyll's complicated drawing as her guide.
BELOW Roses, peonies and foxgloves bloom in the Three Corner Garden below the North Court of the house.

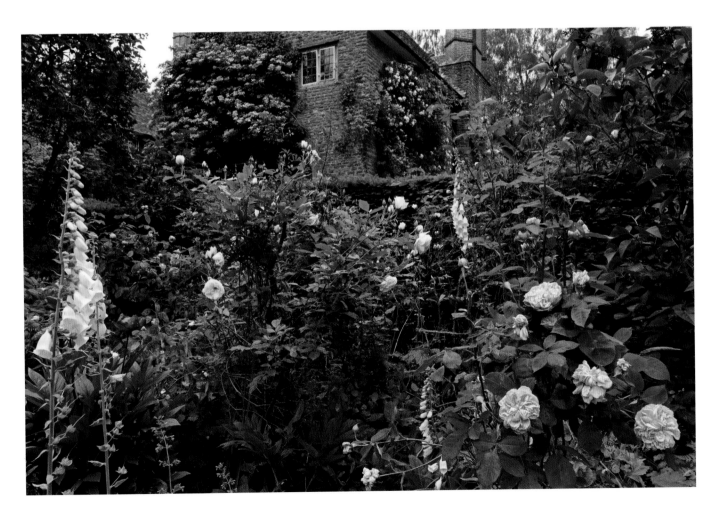

When Stephen moved on, Andrew Robinson became the new head gardener in the late 1990s. In 2002, Annabel Watts, tired of working as a personal assistant in London, answered an advert for a 'part-time gardener, no experience necessary'. For the next 11 years she worked as Andrew's assistant, a period that she considers her apprenticeship. 'I got to know the annual cycle of the woodland and garden, and I learned, understood and absorbed Jekyll's planting theories.'

When Andrew retired in 2013, Annabel became head gardener, maintaining the restored garden with part-time help. She has also become a specialist and expert curator of Munstead Wood's history: and Jekyll's theories, her life and her attributes, are relayed by Annabel to groups of visitors who come to see where this multi-talented businesswoman lived and worked.

Planting theories

Jekyll began creating her garden at Munstead Wood in the early 1880s and in 1895 work began on the Arts and Crafts house, designed by architect Edwin Lutyens (1869–1944). The house was built to fulfil a comprehensive list of specifications from Jekyll, and she moved in in 1897.

Munstead Wood was the first of many house and garden collaborations between Jekyll and Lutyens. Here she experimented and perfected her planting theories and grew the plants for clients, as well as cut flowers for their parties. Lutyens had provided everything she requested: there was a dark room to develop photographs; a nursery and greenhouses; a workshop for inlay work, woodcarving and repoussé; and a flower shop for flower arranging which also sold bunches of cut daffodils.

The many seasonal elements of Jekyll's garden at Munstead Wood have been restored, including the woodland garden's river of daffodils which sweeps through the birch woodland.

ABOVE Miss Jekyll's view from her bedroom windows was of the birch woodland where she planted a river of daffodils.
OPPOSITE The Tank Courtyard just below the North Court of the house, with shapely box mounds and a climbing hydrangea, is much the same as it was when Miss Jekyll created these formal garden areas.

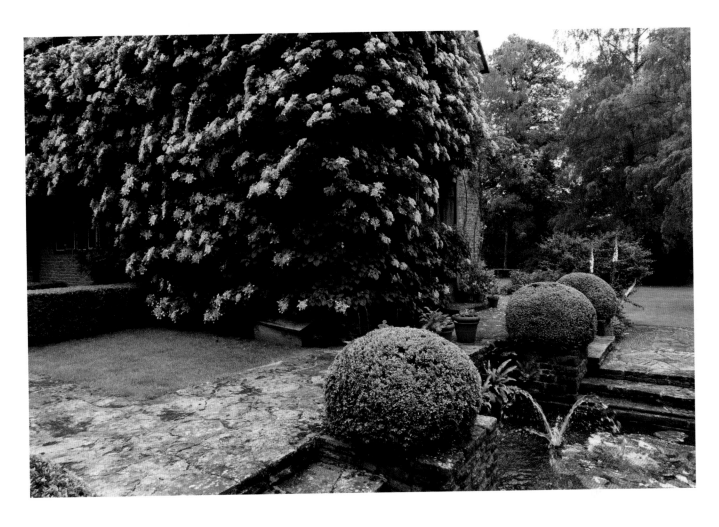

'Munstead Wood was the first of many house and garden collaborations between Jekyll and Lutyens.'

From her bedroom on the south elevation of the house Jekyll looked out on to the ornamental woodland. Here she made five substantial plantings of rhododendron, winter-flowering heather, azaleas and daphne, that continue to light up the woodland in spring. She was influenced by her friend William Robinson, author of *The Wild Garden* and owner of Gravetye Manor (see pages 56–61).

Near the house, Jekyll's plantings were often formal and usually combined with hard-landscaping in the shape of walls, steps, paving or pebble and stone. Two narrow borders near the house showcase plants that she would have seen on her travels in Italy, Algeria and Greece. She noted that silver foliage plants and succulents grew well in hot, dry and infertile soils,

not dissimilar to the sandy soil at Munstead. Spiky eryngiums and yuccas combined with the silver foliage of stachys and santolina were to become some of her hallmark plantings.

Throughout the garden, especially in shady woodland plantings, self-seeding white foxgloves provide shafts of light. Jekyll intentionally removed any foxgloves that had purple/mauve flowers, a practice continued by Annabel today.

The North Court is much the same today as it would have been when Jekyll created a semi-enclosed courtyard garden. She trained clematis along a rope or wire below the Arts and Crafts façade of the gallery to resemble a swag or garland.

Expansive plantings

Annabel leads visitors through the garden explaining how features such as the Nut Walk, underplanted with hellebores, and the Primrose Garden, where Jekyll grew 'Munstead Bunch' primroses, begin the spring cycle of colour and ornament.

Further away from the house the plantings became more expansive and held examples of her seasonal experiments

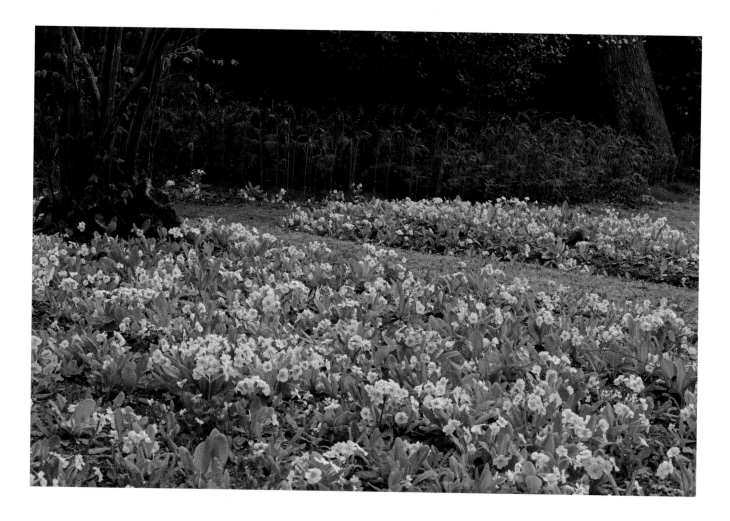

with height, density and colour. Annabel maintains the Main Flower border – all 200 feet/61 metres of it – blooming in a succession of colour waves from midsummer to mid-autumn – using Jekyll's own complicated drawing as her guide. The Michaelmas Daisy border comes to a crescendo of bloom in early autumn.

Particularly poignant is the tomb-like elm seat below a single mature birch that Charles Liddell, a friend of Jekyll and Lutyens, called the Cenotaph of Sigismunda. He said its solemnity and peace reminded him of a legend, which featured an empty tomb. Lutyens remembered that first encounter with

the term cenotaph, when in 1919, he was asked to design a memorial in Whitehall to those who had fallen in the First World War.

Annabel curates the garden at Munstead Wood following Jekyll's concepts to the letter, where possible, given the constraints of time, budget and plant choices.

The Quadrangle

However, another gardening hand is at work just beyond the garden gate where neighbour Gail Naughton gardens in the spirit of Jekyll on one of the other relinquished parcels, the Quadrangle.

'I was given Jekyll's *Home and Garden* by my mother many years ago but never thought I would have the chance to recreate part of the garden at Jekyll's former home. Restoration of a garden is impossible – to what month, to what year? So I have developed a garden at the Quadrangle as I think Jekyll would have done, using her writing and photographs to create a garden in her style, based on the plants she knew would flourish here.'

ABOVE The Primrose Garden was renowned for the 'Munstead Bunch' primroses, which were much in demand as cut flowers and also available as seed from seed merchants, Carters.
OPPOSITE Vibrant colours from tulips and a sculpture grafted onto a tree in the Quadrangle, roses and climbing hydrangea on Munstead's walls, hazel twigs, hellebores and primroses in the Nut Walk, and glimpses into the greenhouse, are among the features at the two gardens.

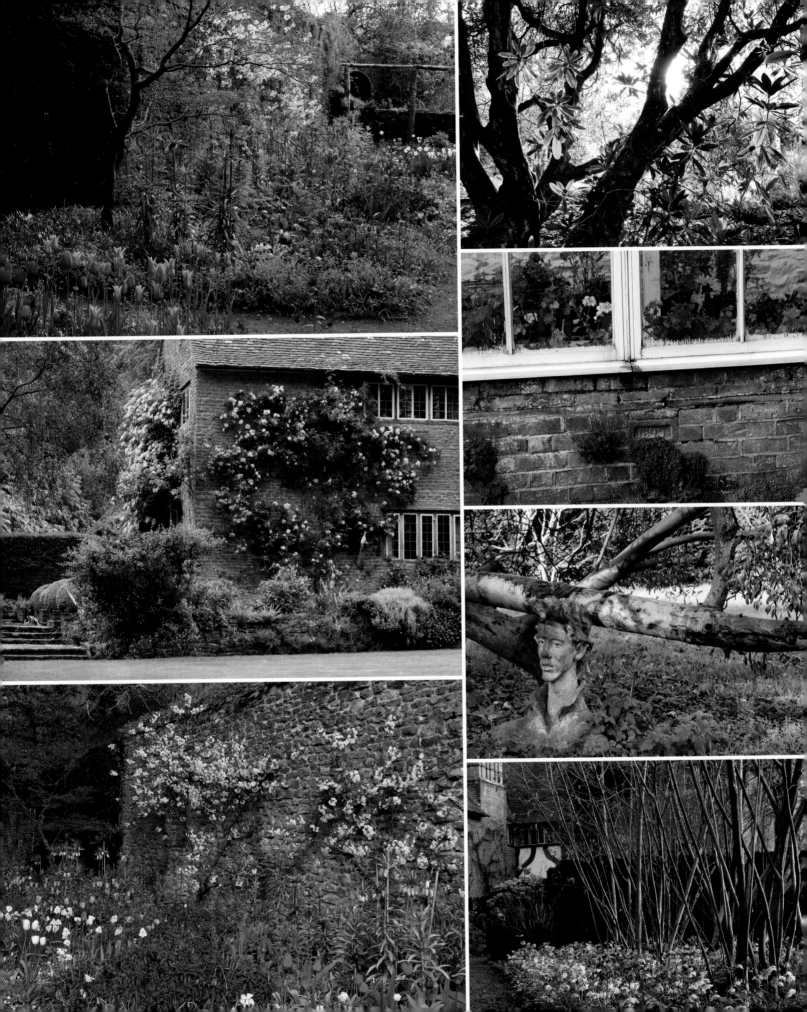

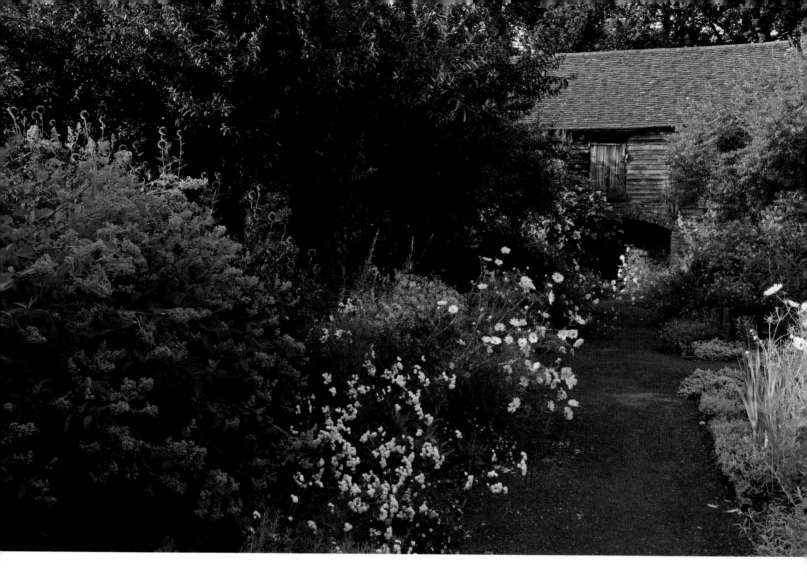

ABOVE AND OPPOSITE The buildings of the Quadrangle were the former stable block and workplace where seeds and bulbs were stored. Gail Naughton gardens there in the spirit of Jekyll, creating garden vignettes using a muted silver-grey to blue colour palette, with cosmos and nigella (self-seeding) and white and pink 'Alba' roses against the walls.
RIGHT Gail Naughton, owner of the Quadrangle, and Annabel Watts, Head Gardener, of Munstead Wood.

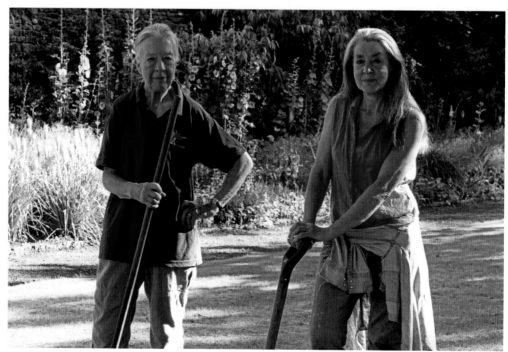

The Quadrangle comprises the former working buildings – the stable block and workplace – where seeds and bulbs were sorted and stored. The lead hopper of the downpipe is marked 'GJ 1891', indicating that these buildings were among the first that Lutyens designed on the site. Jekyll would have worked here while still living across the lane with her mother at Munstead House.

The garden area that was parcelled up with the Quadrangle is about 1 acre/0.4 hectares. It was originally used as a nursery for the plants Jekyll grew for her own use and to sell to clients. Jekyll described the narrow strips as a 'June garden', a 'border for July' and a 'little garden for August'. Gail follows the theory that Jekyll used this area for experimental gardens of summer-flowering plants.

Summer gardens

In the 'June garden' bearded and sibirica irises, tree lupins, catmint and *Peltaria alliacea*, a wild garlic with attractive yarrow-like flowers, tone down the red-hot oriental poppies. In the 'border for July' sea lavender and one of Jekyll's favourites, francoa, provide dainty blooms on tall, wiry stems. Mounds of origanum mark the crossing paths of this garden.

The 'little garden for August' is enclosed by box hedges, which Gail is certain date from Jekyll's time. Strips of lavender edge the borders where Gail keeps to a muted colour palette using grey, pink, white and blue, including the soft grey-leaved stachys and *Artemisia stelleriana*, with white and blue nigella self-seeding gently through the plantings. She also uses white and pink Alba roses, white valerian and white rosemary.

In the area that was once the nursery Gail has planted fruit trees, including apples, a quince and medlar. There are five fig trees, four of which are likely to be Jekyll plantings, and one Gail grew from a cutting to replace an original in the 'little garden for August'. Jekyll was known to be generous about most things, but not figs!

As long as Munstead Wood and the Quadrangle are worked by Annabel Watts and Gail Naughton, garden visitors (by appointment only) are assured of insights into the history of the site and its famous first occupant, as well as ways to garden in an historic setting.

14
Ramster Hall
Chiddingfold, Surrey

LONGEVITY OF OWNERSHIP is a great benefit to a garden or landscape such as that at Ramster, its 20 acres/8 hectares of oak woodland in the Surrey Hills laid out in the early 1900s by Edwardian businessman Sir Harry Waechter.

Waechter created a woodland garden that showcased plants from the neighbouring nursery and landscapers – Gauntletts of Chiddingfold. Gauntletts had tapped into the popularity of all things Japanese becoming the go-to nursery for gardens with Japanese features. It specialized in woody plants imported from nurseries in Yokohama such as *Acer palmatum* 'Dissectum' and offered accessories including stone lamps, red bridges and Tori arches, as well as statuary.

Among the plants that Gauntletts sold to Sir Harry are the many acers that form one of the spectacular autumnal features at Ramster. Now over 120 years old, they are planted as a double avenue that offers sensational colour and form in all seasons, but particularly when their fiery autumn foliage develops. That these and other 'heritage' plants still survive at Ramster is due to a century of ownership by several generations of one family with an impeccable horticultural connection.

Sir Henry and Lady Norman bought the property from Sir Harry Waechter in 1922. Fay, Lady Norman, was the granddaughter of Henry Pochin, who, in 1875, started the famous garden at Bodnant, in Wales. It was her mother, Laura Aberconway, and then her brother Harry, the 2nd Lord Aberconway, who created and continued the development of that outstanding garden.

Ramster's woodland garden was further developed by Lady Norman, who began its extraordinary collection of rhododendrons. Many of them were grown from seed brought back from China by collectors such as George Forrest and Ernest Wilson.

OPPOSITE The Dell is ablaze with colour in spring, as azaleas and rhododendrons burst into bloom, backed by the foliage of maples.
BELOW In autumn the colour baton is handed on to the shapely trees in the Acer Avenue, now over 120 years old.

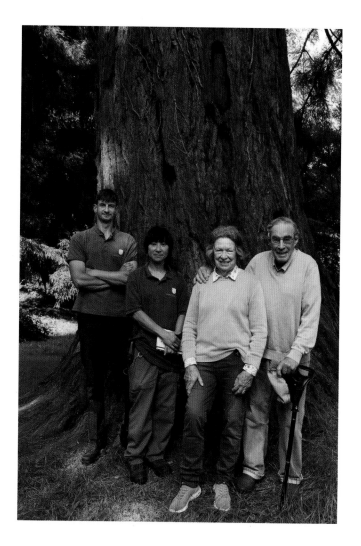

a coastal redwood (*Sequoia sempervirens*), a wellingtonia (*Sequoiadendron giganteum*), swamp cypresses (*Taxodium distichum*), tulip trees (*Liriodendron tulipifera*), American red oaks (*Quercus rubra*) and katsuras (*Cercidiphyllum japonicum*).

'We started doing the things that needed to be done at first, such as reduce the rampant bamboo and knotweed, but gradually we became immersed in the garden. A garden like this takes over your life… everything is geared to the garden year-round,' says Miranda.

There is a main path through the garden, which leads past the Tennis Court Garden (formerly the Millennium Garden), one of Miranda's new gardens, and the wildflower area, which dances with blooms and insects in summer. It continues past the Camellia Walk, the Magnolia Glade and for late-summer interest, the massed plantings of hydrangeas, before reaching the Lake. There are many informal paths that lead to specific features and viewpoints, including the Azalea Garden, the Fern Garden and the Grouse Hole. Here there is a bench and a beautiful viewpoint across the Pond to the red Tori Arch. This has been used by family members for as long as Miranda can remember as the place to go to recover from a grump, should the need arise!

There is no season when the woodland garden here is not full of flower or contrast of leaves and bark. In spring, camellias and daffodils, followed by magnolias and the 300 or so different varieties of rhododendron are the main players. Bluebells carpet the ground while climbing roses and wild flowers make good displays. Autumn colour sets the hillsides on fire as the acers and liquidambar start to colour up.

Rhododendron collection

One of the many projects Miranda undertook was refreshing and continuing Ramster's rhododendron collection. She is cataloguing the rhododendrons that her grandmother grew, many of which Lady Norman hybridized herself or grew from seedlings sent to her from her Bodnant family.

In addition, Miranda cleared an area in the woodland and named it 'Ant Wood' for her uncle Anthony who left her a bequest. She devoted this area to large, hardy hybrid rhododendrons so that they could be conserved and identified.

From about 1968 Lady Norman's granddaughter Miranda Gunn, with her husband, the artist Paul Gunn, gradually took over the running of Ramster and by 1983 had moved there permanently.

According to Miranda, 'Sir Harry and Gauntletts were a formidable team. The infrastructure they put in was superb. The drive is so well drained that we don't need to touch it and the paths are all underpinned with sandstone. They created the lake, taking all the silt out, with more than 40 people working on the site, and now we just have two full-time gardeners.'

Champion trees

Before they began to create new gardens or add further plantings Paul and Miranda set out to do as much as possible to maintain the garden's historic trees and plants. Much of the original oak woodland remains but now matured and historic tree additions include a champion handkerchief tree (*Davidia involucrata*),

ABOVE (Left to right) James Freeland, Misako Kasahara, Miranda and Paul Gunn, in front of a *Sequoiadendron giganteum*, or wellingtonia, which is about ninety years old.
OPPOSITE Ramster's rhododendrons and azaleas were introduced by Lady Norman, Miranda's grandmother. Miranda has added to the collection and now the garden is home to some 300 different varieties, offering a dazzling display in spring.

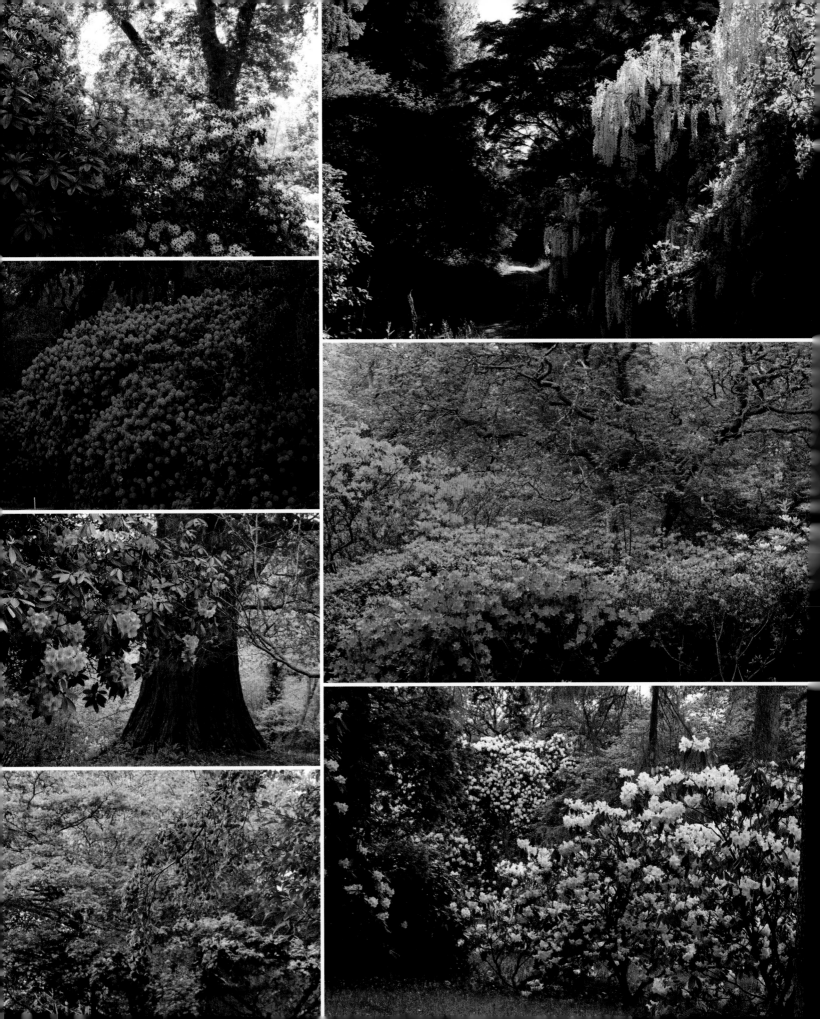

Because of their ultimate size many nurseries no longer stock some of the hybrids dating from 1890–1939. The collection numbers some 192 varieties and 500 plants.

In another part of the garden Miranda established a collection featuring rhododendrons and their companion plants for the twenty-first century. These rhododendrons are modest in size and suitable for smaller gardens. They all have good foliage, provide year-round interest, and are planted with worthy companions and ground cover.

'There are many modern rhododendrons with lovely indumentum (bronze velvety covering) on their foliage and so many are good for small gardens – they deserve to be better known,' says Miranda.

Rhododendron 'Cynthia', prolific at Ramster and often described as its signature rhododendron, has benefited from a particular treatment by Miranda. At around 100 years old, they tend to push forwards with their long branches, laying them along the ground, to make new plants. To create a sculptural effect and lighten the density of the plants,

Miranda has cut them back and exposed the upright, dark, bare trunks of the plants, creating a jungly look and a view through to the Lake.

Another of Miranda's gardens – the Tennis Court Garden – began life as a Millennium project. 'We had stopped using it and we felt it could benefit from change.'

Now surrounded by pleached limes, with a low lonicera hedge at their feet and gravelled, it has taken on the Mediterranean character that Miranda intended. Within the pleached lime framework there is a canal-like water feature, fragrant plants including *Rhododendron fragrantissima* (which is not hardy) as well as alliums, heucheras and snake bark acers.

ABOVE Majestic woven willow deer rise out of the early morning mist.
OPPOSITE Statuary, including an eagle carved into a log, Miranda and Paul's grandchildren by Christine Charlesworth, a Japanese lantern and two herons placed in the water, is thoughtfully chosen and placed in different parts of the garden.

The next generation

Rosie, one of Miranda and Paul's children, and husband Malcom Glaister took over the running of the family business at Ramster in 2005. Following her mother and great-grandmother she is beginning to make her mark in the garden. In the summer of 2021 with a former Ramster gardener, now designer and consultant Rama Lopez-Rivera, Rosie has added a summer garden to the family repertoire, filled with her favourite herbaceous plants. At the centre of the garden is a modern sculpture entitled 'In the Beginning' by artist Lynn Warren.

It joins many other well-placed sculptures and objects in the garden: some, such as the two herons in the Iris Pond, date back to the first Gauntlett landscaping in the 1890s. The pond is also the site of some surviving Japanese irises from the early Gauntlett plantings. Other evocative pieces of sculpture include a group of children playing 'Oranges and Lemons' by sculptor Christine Charlesworth. The children represent Paul and Miranda's grandchildren.

The family celebrated a centenary of curating the garden at Ramster in 2022. To mark this, Miranda began creating a Centenary Garden two years earlier, arranging a sequence of curved beds to highlight plants grown there in both 1922 and 2022. Magnolias and rhododendron, or course, and some of Ernest Wilson's 50 evergreen azaleas, are included. There are about 35 of the Wilson 50 at Ramster which, according to Miranda, may have been the best when they were introduced to the UK, but are now superseded by stronger modern hybrids.

Just five years after they took over the garden, Miranda's grandparents joined the 600 pioneer owners who first opened their gardens for the National Gardens Scheme in 1927. Along with the royal gardens at Sandringham in Norfolk, Ramster has opened for the scheme every year since – a true testament to longevity.

15
Restoration House
Rochester, Kent

ON 29 MAY 1660 Charles II set out from here to be restored as King, a pivotal moment in British history from which the house gets its name. Some 200 years later Charles Dickens pictured the house, then encrusted in ivy and deprived of its original 250-acre/101-hectare estate, as the gloomy setting for Miss Havisham in *Great Expectations*. The house has been through several cycles of prosperity and decline since then, and in the 1980s there was talk of turning the garden into a council car park! Fortunately though, Jonathan Wilmot and Robert Tucker, who bought the house in 1994, have slowly transformed it into one of the most beautiful city mansions and private gardens in England.

The house has had its own supply of fresh, clean water from the spring in the south-west corner – the 'source' of the human occupation of the site that goes back at least to Roman times and probably much earlier. It also had a large formal garden dating from around 1600, together with a cherry orchard,

stables and vegetable garden. When the diarist Samuel Pepys visited in 1666, he described the place as a 'pretty seat'.

Today the garden is divided into three main sections, each with its own distinct character. The area behind the house is a double-walled garden divided into 'rooms' with fruit, wisteria and climbers clambering up the south-facing walls, a parterre, topiary, cutting and mulberry gardens, as well as a formal pond, which glides under arched windows set in the dividing wall to create a cross-axis. A long border runs down on three different levels to the steps up to the Mount at the back of the garden. Mature trees guard the eastern boundary, including a magnificent *Catalpa bignonioides* – a seedling of the tree planted in front of Rochester Cathedral.

The sunny formal garden to the south has been recovered from threatened development and is now an Italian Water Garden with raised walks, sculpture, fountains and rills fed from the same aquifer that supplied the original spring. Four different

LEFT Replacing a formal rose garden, the immaculately shaped parterre planted in 1995, below the Mount, matches in terms of drama, the towering *Catalpa bignonioides* – a seedling of the one planted in front of Rochester Cathedral.
RIGHT The Witches Hat yew topiary was made from an ancient existing yew, and the rest were planted by Robert and Jonathan to complement it and add depth to a border on the south side. Now these quirky topiary yews provide visual humour as well as shadow play on the lawn of Yew Court.

varieties of lemon enjoy the enclosed south-facing aspect from late spring to mid-autumn, alongside lime, grapefruit and Buddha's hand. To the east the Lower Garden stretches down to the old Brewery (which also features in *Great Expectations*). Terraced grass banks step down to the most sheltered part of the garden where an 1820s vinery, the Tropical House and the Melon House nestle behind an alley of cannas and another long border, punctuated by giant spires of echium.

Painstaking restoration

When Robert and Jonathan began their work, restoring and furnishing the Grade I listed house was the priority, but it was always the intention to create a garden that enhanced the architecture of the house. Robert's fascination with the history of English houses, interiors, furniture, ceramics and paintings – all the greater for having grown up in Australia – dictated a patient archaeological approach. Understanding what was once here and how it had evolved before making major interventions was key. Using the appropriate building materials, techniques and even paint was a vital part of the process.

The same principles were applied to the garden, with Robert taking the lead for the hard landscaping and Jonathan for the planting. Walls have been rebuilt on the original footings using old bricks and lime mortar, and the paths made from a range of materials including granite setts, paviours, limestone slabs and herringbone brick, all reclaimed and recycled, much depending on what was available. Some of the paths are sunk just below the surface of the adjoining lawn or border, harnessing the light, or making a sort of a shadow that edges the different sections of the garden, rather like the moulding on a picture frame. All the new walls and paths blend seamlessly with the seventeenth-century brick of the main house and, most importantly, look as though they have always been there.

According to Robert: 'The best thing about working slowly is that the design feels entirely natural, as if it had grown out of the ground, rather than been imposed by a modern designer.'

Though there was no surviving documentary evidence about the garden in the seventeenth century, local garden archaeologist Elisabeth Hall helped to decipher what was on the ground, and suggested that there was likely to have been

a formal parterre below the raised walk or Mount at the back of the garden.

The Mount now overlooks the box parterre planted in 1995 based on the simple, yet effective Jacobean design seen on the wooden back and front doors of the house. Replacing a formal rose garden, the parterre offers a pure green effect with a mown lawn between it and the Mount, the precision of the box set off by the towering catalpa on the bank. The sides are battered to let more light into the bottom of the hedges, as advised in Nathaniel Lloyd's classic *Yew and Box*. It is shaped and trimmed by hand in late spring by two of the garden team, Aaron Danton and Tim Schooley, who also cut the yew hedges and topiary to

perfection every autumn. And Aaron keeps the lawns lush and green even in the hottest summers, through a combination of hard labour and abundant water from the 'source'.

Planting dynamo

But the garden is much more than the seventeenth-century poet Andrew Marvell's 'green thought in a green shade'. It is full of interesting plants, some of them difficult to grow on the free-draining chalky soil, such as the Himalayan blue poppy that head gardener Sarah Pollard somehow nurses in successive batches (they are monocarpic and die after flowering) through wet, mild winters. She is a dynamo when it comes to the maintenance and upkeep of all three gardens with volunteer Lesley Perretti, and irrepressible when it comes to finding and growing new plants and planning changes to the borders with Jonathan.

The cutting garden is bounded by an ornamental and productive espalier system of apples on stout wooden trellises. Complete with sturdy posts for the dahlias, its four quadrants packed with a succession of flowers though the seasons, it

OPPOSITE On the site of the seventeenth-century formal garden, acquired in 2009, Robert and Jonathan have created a Renaissance water garden where they bring out their considerable collection of citrus to spend the summer in great terracotta containers.

ABOVE An 1820s Vinery, Tropical House and *Limonaia*/Melon House nestle against the south facing walls leading down to the brewery courtyard with the tropical border and raised vegetable beds in front.

started out as the vegetable garden but is now very much Robert's domain. From this base camp, he and his friend Katie Morgan produce the spectacular flower arrangements that animate the house throughout the months it is open to visitors and sumptuously decorate it during numerous concerts held in the Great Chamber. From the peonies, pinks, sweet peas and old roses of early summer to the dahlias, asters, helenium and zinnias of early autumn, the treasures of the garden are displayed inside and out. 'Jonathan is always moaning that I've over-picked and left the borders looking bare,' says Robert, completely unrepentant.

In 2007 the context of the house and its Grade II* neighbours was threatened by a questionable planning permission to build 34 houses and flats next door, including in the area Elisabeth Hall had identified as the original and ambitious formal garden. But the global financial crisis intervened, the developer went bankrupt and Robert and Jonathan managed to buy the whole site from the receivers. But only after taking Medway Council to the High Court and undermining the original flawed planning permission, which failed to protect the listed structures 'within the original curtilage of Restoration House'. It was a landmark judgement and so, in 2009, Robert and Jonathan acquired the half-built housing and the site extending down to the historic brewery (now converted into flats and studios).

Overnight their garden more than doubled in size and once again Robert and Jonathan returned to painstaking archaeology and rediscovery of the past. Gradually, the remains of a major garden, on several levels with terraces and wide walkways, were revealed. Their architect even suggested parallels in siting and proportions to Villa Lante, one of their favourite gardens in Italy. Twelve years later, and there are now three exceptional gardens in which architecture, fruit, flowers and formality combine to magical effect.

'It has been a huge project,' says Jonathan 'and none of it would have been possible without the amazing craftsmen and tradespeople we have worked with – bricklayers, stone masons, painters, archaeologists, Rob the "water doctor" and our master of logistics, Matthew Patterson, who started as a part-time garden boy at 16 and left 25 years later having overseen one of the most exciting restoration projects in the country.'

'And, of course, without Sarah and Aaron, with help from Tim and Lesley, it wouldn't be such a joy to live in and use,' says Jonathan.

Originally Restoration House visitors were drawn to see the house, but now the plant lovers come just to see the garden, hidden and unsuspected behind its enclosing walls. Its many rooms and unique plan provide formal and herbaceous surprises, culminating in the jaw-dropping Italian Garden where statues, citrus, immaculately mown plats and wide, terraced walks, glitter in the spray of fountains and other water features. Arcadia restored.

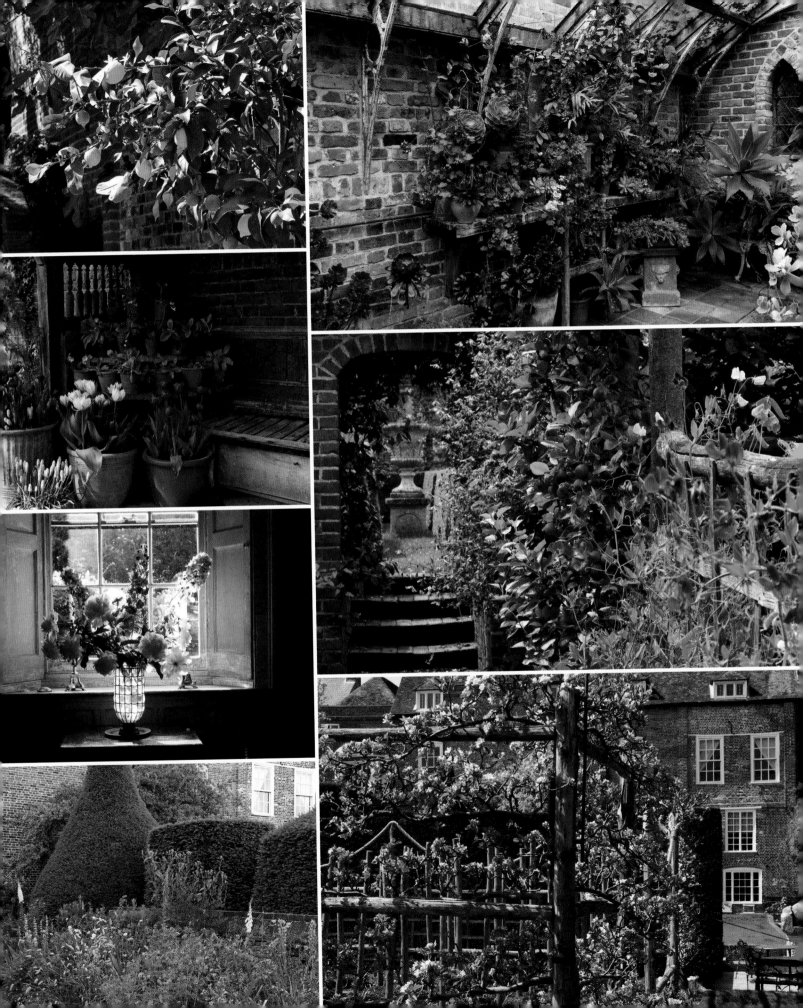

16
Sussex Prairie Garden
Near Henfield, West Sussex

DREAMS DO COME TRUE, especially if like Pauline and Paul McBride you have plant skills, determination and as Pauline notes 'crazy grand ambitions!'. Sussex Prairie Garden is the fruition of their desire to create a garden together.

It all began during the dozen years that they lived and worked in Luxembourg, collaborating on horticultural projects, combining Paul's plant prowess with Pauline's textile artistry. One of their clients, the owner of a private garden, commissioned renowned Dutch designer Piet Oudolf to create a border, and the McBrides worked alongside him on the project for two years.

'This was the chance of a lifetime for us – the opportunity to work with our plant guru. It was like having Michelangelo as mentor and tutor… And it gave us the confidence and inspiration to create this garden when we came home,' noted Pauline.

Planning and propagating

Sussex Prairie is an 8-acre/3-hectare garden on what was a field of Morlands Farm, Pauline's family home and where she grew up. 'When I left home at 18 I never imagined I would come back to live. But then I met Paul who was a horticulturist, and thoughts of making an amazing garden together started to bubble away. This seemed the perfect place.'

The McBrides began planning while still in Luxembourg, buying the land and preparing the ground. 'We started out with hand-drawn scale plans and realized we were going to need 35,000 plants. So we set about propagating by division, cuttings and seed sowing in our nursery in Luxembourg and every weekend travelled to Sussex with 3,000 plants.'

When Pauline was growing up hay was stored in the old, traditional, corrugated iron-clad Dutch barn. She loved to make dens and hidey-holes up under the barn's curving roof. So not only did Pauline come back home but when,

Hornbeam hedges echoing the soft roll of the South Downs, fastigiate hornbeams and a flowing grass rill of miscanthus, offer a shapely breathing space at the heart of the spiral borders.

in 2019, the McBrides moved into the newly converted and repurposed barn, it brought Pauline right back to her childhood den. Picture windows in the upstairs open-plan living area are perfect for garden gazing and plotting new horticultural, textile and travel adventures.

A viewing tower in mild steel, now artfully rusting, was completed in 2021 near to the Cutting Garden where the McBrides grow annuals, trial new plants and keep the dahlia collection. The tower offers visitors the chance to see the garden from above and take in the sweeping Sussex Downs and, in particular, the Iron Age hill fort of Chanctonbury Ring.

The predominantly clay soil is waterlogged and sticky in winter so the McBrides had to put in land drains.

The McBrides set aside the topsoil from these excavations and from digging three new ponds. The topsoil was eventually returned to the borders and the spoil went to make the viewing mounds at the far end of the garden which, prior to the tower, were the only areas of high ground.

With drainage sorted and the ponds created, the real planning of the large, free-flowing borders moved on-site 'with sticks, string and a fair amount of shouting, but we marked out the whole plan more or less in one hit'.

Once the deep and shapely, sinuous beds were marked out, they were treated several times with herbicide before they were ploughed. Then compost was rotavated in.

The McBrides have a reputation for throwing a good bash, so when invitations went out for a 'plant party', acceptances came thick and fast. In May 2008, around 40 friends and family joined them in a massive plant-out – 35,000 plants in all – and a year later the garden opened to the public.

Although they only open the garden in summer and autumn, they maintain it year-round to produce the sweeping blocks of colour and texture that their plant palette provides.

In spring, mulching on a grand scale, followed by renewal of the bark paths that weave and wind through the arcing spiral borders, takes precedence. Because they have the space, they invited Horsham District Council to store local green

OPPOSITE Curving paths through the grand spiral of the borders bring you up-close so you can experience the undulation of the plants and their blocks of colour from within.

ABOVE The former threshing barn is now the McBrides's home complete with a striking viewing tower.

LEFT In the Cleet Garden, a slightly enclosed area, there are dazzling massed, single species plantings, including rudbeckia, grasses and sanguisorba.

waste compost in huge mounds on the farm, which benefits the garden. Similarly, local arborists are welcomed and their woodchip waste refreshes the extensive garden paths.

The most impressive part of their annual maintenance is the firing off, done when the garden is tinder dry. It usually takes place early in the year when all the previous year's top growth is disposed of in a spectacular burn out. 'It is a good way to manage a garden of this scale. It is dramatic and we have the space… but we have to avoid collateral damage. Don't try this at home!'

The plan on the ground follows the spiral shape of a nautilus shell. Cutting through the spiral and running north-south through the centre of the garden, separating the flowing borders, is a linear 'breathing' space, lined with hornbeam hedges, clipped into soft, mounded shapes and echoing the curves of the South Downs. Growing up and through each of the hedges, asymmetrically placed, are fastigiate hornbeams. Running through this space is what Pauline describes as a 'grass rill'. Instead of water running along a channel, silver blocks of miscanthus ripple through, providing movement and seasonal texture.

Repeating patterns

Pauline describes the walk from the main entrance through the woodland and the tropical settings as a kind of decompression prior to the sweeping open plantings ahead.

'I hope our visitors are encouraged to let their imagination run free as they step out into the wider, open space of the prairie-style plantings.'

To achieve the special effect of the grand, wide-open space, Paul and Pauline plant in large blocks that show off the qualities of the plants, and fortunately are easier to maintain. 'We repeat patterns of different plants to add rhythm, as well as to draw your eyes and feet deeper into the garden.'

Four of the star plants that Paul recommends for a changing climate are *Calamagrostis* × *acutiflora* 'Waldenbuch', a sturdier, stockier and rust-resistant alternative to 'Karl Foerster'; *Miscanthus sinensis* 'Malepartus', a strong, old variety with stunning deep purple flowers; *Panicum virgatum* 'Hänse Herms', a dreamy, wispy grass giving a soft focus to the borders, and offering magical autumn colour; and *Veronicastrum virginicum* 'Diane', with its elegant white spires up to 5.2 feet/1.6 metres tall in summer.

Once the plants start their relentless, almost tidal, rise and fall in the borders, visitors are enticed by meandering paths to venture right to the heart of each half circle. There is nothing quite like experiencing the flow and undulation of these sturdy stands of perennials from within.

'Although we love the intimacy of enclosed garden rooms here, our open space demanded that we incorporated the length and distance of long views into the overall scheme of the design.'

The Cleet Garden is one area which bucks the open nature of the site. Here the McBrides were inspired by two US designers, Wolfgang Oehme and James van Sweden, and have planted outsized blocks, mainly of grasses, but also of sanguisorba and rudbeckia. The feeling that the plants are hedged in and enclosed contributes to the atmosphere.

Gardens and art

Paul and Pauline are indefatigable propagators, making new plants for their own stocks and to offer visitors as a starter kit to create similar effects themselves. 'It is important that visitors can buy what they see growing here, on the spot.'

Pauline has always felt a strong connection between gardens and art, so it is no surprise that she welcomes ways to showcase creative talent, particularly that of textile artists like herself. Some sculptures, such as the giant metal buffalo, designed by her and made in Luxembourg, are permanent. Also permanent and designed by her, as testimony to their love of the place and for each other, is *Big Love*. It is made of three separate steel structures, which when viewed from

a certain angle merge and become one big heart-shape. Other sculptures, made in a variety of media, are more transient, staying only for a season or two.

And what is next, now the garden dream has been achieved? Well, no one here is sitting on their hands. Pauline and Paul have now embarked on drawing up new landscape plans for the establishment of a 20-acre/8-hectare woodland and a series of wildflower meadows to the west of the garden. Wild and towering ambition indeed!

ABOVE (On the right) Pauline and Paul McBride between mum Patricia Tidey and sister Anna Tidey, with dogs Vigo and Darcy. (On the left) members of the gardening team Stuart Southwell (far left), Nick Bielby (7th left back), Mark Baldwin (9th left back), Lin Potter (9th left front), with longest-serving volunteers Ron and Libby Kersey (2nd and 3rd left front), and all the other volunteers Diana, Fanny, Liz, Penny, Veronique, Kayla, Paul, Allison, Faith, Harriet, Gen, Fergus, Debbie and Henry.
OPPOSITE Throughout the garden Pauline makes strong connections between plants and art, highlighting work, some permanent and some transient, by sculptors and textile artists, including (top right) a permanent piece called *Big Love*.

17
The Hannah Peschar Sculpture Garden
Ockley, Surrey

SCULPTURE IN A GARDEN is often a singular entity and is always a deeply personal choice. The Hannah Peschar Sculpture Garden near Dorking in Surrey is one of the oldest outdoor sculpture gardens in the South East, established in the 1980s in a 10-acre/4-hectare woodland and water setting, in which today several hundred sculptures find their own individual space.

The late Hannah Peschar and her husband, landscape architect and designer Anthony Paul, moved here in the 1970s. (Very sadly, Hannah died in August 2021 while this book was in progress.)

Before they moved here, the site had been landscaped in the early part of the twentieth century but had become overgrown and was constantly flooded by the Standon stream, which flows on its way to join the River Arun. In winter the stream can be a raging torrent while in summer just a trickle.

Hannah and Anthony spent the first years clearing fallen trees, hacking back, weeding and planting. Trees and shrubs, with bold and shapely structure and foliage, as well as herbaceous material, were planted in large groups, rather than in borders, to create a predominantly green landscape.

'A garden takes time to develop, especially as plants and trees are usually put in as immature specimens. Then you sit back and wait 20 years to see the garden mature like a very slow-motion film,' Anthony explains.

Hannah and Anthony also restored the weir, which controls the flow of water through the garden and into the various ponds. The seclusion of the site, together with the Standon stream curving through it and the various lakes and ponds, offers tranquility within a natural framework of mature trees. Adding to the existing pools and lakes, Anthony created new ponds and used massed plantings of moisture-loving plants to encircle and clothe them.

LEFT *Passage* by Frederick Andrews draws the eye through the garden.
BELOW Rick Kirby's *Witness* stands tall among gunnera foliage and giant hogweed flower heads beside the pond.

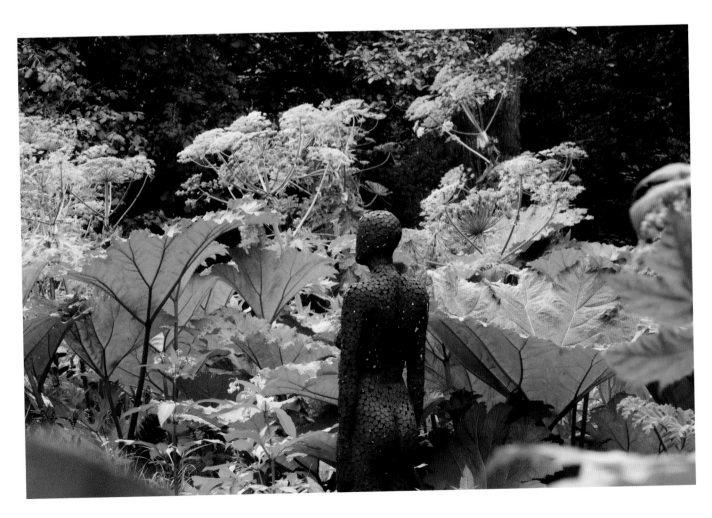

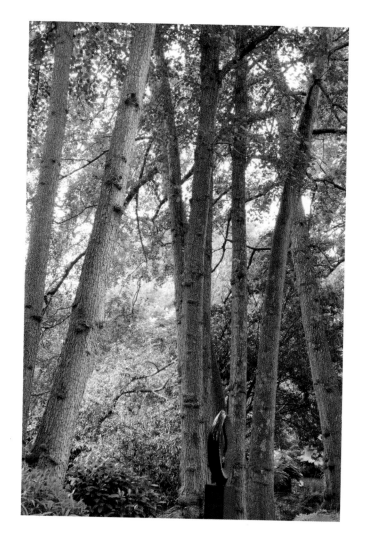

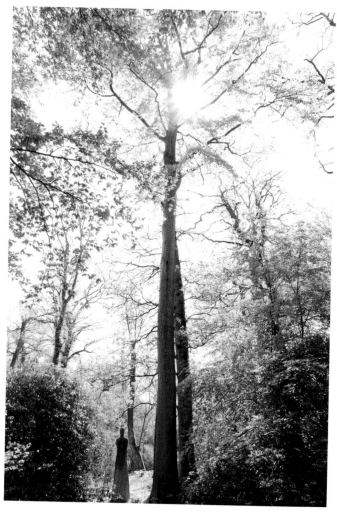

'The large-leaf architectural monsters such as gunnera and petasites – giants of the plant world – are vital in this garden for scale and form. My hypothesis is that all gardens are about scale. Gardens which lack scale mostly lack drama and I get bored very quickly by planting which has no bold groups of plants to set it off.'

A perfect setting

Hannah had one of those light-bulb moments when visiting her native Holland. Her friend was running an exhibition of a ceramicist's work, and there was so much to show that some of it was displayed outdoors. In that second Hannah realized that the landscape around her seventeenth-century black and white cottage in the Surrey Hills would be the perfect setting for a large-scale, annual sculpture exhibition.

Artistic and a lover of art, Hannah had an eye for what would look good in this environment and canvassed the idea with art schools and artists. She also realized that the landscape offered boundless scope for artists to use materials outdoors, such as glass and metal, that would be enhanced by natural light, reflections in the pools, the movement of the water, shadows and even the skyscape and weather.

As she often said: 'I have always been interested in art – it rubs off on you, and then you find you can't live without it.'

Her first sculpture exhibition was in 1983 when 20 pieces were sited on the lawn in front of the cottage. By 2021, some 200 pieces, the work of over 50 artists, were installed in the garden. Hannah helped launch the careers of countless sculptors in gardens around the world. Among them are David Begbie, whose mesh torsos float from trees; Walter Bailey, whose contact with Hannah led to the commission of 14 carved wooden totems across the Surrey Hills; and Neil Wilkin, a glassmaker whose work is particularly suited to waterside settings.

'Hannah's exhibitions changed the face of the British sculpture scene.'

Anthony's choice of sculptural and architectural plants with large and shapely leaves offers a perfect and strong backdrop for the sculptures. All shades of green are present and in the changing seasonal and diurnal light the outdoor gallery enhances the minute details of each of the works. Mood and atmosphere offered by plants and the changing landscape combine to bring out the best in the artworks.

Trees and branches that would overhang are propped up and held back by forked supports, reminiscent of techniques used in Japanese gardens to manage wayward growth. In many places the trees themselves are more installation than nature as one leans into another's branches. Waterside sedges and giant hogweed are not for the faint-hearted but in the context of this garden they provide strong foils of foliage and muted flowers, which accommodate the artworks placed near them. Petasites, rheum, gunnera and ferns, for example, are the perfect companions for one of Neil Wilkin's glassworks, a striking ruddy orange flower, *Gloriosa Double Orange*, made from hot-formed glass on a stainless steel post.

Seasonal changes

There is little flower colour to diminish the impact of the sculpture, except in spring from massed bulbs and later from occasional bursts of colour in summer. Competition from colourful borders would dilute the effects of the sculpture and detract from the natural location.

In autumn, as the foliage intensifies, the mood changes completely. In winter it changes again but then the garden is closed to visitors. This is when next year's show is planned and adjustments are made to the plantings. Co-curator Vikki Leedham notes: 'There is often tree loss in winter. It is heartbreaking but is Nature's way of creating new space and opportunities for change in the garden.'

OPPOSITE LEFT AND RIGHT *Tempest* by Matt Maddocks and *Warrior* by Walter Bailey appear to rise from the woodland floor.
RIGHT TOP Pieces like Deborah Davies' woven willow installation *Belonging* need to be sympathetically placed for maximum impact.
RIGHT CENTRE Neil Wilkin's flowers, such as *Big Red Flower* made from hot-formed glass and stainless steel, rise up in various places in the garden, offering bright splashes of colour.
RIGHT BOTTOM In spring the bicycle bells of *Sound Architecture 5* by Ronal van der Meijs are complemented by the bell-shaped flowers of snakeshead fritillaries.

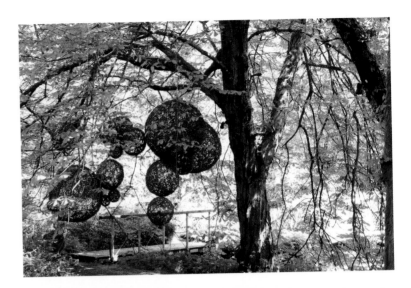

RIGHT Vikki Leedham, Anthony
Paul on *Standing Mare* by Stuart
Anderson, and Peter Bye.
OPPOSITE Placing sculpture in
the right setting is key: here
works by Rob Mulholland,
Lucy Unwin, Nimrod Messel
and David Begbie, including a
work he renamed *Hannangel*
and donated to the Sculpture
Garden, showcase different
facets of the human body
combined with a range of plants.

In 2015, after Hannah stepped down from curating the sculpture garden due to ill health, Vikki Leedham became co-curator with Anthony. Vikki grew up nearby and as a child visited with a school party. She even centred her art school project on an outdoor exhibition inspired by the garden. In 2009 she asked Hannah if there was an opportunity for work experience and was offered a job on the spot. In the early days Hannah would 'give' her a particular artist to place and curate, as she herself continued to choose the artists and decide where to place them.

Placement is fundamental to the success of the art in this garden and head gardener Peter Bye plays a key role in this. He has worked in the garden for more than 20 years and is greatly involved in the logistics and placement of the sculptures. According to Vikki: 'If Peter can't work out how to get a sculpture to a specific spot in the garden, no one can.'

Several times a week Peter works his way round the garden, blowing away leaves, collecting sticks and debris, and dealing with seasonal flood damage and maintaining the planting, ensuring the atmosphere is relaxed and informal. Working so closely with art and nature it is no surprise that Peter has developed his own artistic endeavours. Keep an eye out for his murals around the garden and especially for the eyes he has painted on some of the trees.

Indoor gallery

A ticketing system was introduced during the pandemic limiting visitors to 60–70 per day arriving over three time slots and staying as long as they wish. The garden is large enough to 'swallow' visitors and absorb noise so, while there may be others wandering about, you still have the feeling of being the only person in here. The garden is also a haven for birds and insects, including dragonflies and beetles, and the pond is home to water birds all year round. In late summer when the verdant green of duckweed takes hold, the water becomes a canvas for the shadow-work of trees and light, and birds sailing through it make their own artworks.

As Vikki Leedham noted in the order of service for Hannah's memorial in August 2021: 'Celebrating the harmony between art and nature, Hannah's exhibitions changed the face of the British sculpture scene – demonstrating that exciting new materials, striking contemporary sculptures and pieces of any scale could all be framed, supported, and enhanced by a lush and natural landscape.'

Hannah's name will live on in many ways but specifically with the launch in 2022 of a purpose-built indoor gallery space, nestled in the tree canopy. Here smaller sculptures telling the story of art in a natural setting will be added to the repertoire at the Sculpture Garden.

18
Town Place
Near Sheffield Park, East Sussex

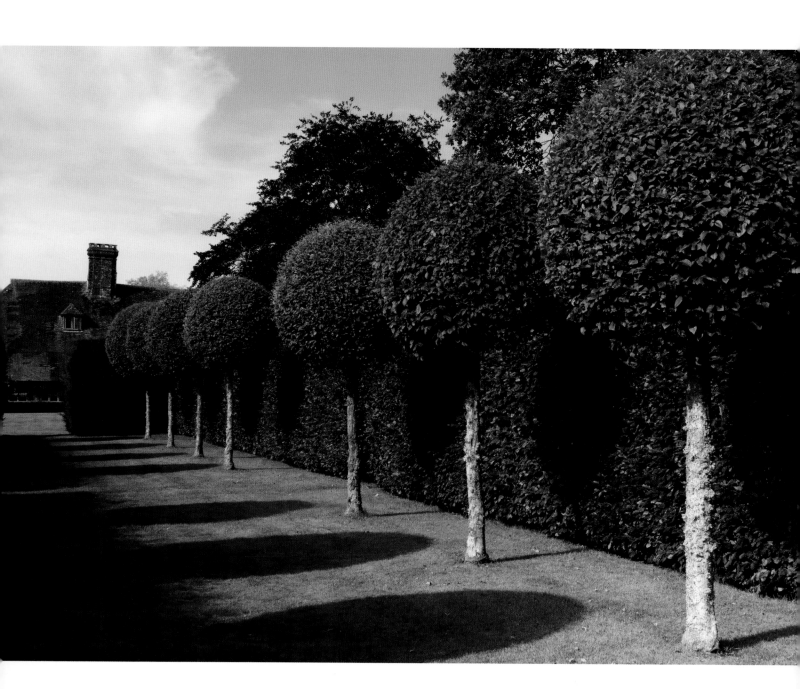

THE PROJECT OF TRANSFORMING Town Place from a featureless landscape into an exciting series of plant installations – some enclosed, some more open – where formality and precision provide a strong counterpoint to colourful exuberance has kept Anthony and Maggie McGrath occupied for more than three decades.

Though they had actually been seeking a modern house, the McGraths came to this 400-year-old Grade II-listed timber-framed house (with its 3.5-acre/1.4-hectare garden) in October 1990. Its name, originally 'Toune', is recorded as a farm dating back as far as 1288. 'We were looking for a blank canvas so we could create an English country garden. We had failed to find a modern, low-maintenance house with

'All decisions about planning and the garden are discussed and researched by Anthony and Maggie.'

a suitable garden but this old house is the perfect backdrop for the garden we have made around it.'

Maggie and Anthony were keen gardeners both of whose green-fingered mothers had handed down their enthusiasm. Maggie decided to back up her knowledge by studying for the RHS Certificate in General Horticulture at Plumpton College in East Sussex and later took a design course there too.

Maggie and Anthony each have their garden areas and responsibilities at Town Place with Anthony in charge of watering (from a ring main all round the garden), the greenhouse and propagation, the Herb Garden and Potager. Maggie is the composer of the rhythm and colour in the borders, tackling the roses and deadheading… no small task in this garden.

LEFT The Hornbeam Walk of 16 mop-head hornbeams is backed by copper beech hedges and lies between the Potager and the English Rose Garden.
BELOW Rambling roses such as 'American Pillar', 'Albertine' and 'Chaplin's Pink' clothe the pergola surrounding the Sunken Rose Garden.

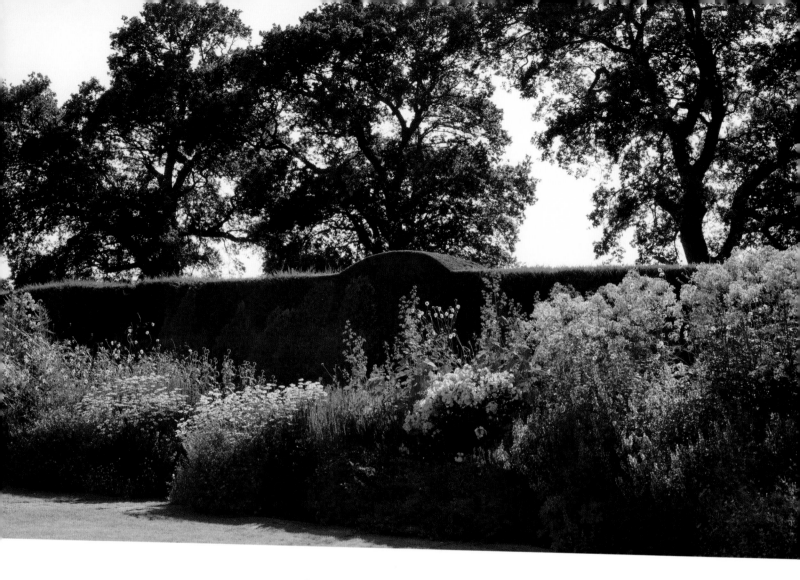

ABOVE Purple is one of the main flower colours in the Long Border backed by a closely shaped tapestry hedge of x *Cuprocyparis leylandii* 'Haggerston Grey' and golden *Thuja plicata* 'Zebrina'.

RIGHT Late summer perennials and ornamental grasses including *Dahlia* 'Karma Choc', perovskia, veronicastrums and *Pennisetum orientale* combine with annuals such as Californian poppy 'Mikado' to dazzle in Prior's Walk.

OPPOSITE In the Short Border *Nepeta* 'Walker's Low' and *Salvia* x *superba* 'Superba' frame the view through to the East Lawn and the Apple Arch beyond, complete with one of 'Ado' Admir Sljivic's statues, *The Apple Scrumper*.

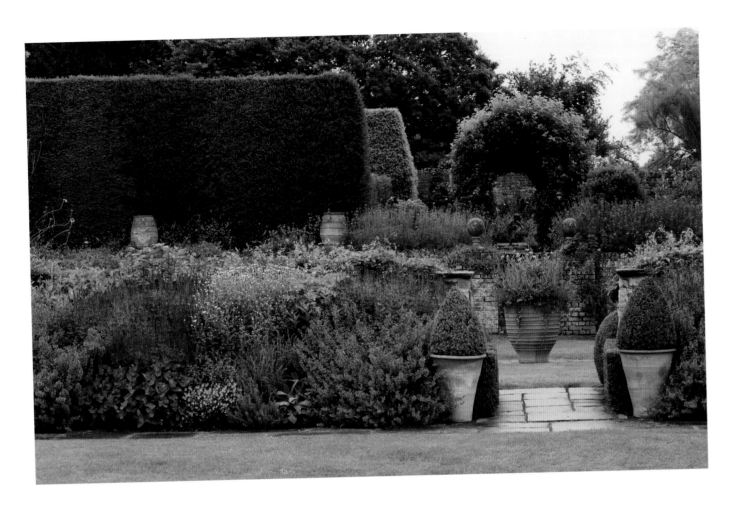

The McGraths keep enviable annual records of plantings — successes and failures — as well as changes made over the years. It is this combination of precision and formality, juxtaposed with free-flowing and exuberant plantings, as well as storytelling, that makes the garden compelling in all seasons.

Herb Garden

At first, the McGraths added walls and fences to keep out deer and rabbits and planted hedges of yew, copper beech and hornbeam to add structure and protect plants from prevailing winds. They worked their way around, area by area, creating borders and enclosures with individual identities. A practical and useful herb garden near the house was an early project that evolved into a cottage-style Herb Garden where Anthony now has a substantial collection of ornamental sages.

Given their division of labour and the size of the garden, it is easy for the McGraths to garden with their regular team of Roy Black, Amelia Holmwood and Justyn Bell, and not see each other during the day. Meetings are vital though, and all decisions about planning and the garden are discussed and researched by Anthony and Maggie, where a little compromise is essential.

It is Anthony, however, who initiates the many new projects that they take on each year. Gardens and gardening people, including Sissinghurst and Great Dixter, Harold Nicolson and Vita Sackville-West, are among the couple's many reference points that inform their choices and decisions for the garden.

An early planting within two copper beech hedges of the Hornbeam Walk uses 16 standard mop-head hornbeams, and has now matured to offer a tranquil space between the Potager and the English Rose Garden. This rose garden contains 450 roses (comprising 60 cultivars) in the ground and on pergolas. In winter, frost adds its prickly patterning to the ground and foliage of the Hornbeam Walk, while the shadow play of trunks and spheres is the additional ornament in summer.

The Potager is always 'on show' and the McGraths rarely harvest its colourful crops until visiting days are over. Metal arches holding sweet peas and stands of dahlias provide the floral notes, while cardoons and asparagus fern offer visual feasts in swathes of grey or green foliage.

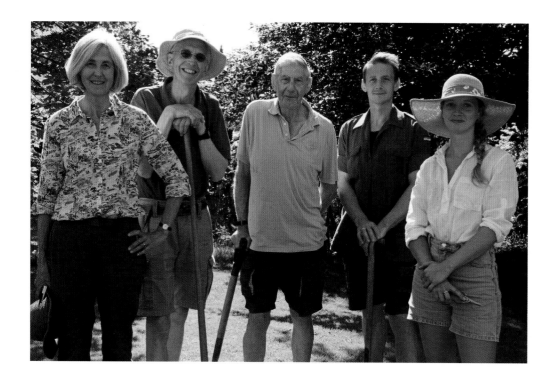

Support and access

One of the existing features they found at Town Place was a tapestry hedge made by combining two conifer species – golden *Thuja plicata* 'Zebrina' and × *Cuprocyparis leylandii* 'Haggerston Grey' – side by side, in a row. They have grown together and subsequently been cut and shaped so precisely to form a grey-green and golden 'wall'. This is now the backdrop for the triumphal march of a pair of herbaceous perennial borders whose combined length is 148 feet/45 metres. Maggie uses a repeating combination of colours – mainly primrose yellow, purple, mauve and dusky pink – as well as heights and shapes to provide the drama front-to-back and side-to-side, peaking from early to late summer. The repeated blocks of plants punctuate the borders at intervals, stopping eyes and feet from rushing past.

Key to the success of the Long Border is Maggie's rigorous and regular deadheading, but support and access are two other important parts of its seemingly effortless maintenance. Supports for taller, more wayward plants are essential and these, all made from natural materials are installed well before needed and so disappear as plants grow. And there is a wide grass service path between the hedge and the border, so that the hedge can be maintained and the back of the border managed easily.

The area on the other side of the tapestry hedge gives on to the orchard, which is kept informally mown and planted with daffodils and other bulbs that burst into life in spring. Here many new plantings were made following storm damage, including a Judas tree (*Cercis siliquastrum*), tulip tree (*Liriodendron tulipifera*) and wedding cake tree (*Cornus controversa* 'Variegata').

Their love of roses not quite sated by the hundreds planted in the English Rose Garden, there is also the Sunken Rose Garden – one of the original garden features dating from the 1920s – where a mere 150 roses (comprising 12 cultivars) offer colour and fragrance. This garden is surrounded by two old ramblers 'Albertine' and 'American Pillar', growing on the house and pergola.

Sculpture in the garden

Humour and imagination go hand-in-hand in this garden, especially in the names given to different areas. For example, the Circus is so-called because a visitor once saw a clown's face in one of the topiary shapes. (In fact, the topiary shapes represent Henry Moore sculptures and were inspired by Sir Roy Strong's idea to recreate works of art in topiary.)

Real sculpture plays its part here, especially in the area called Chequers, which is planted with mainly aromatic shrubs and perennials. Bounded by a substantial planting of *Rosa* 'Excelsa', it holds an over-sized chessboard and chess pieces.

Two groups of statues, one backed by a mature yew hedge, were designed by Anthony, sculpted by 'Ado' Admir Sljivic

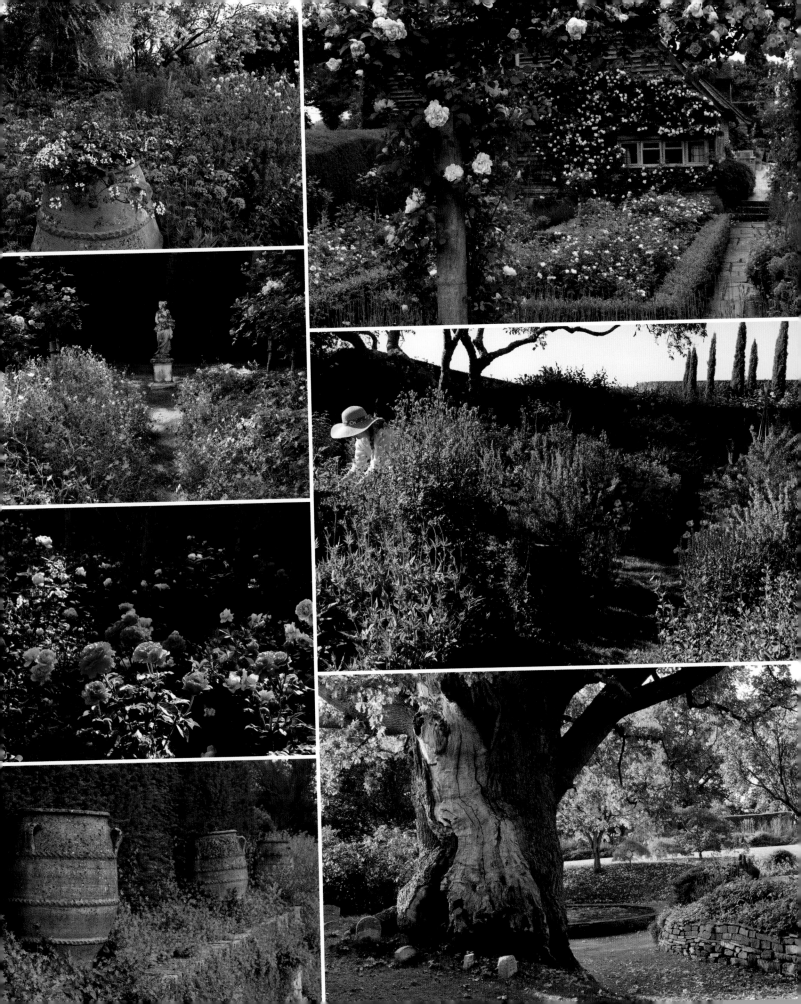

and cast in bronze resin by Chilstone. The figures are a modern interpretation of the seven liberal arts. In one group are grammar, logic and rhetoric, while the other has music, geometry combined with arithmetic, and astronomy.

The New Territories

The fruits of Maggie's studies at Plumpton College are visible in many parts of the garden, as are Anthony's ideas and propagation prowess. By far the boldest of Anthony's leaps of imagination is on show in an area known as the New Territories, the most breath-taking architectural plantings. Here he has put in play his study of Romanesque architecture, not immediately associated with an English country garden.

ABOVE A processional path lined by *Juniperus scopulorum* 'Skyrocket' leads the way to Anthony's imaginary hornbeam Toune Priory.
OPPOSITE TOP A thousand hornbeam whips were planted in 2001 to form the walls of a ruined Romanesque priory.
OPPOSITE BOTTOM The buttressed hedges of Toune Priory have reached 13 feet/4.2 metres.

Inspiration for this came from a visit to the Manoir d'Eyrignac in the Dordogne, which featured long, high *allées* of hornbeam. Anthony sketched out a ruined church, which he called Toune Priory and committee discussions ensued.

'We marked out the lines of the church, bought a thousand hornbeam whips and started planting. We gave it buttresses and windows and added the ruined cloisters as well. It now appears on local Ordinance Survey maps,' he explains.

Leading you towards the priory along a processional path is a double line of pencil-slim junipers, *Juniperus scopulorum* 'Skyrocket', that shoot skywards, adding great atmosphere to the setting.

There is no immediate floral diversion or distraction from the tranquility of the hornbeam priory, but a little way off a border named Priors Bank provides a dramatic show.

The hornbeam church has always been a talking point but in summer 2021 it was centre-stage when the McGraths' daughter's marriage ceremony, officiated by a Druid celebrant, took place here. It must have made proud parents prouder still to see their daughter wed in a church they had grown!

19
Vann
Godalming, Surrey

DEEP IN THE HEART of leafy woodlands in Surrey the garden at Vann appears to float between water and meadow, gently disclosing its many facets and ornamental delights, including a notable Jekyll water garden.

This Grade II* registered garden around a Grade II* listed sixteenth-century house has been in the hands of the Caroe family for 112 years. Four successive generations have, in their turn, contributed to Vann's style and charm.

At first glance, the plants and plantings at Vann, a 5-acre/2-hectare garden, seem to keep close company with the house, as climbers including Virginia creeper, wisteria, *Rosa* 'Madame Alfred Carrière' and numerous clematis clothe the house walls and roofs and wind up and over pergola supports.

Step away from the house and its beautifully kept formal lawns, paths and beds and you realize that there are several yew- or beech-enclosed garden rooms to explore. Woodland, water, formal borders and meadows, with a touch of topiary humour such as the two cats chasing a mouse in yew, are some of the sumptuous parts that make up the whole, providing flowers, foliage and wildlife through the seasons.

Wisteria pergola

W.D. (William) Caröe, an Arts and Crafts ecclesiastical architect, took on the lease of the property in 1907. He carried out extensive building work, completed in 1908, including the installation of a long and wide pergola with piers made from local Bargate stone and capped with oak beams. Today, a white wisteria covers the pergola and it is underplanted with spring bulbs, acanthus, hellebores, pulmonaria, thalictrums and ferns.

In 1910, William established the Yew Walk and rill, also made from Bargate stone, at the north-east end of the garden. In 1912, he and his wife Grace asked their neighbour Gertrude Jekyll (1843–1932) to advise on and provide plants for a woodland water garden. (See page 88, her home at Munstead Wood.)

Martin (William's grandson) and Mary Caroe came to Vann in 1969 and worked together on the garden to foster its tranquillity and romantic informality, until Martin's death in 1999. Mary continued the stewardship of the garden, often working in it 12 hours a day, creating new areas such as the Centenary Garden, to mark 100 years of the family at Vann. Here yews shaped into small arbours are the backing for seasoned oak seats. Each seating area is paved with up-ended bottles marking the local history in glassmaking, which was proven by Martin's father, Alban Caröe, and his friends, during archaeological excavations in 1931. In April 2020 Mary died from Covid and now the fourth generation, siblings Rebecca, Oliver, Ruth and Emily, see Vann as a memorial to their parents and ask visitors to appreciate it in that spirit.

Emily, who is custodian, describes this new relationship: 'Before it was the house that I loved so much, it was my passion, my sanctuary, but now I live here each day I understand the

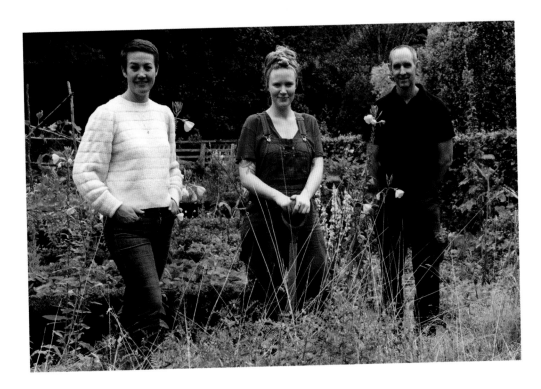

OPPOSITE Stands of white foxgloves and ox-eye daisies vie with greater quaking grass, *Briza maxima*, and globe artichokes to make ornamental rather than productive displays in the former kitchen garden.
LEFT Emily Caroe with Georgia Lingwood and Gordon Keddie.

draw of the garden – I fall in love with it more every day. My mother's hand is on everything – whether it was weeding or planting – she was here at all hours and it is a magical place.'

The legacy of Vann is not as straightforward now as it may have been for earlier generations, and the family are looking to negotiate a sustainable heritage and succession to preserve the special the relationship between house, landscape, collections and the history of Caroe family stewardship.

Trial and error

Mary and Martin approached the garden as a place of experimentation and adaptation, where trial and error brought many successes and where change and evolution was easily accommodated. Martin was an early proponent of leaving grass long and allowing wild flowers to emerge in the orchard and later, in and around the vegetable garden, which suffered from the attention of deer. In 2021, perennial vegetables such as globe artichokes were added to the vegetable garden, enjoyed for ornament as much as utility, surviving in close company with massed self-seeded greater quaking grass (*Briza maxima*), daisies, poppies and stands of white foxgloves.

Two standard mauve-blue wisterias and a romantic seating area in stone mark the start of the rill enclosed by the formal Yew Walk of 1910. The rill was originally bordered with standard roses, but as they, like the vegetables, were constantly attacked by deer, Mary decided to replace the planting in a naturalistic way, with bulbs, low-growing shrubs and perennials, including euphorbias, foxgloves, aquilegias and daisies, softening the formality of the topiary.

Between 2015 and 2017 head gardener Gordon Keddie and the garden team pruned the yew hedges drastically to rejuvenate them and now, relieved that they have grown back so well, they plan to cut alcoves into the yew for extra ornament.

Woodland water garden

The rill flows with water for about seven months of the year – drying up in summer droughts – running down to the large, quarter-acre pond rimmed with ferns and water marginals. The pond has benefitted from the loss of many of large trees knocked out in the storm of 1987. Mary and Martin used the opportunity, devastating though it was at the time, to introduce plants to the pond banks, such as iris, cornus and Chinese bramble (*Rubus tricolor*) that thrive in the more open setting.

Just below it is the woodland water garden installed in 1911–12 by William and Grace to Gertrude Jekyll's plan and with her plant choices. The wonder of this is that although Jekyll wrote about water gardens this is likely to be one of the few, or even the only one, of her making, to survive.

The bare bones of the water garden in the wooded valley are the curving paths and narrow bridges, which loop between and around small ponds. The paths, made from Bargate stone, snake across the four pools in the water garden making figures of eight of varying depths. On the stream banks, edging the paths and on the sloping sides of the valley alongside, are the many descendants of the original 1,500 plants that Jekyll listed and sold along with her original plans.

Proof of the origin of the water garden plants came in the 1980s when 32 of Jekyll's notebooks were discovered in a dusty shoe box at Godalming Library, listing the plants supplied to her clients. It is extraordinary that Mary Caroe was able to bring home the notebook labelled *Vann (No. 24)* to compare the lists to the plants that were still growing in her woodland water garden.

Jekyll plantings

In summer as you cross the bridges and follow the meandering paths, the dominant feature is foliage spilling over and all but engulfing the route. Masses of velvety-leaved lady's mantle (*Alchemilla mollis*) and dense plantings of shapely *Rodgersia pinnata*, along with epimediums and pulmonarias, wind like textured ribbons through the waterside setting.

Among Jekyll's suggestions for shade- and moisture-loving plants were mossy saxifrage, *Primula denticulata*, summer snowflake (*Leucojum aestivum*), hostas, galax, marsh marigolds, mimulus, male fern, ostrich fern, hart's tongue fern and *Helleborus hybridus*. Giant hogweed (*Heracleum mantegazzianum*) and giant rhubarb (*Gunnera manicata*) were also on the list and continue to thrive.

Below the water garden Jekyll's plantings still hold sway becoming more and more naturalistic as they spread over time and space. Snake's-head fritillaries have prospered with a mix of white- and mauve-flowered forms in the water garden in spring. However, a short way off in Grandmother's White Garden, mauve forms of snake's-head fritillary and pink foxgloves are assiduously 'weeded' out and moved to other areas of the garden. Included among the permitted white blooms are white narcissus that have naturalized over the years.

Romantic plantings throughout, combined with the formality of manicured, striped lawns and precisely shaped topiary, make Vann a memorable sanctuary destination.

OPPOSITE The Yew Walk (top left) at Vann highlights the many formal and informal planting combinations that run through the garden. In spring massed fritillaries and narcissus carpet the ground in the woodland water garden, and in summer areas of unmown grass and swathes of daisies contrast with the closely clipped cat-and-mouse topiary.

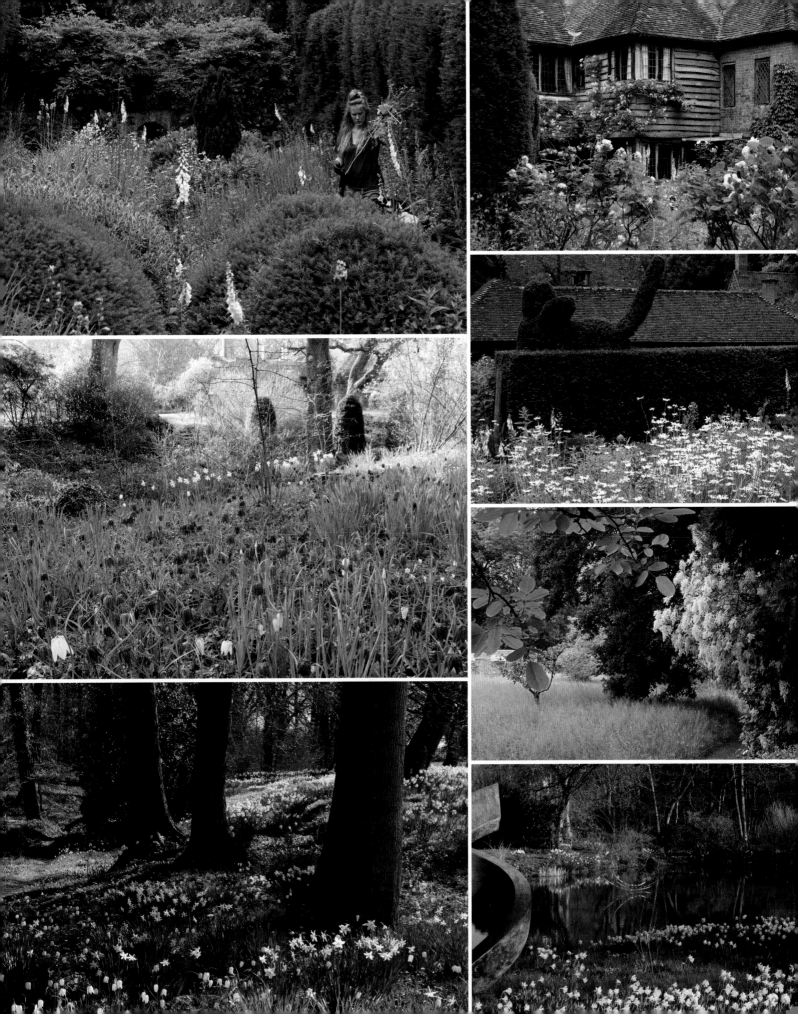

20
White House Farm
Sevenoaks, Kent

White House Farm Garden and Arboretum is a plantsman's garden, arboretum and woodland established by modern plant hunter Maurice Foster since the 1970s. It combines mature horticultural plantings and recent botanical treasures in a relatively small place (15 acres/6 hectares) to create a magnet for experts and enthusiasts alike.

What you see growing at White House Farm Maurice has collected, propagated, planted and maintained himself. This includes cultivars (several hundred each of his favourite magnolias, camellias, rhododendrons), recently introduced species and the latest hybrids. This garden shows what a solo gardener can do, over time, and using certain companion-planting methods, to achieve a year-round display that is almost self-maintaining: the great potential of woody plants that Maurice feels is most often missed.

'In a woody garden,' he says, 'trees are the main feature. Representative collections of oaks, hornbeams, maples, rowans, birches, magnolias and conifers shelter an understorey of flowering shrubs and ground cover of bulbs and herbaceous plants. If you plant trees and shrubs together at the same time, they find their own balance – which is how things grow in nature.'

Seasonal colour

Camellias, rhododendrons and hydrangeas jostle to fill the space and once established, their stable symbiosis needs minimal pruning and weeding.

'We plan for colour in every season, so as one thing fades into the background another catches the eye, with form and texture setting each other off year-round.

'Our planting method is based on what my early mentor, Michael Haworth-Booth [author of *Effective Flowering Shrubs*], called the close boskage system, where plants are quite close

OPPOSITE Birches from different parts of the world planted on the main lawn in the garden.
BELOW In the woodland is Maurice's breath-taking collection of hydrangea seedlings he has bred.

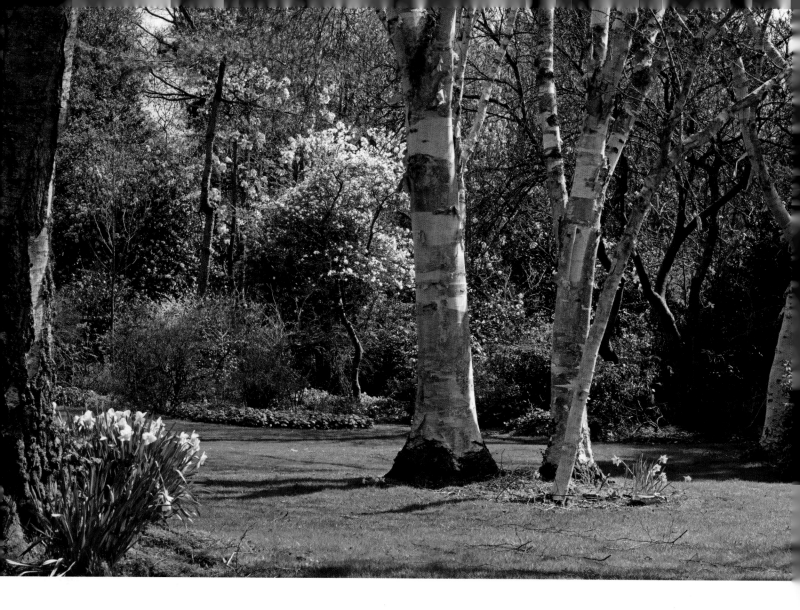

to each other, so in effect each supports the other, but still their personality shines through. It is also a labour-saving method, as weeds rarely survive and no staking is necessary.'

What the visitor can enjoy in early and mid-spring are towering forests of white, pink and yellow magnolias combining with free-flowering displays of mature rhododendrons and camellias in the shade below. In late spring, sumptuously coloured, large-flowered tree peonies, deutzias, philadelphus and clematis weave themselves together in borders alongside a network of gnarled wisterias, supported on a larch pergola that lines and shades a main path through the garden. In mid-

ABOVE Beyond the birches camellias and magnolias bloom in spring.
OPPOSITE TOP In a woodland gully among rhododendrons, wild naturalised bluebells make a spring time display.
OPPOSITE CENTRE One of the mature camellias, *Camellia* 'Donation', growing below the main lawn.
OPPOSITE BOTTOM *Hydrangea aspera* 'Kouki' with dark foliage is one of Maurice's favourites.

and late summer the same areas become a hydrangea garden, leading on to the glowing colours of autumn.

'There always should be something that draws your eye as you look up, down and around, for each season, even winter. I love bark and I think of trees as a substitute for hard landscaping. Clusters of birches on the main lawn to the north, for example, each from a different part of the world, are beautiful picked out in low-angled southerly winter light, especially as snowdrops and other early bulbs begin to appear.'

Maurice follows what he calls his rule of the five f's – the idea that you grow a tree for either its fruit, foliage, flower, fragrance or form – and if it has none of those 'you grow a rose, clematis, or wisteria into it: sometimes all three'.

Wild-collected roses
White House Farm is a vertical garden, you have to look up. Climbing roses and wisteria can appear in trees in the distance as high as 60 feet/18 metres. Roughly a half-mile of wild collected roses grow on boundary trees around the perimeter

I can stand in my garden and be in the centre of the world.' MAURICE FOSTER

of the arboretum. Climbing roses that Maurice has raised include 'Rosemary Foster', a pink-fading-to-white *R. filipes* hybrid, named for his late wife.

'They need watering for two years to help them establish amid surface root competition, then once established, will appear at various heights,' he explains.

Plant expeditions

Maurice and Rosemary began transforming the 5 acres/2 hectares of abandoned nut orchard, overgrown disused quarries and fields that would become White House Farm in the 1970s. In the 1990s Maurice was part of several plant-collecting expeditions to remote areas of China, Bhutan, Pakistan, Mongolia, Japan, Australia and New Zealand and by 1995 he had run out of planting space. So when a nearby pick-your-own strawberries field and Bramley orchard came up for sale he bought them to create an arboretum. It is dedicated to specimens of known wild provenance collected in the last 40 years from all over the world. From these, and his decades of breeding, Maurice also has developed his own species selections and hybrids, all growing here.

In 2010 he was able to add a strip of woodland for rare shade- and moisture-loving forest species, making White House Farm a plantsman's 'playpen', as he puts it. A quarter-mile-long gully (from ragstone extraction centuries ago) runs through the woodland, an opportunity for snowdrops, daffodils, epimediums, camassia and other displays of bulbs, so that they and other miniature and ground-hugging plants can be admired at close quarters. Existing sweet chestnut, native oak, hawthorn and hazel provide nursery cover for new small trees and flowering shrubs, with hundreds of *Narcissus poeticus* to complement the mass of wild bluebells.

Intense colours

Part of the wood is a horseshoe-shaped walk featuring 100 or more hybrid selections from Maurice's crosses of *Hydrangea serrata* and *H. macrophylla*. In his selections he aims for the compact form of Japanese *serrata* cultivars, but with more intense colourful flowering (dark blues, purples and reds) and often darker foliage, with some of the plants as attractive in autumn colour as in fresh bloom.

Another path in the wood features his many hybrids of *H. aspera*, especially the successful dark purple foliage forms

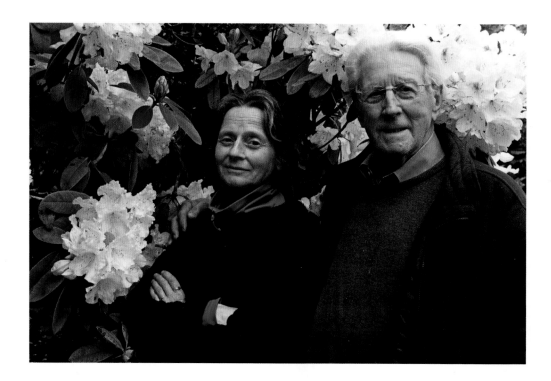

such as the widely available 'Hot Chocolate', and 'Rosemary Foster' which was awarded a gold medal in 2020 at a Belgian trade show.

Maurice's own enthusiasm for plants, gardening and nature is as undimmed at age 86 as it was at six. Maurice spent his childhood roaming the Northamptonshire countryside, and his passion for plants took root when he won a scholarship to Cambridge in the 1950s. There he discovered the botanic garden and college gardens, opening his eyes to a wider world of plants with their extraordinary histories and geographies. Now, in his own garden he can rightly declare, 'I can stand in my garden and be in the centre of the world.'

After university he began collecting seed, growing and propagating all kinds of plants in the suburban postage-stamp back garden of his first house in the 1960s.

After he retired, at 58, to devote himself full time to developing White House Farm with Rosemary, he increasingly participated in RHS committees, trials, awards and shows.

He has been Chair of the Rhododendron, Camellia and Magnolia Group, a member of the RHS Woody Plant Committee, a trustee of the Tree Register of UK and Ireland, and a judge at all the major RHS flower shows. In 2013 he was awarded the RHS Victoria Medal of Honour, given to horticulturists and limited to 63 recipients. After that he won the Jim Gardiner Cup for services to magnolias, and the David Trehane Cup for his contribution to camellias.

Among the thousands of specimens on White House Farm's database are 77 'champion' trees (the largest in the UK). The wood and arboretum feature rare specimens wild-collected since the 1980s by individuals, institutions, seed subscription and plant donation or exchange, during what Maurice has called a 'second golden age of woody plants'. White House Farm is part of an informal international network of collections that has been sharing and trialling new plants for decades – a need that will only intensify in future, as access to these is lost, or original populations are destroyed.

This is partly why Maurice's daughter Clare has been working with her father to document the plants and set up the White House Farm Arboretum Foundation, to ensure the survival of his remarkable plant collection.

Clare notes: 'If you are learning about gardening and plants as I am, the beauty of this place is that it is also an interesting resource for the relatively new keen gardener. I can see an amazing number – 200 or more – of well-known cultivars of the magnolia, camellia, rhododendron and rose genera. Then I can compare them with some of the original species they came from in the wild, as well as some of the latest entries in that line that Maurice and others are just now propagating and breeding.'

Clare's engagement with the history of the plants and the unique setting will benefit the future of White House Farm. It is reassuring to know that this special place has a champion for its future.

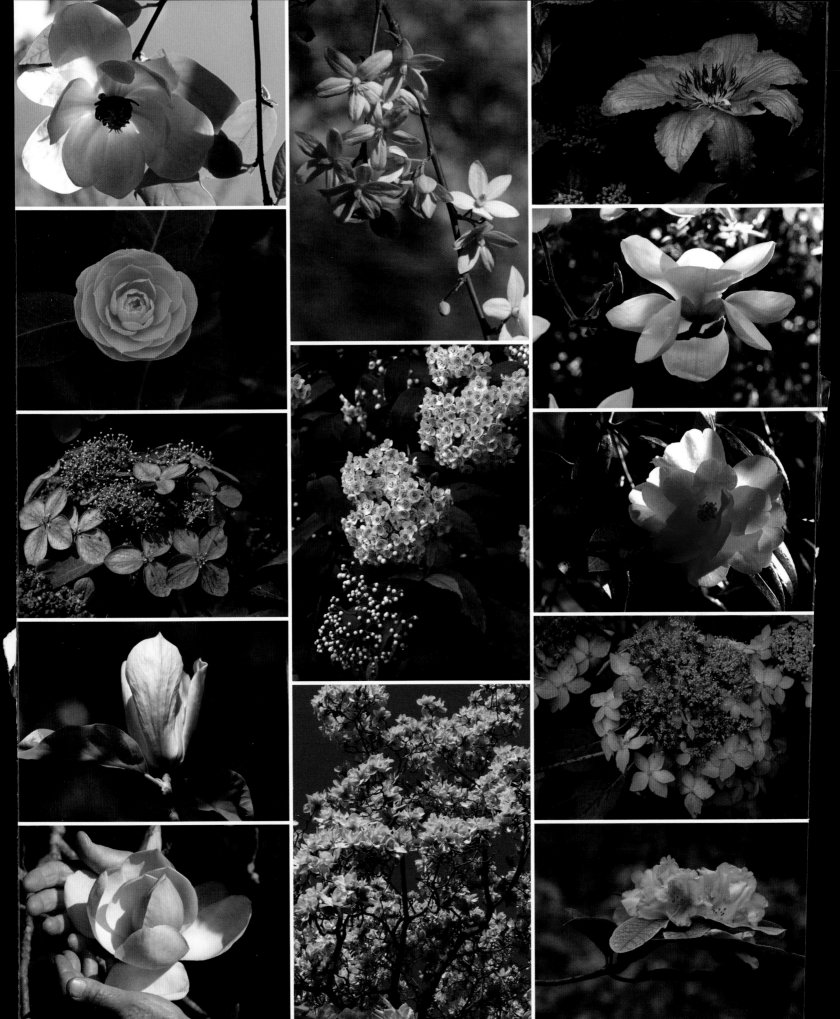

Visitor information

There are so many wonderful gardens, large and small, in Surrey, Sussex and Kent. In addition to the 20 listed here are covered in detail in this book, the others represent just a fraction of the gardens that will delight visitors. At the time of publication, most of these gardens were open to the public at some time during the year. Please check opening times on each garden's website or (if applicable) on the National Garden Scheme (NGS) website (www.ngs.org.uk).

87 Albert Street (page 10)
Whitstable, Kent CT5 1HU
Whitstable Town Gardens
www.facebook.com/
whitstableopengardens
Open as part of NGS (www.ngs.org.uk).

Arundel Castle (page 16)
Arundel, West Sussex BN18 9AB
Tel: 01903 882173
Email: visits@arundelcastle.org
www.arundelcastle.org/gardens
Check website for opening times, prices and NGS dates (www.ngs.org.uk).

Balmoral Cottage (page 22)
The Green, Benenden,
Cranbrook, Kent TN17 4DL
Tel: 01580 240308
Email: thepottingshedholidaylet@gmail.com
www.thepottingshedbenenden.co.uk
Open as part of NGS (www.ngs.org.uk).

Borde Hill Garden
Borde Hill Lane, Haywards Heath,
West Sussex RH16 1XP
Tel: 01444 450326
Email: info@bordehill.co.uk
www.bordehill.co.uk
Check website for opening times, prices and NGS dates (www.ngs.org.uk).

Boyton Court (page 28)
Maidstone, Kent ME17 3BY
Tel: 07796 446209
Email: samantha.adrian@yahoo.com
Open for small, private groups from specialist garden societies such as Alpine Garden Society, Hardy Plant Society and others. Parking is very limited.

Clinton Lodge Gardens (page 34)
Fletching, East Sussex TN22 3ST
Tel: 01825 722952
Email: garden@clintonlodge.com
www.clintonlodgegardens.co.uk
Check website for opening times and prices.

Denmans Garden (page 42)
Denmans Lane, Fontwell,
West Sussex BN18 0SU
Tel: 01243 278950
Email: office@denmans.org
www.denmans.org
Check website for opening times, prices and NGS dates (www.ngs.org.uk).

Doddington Place Gardens (page 48)
Sittingbourne, Kent ME9 0BB
Tel: 07949 746792
Email:enquiries
@doddingtonplacegardens.co.uk
www.doddingtonplacegardens.co.uk
Check website for opening times, prices and NGS dates (www.ngs.org.uk).

Gravetye Manor (page 56)
Vowels Lane, West Hoathly, East Grinstead,
West Sussex RH19 4LJ
Tel: 01342 810567
Email: info@gravetyemanor.co.uk
www.gravetyemanor.co.uk
Check website for garden visiting arrangements. Open April to October for garden tours of up to 20 people on Mondays, Wednesdays and Fridays

combined with a lunch reservation or if a hotel guest free to wander at leisure.

Great Dixter House,
Gardens and Nurseries
Northiam, Rye, East Sussex TN31 6PH
Tel: 01797 253107
Email: info@greatdixter.co.uk
www.greatdixter.co.uk
Check website for opening times, prices and NGS dates (www.ngs.org.uk).

Hole Park
Benenden Road, Rolvenden, Cranbrook,
Kent TN17 4JA
Tel: 01580 241344
Email: events@holepark.com
www.holepark.com
Check website for opening times and prices.

Leonardslee Lakes and Gardens
Brighton Road, Lower Beeding, Horsham,
West Sussex RH13 6PP
Email: info@leonardsleegardens.co.uk
www.leonardsleegardens.co.uk
Check website for opening times and prices.

Long Barn (page 62)
Sevenoaks Weald, Kent TN14 6NH
Email: lbgardenskent@gmail.com
www.longbarngardens.uk
Open for pre-booked groups
(minimum 8, maximum 50 people).

Malthouse Farm (page 70)
Streat Lane, Streat, Hassocks,
West Sussex BN6 8SA
Tel: 01273 890356
Email: helen.k.keys@btinternet.com
Open to the public under NGS
(www.ngs.org.uk) on selected dates and by arrangement May to September for groups
(10–30 people).

Marchants Hardy Plants (page 78)
2 Marchants Cottages, Mill Lane,
Laughton, East Sussex BN8 6AJ
Tel: 01323 811737
Email: marchantshardyplants@gmail.com
www.marchantshardyplants.co.uk
Check website for opening times, group
bookings and prices.

Moleshill House (page 84)
The Fairmile, Cobham, Surrey KT11 1BG
Tel: 01932 864532
Email: pennysnellflowers@btinternet.com
www.pennysnellflowers.co.uk
Open as part of NGS (www.ngs.org.uk)
and by arrangement.

Munstead Wood and the Quadrangle
(page 88)
Heath Lane, Busbridge, Godalming,
Surrey GU71UN
Email: contact@munsteadwood.org.uk
www.munsteadwood.org.uk
Check website for opening times and
prices. Garden tours for up to 15 people
by appointment only.

Parham House and Gardens
Pulborough, West Sussex RH20 4HS
(use RH20 4HR for sat-nav)
Tel: 01903 742021
Email: enquiries@parhaminsussex.co.uk
www.parhaminsussex.co.uk
Check website for opening times
and prices.

Prospect Cottage
Dungeness Road, Dungeness,
Romney Marsh, Kent TN29 9NE
The late Derek Jarman's home and garden
which after a fund-raising campaign in
2020 is being preserved by the Art Fund.

Ramster Hall (page 96)
Petworth Road, Chiddingfold,
Godalming, Surrey GU8 4SN
Tel: 01428 654167
Email: office@ramsterhall.com
www.ramsterevents.com
Check website for opening times, prices
and for NGS dates (www.ngs.org.uk).

Restoration House (page 102)
17–19 Crow Lane, Rochester,
Kent ME1 1RF
Tel: 01634 848520
Email: robert.tucker@restorationhouse.co.uk
www.restorationhouse.co.uk
Check website for opening times and prices.

Sissinghurst Castle Garden
(National Trust)
Biddenden Road, near Cranbrook,
Kent TN17 2AB
Tel: 01580 710700
Email: sissinghurst@nationaltrust.org.uk
www.nationaltrust.org.uk/sissinghurst-
castle-garden
Check website for opening times and prices.

Sussex Prairie Garden (page 108)
Morlands Farm, Wheatsheaf Road,
near Henfield, West Sussex BN5 9AT
Tel: 01273 495902
Email: morlandsfarm@btinternet.com
www.sussexprairies.co.uk
Check website for opening times, prices
and for NGS dates (www.ngs.org.uk).

The Hannah Peschar Sculpture Garden
(page 116)
Black & White Cottage, Standon Lane,
Ockley, Dorking, Surrey RH5 5QU
Tel: 01306 627269
Email: hannahpesharsculpture
@gmail.com
www.hannahpesharsculpture.com
Check website for opening times and prices.

Town Place Garden (page 122)
Ketches Lane, Freshfield, Sheffield Park,
West Sussex RH17 7NR
Tel: 01825 790221
Email: mcgrathsussex@hotmail.com
www.townplacegarden.org.uk
Open under NGS on selected dates and for
groups by arrangement in June and July
(www.ngs.org.uk).

Vann (page 130)
Vann Lane, Hambledon,
Godalming, Surrey GU8 4EF
Tel: 01428 683413
Email: vann@caroe.com
www.vanngarden.co.uk
Check website for opening times, prices
and for NGS dates, For group visits email
Emily Caroe (caroe.emily@gmail.com).

**White House Farm Garden and
Arboretum** (page 134)
High Cross Road, Ivy Hatch, Sevenoaks,
Kent TN15 0NN
Tel: 07595 461 806 (Clare Foster)
Email: whitehousefarmarb@gmail.com
www.whitehousefarmgardenandarboretum.
wordpress.com
Visits are by prior arrangement for groups
of 10–30, with two open days a year.

Whitstable Joy Lane Gardens
19 Joy Lane, Whitstable, Kent CT5 4LT
www.facebook.com/
whitstableopengardens
Open as part of NGS (www.ngs.org.uk).

Index

ACKNOWLEDGEMENTS

So many thanks are due to the open-hearted garden owners and gardeners who have given me their time and expertise in such unstinting measure, despite the strangeness of recent times. It has been a privilege to visit all the gardens in the book, as well as many that we sadly couldn't include. They have all been so interesting and so different, and I have loved getting to the heart of the stories of the plants and people that make each garden special.

Huge thanks to Fergus Garrett – consummate plantsman and garden 'knower' – for his generous Foreword to the book.

So many people told me about gardens in Surrey, Sussex and Kent that they loved, and introduced me to owners and gardeners. Thank you so much Rosie Atkins, Marian Boswall, Annie Guilfoyle, Paula McWaters, Debbie Roberts and Jo Thompson.

Many thanks to my cousin Naomi Clifford Klein who read the first draft of the book and made many sensible and kind suggestions as well as necessary cuts. There are also many friends including Gary Avis, Philippa Burrough, Susan Burton, Michelle Chapman, Anglela Clarke, Simon Edge, Karen Gimson, Judith Glover, Tanya Hamilton, Tim Holder, Andrew Jones, Richard Roberts, Phee Smith, Christine Webber, Judy Wolff and (the now late) Heather Pickard, all of whom cheered me onwards and up.

Working with Helen Griffin, who commissioned this book way back in 2019, before we had heard the words 'lockdown', 'pandemic', 'furlough' and 'jabs', is always a pleasure. Her support and encouragement during that period of uncertainty was invaluable.

Photographer Clive Boursnell's enthusiasm and absolute devotion to ensuring that his images show plants and gardens at their very best and reveal their unique qualities, is a joy. Lucky me and fortunate gardens that the visual aspect of the book was so safe in his hands, lens and eyes.

Once the text and images come together in layouts, something magical happens to a book. And this book was no different to any other. Designer, editor, photographer and author work collaboratively at this point. Things converge and the work becomes 'ours', not just Clive and I travelling on our parallel paths. Thank you to Helen Griffin, Michael Brunström and Anne Wilson for pulling it all together into a wonderful shape.

I hope that you will find much pleasure in the book and visit the gardens when possible… opening garden gates to find untold beauty.
Barbara Segall

I have had an absolutely privileged time from Autumn 2020 to November 2021 visiting some 40 gardens in the South East of England. Alas only 20 gardens could be included. Even 20 owners and garden teams are too many to name individually here due to lack of space.

As luck would have it, the one thing common to all the garden owners and garden teams was the enormously warm welcome I received, including on the one occasion when I turned up during a daughter's wedding that was taking place in the garden. I just needed to photograph a particular rose trellis at its peak. I and my camper bus were totally accepted in the garden overnight for last-light/first-light shootings.

My warm welcome to the gardens often included evening suppers with my delightful hosts, when supper for two suddenly became supper for three.

I feel so lucky loving the early light, and the joy of waking up in these gardens is such a privilege. Every one is so very special and unique, amply rewarding the 12,500 miles of driving through and around roadworks over the three counties.

I'd like to thank Helen Griffin our Editor, our lighthouse, anchor and navigator when everything seemed at sea in March 2020. Thank you to Anne Wilson, who had the hard task laying out the pictures for the book with the photographer jumping up and down shouting 'This picture is a must, and no cropping!' Deep thanks to my better half who for the third time in four summers lost me for three of them. Three books in four years.

But I must return to all the garden owners, head gardeners and their teams to offer my deepest thanks. Without you all opening your garden gate to me we would have no book. Thank you, all.
Clive Boursnell, BEM

First published in 2022
by Frances Lincoln,
an imprint of The Quarto Group.
The Old Brewery, 6 Blundell Street,
London N7 9BH, United Kingdom
(0)20 7700 6700
www.Quarto.com

A catalogue record for this book is available from the British Library.

ISBN 978-0-7112-5260-8
Ebook ISBN 978-0-7112-5261-5

Edited by Helen Griffin
Design by Anne Wilson
Printed and bound in China

10 9 8 7 6 5 4 3 2 1

MIX
Paper from responsible sources
FSC® C016973
www.fsc.org

Brimming with creative inspiration, how-to projects, and useful information to enrich your everyday life, quarto.com is a favourite destination for those pursuing their interests and passions.